Pottery by American Indian Women
The Legacy of Generations

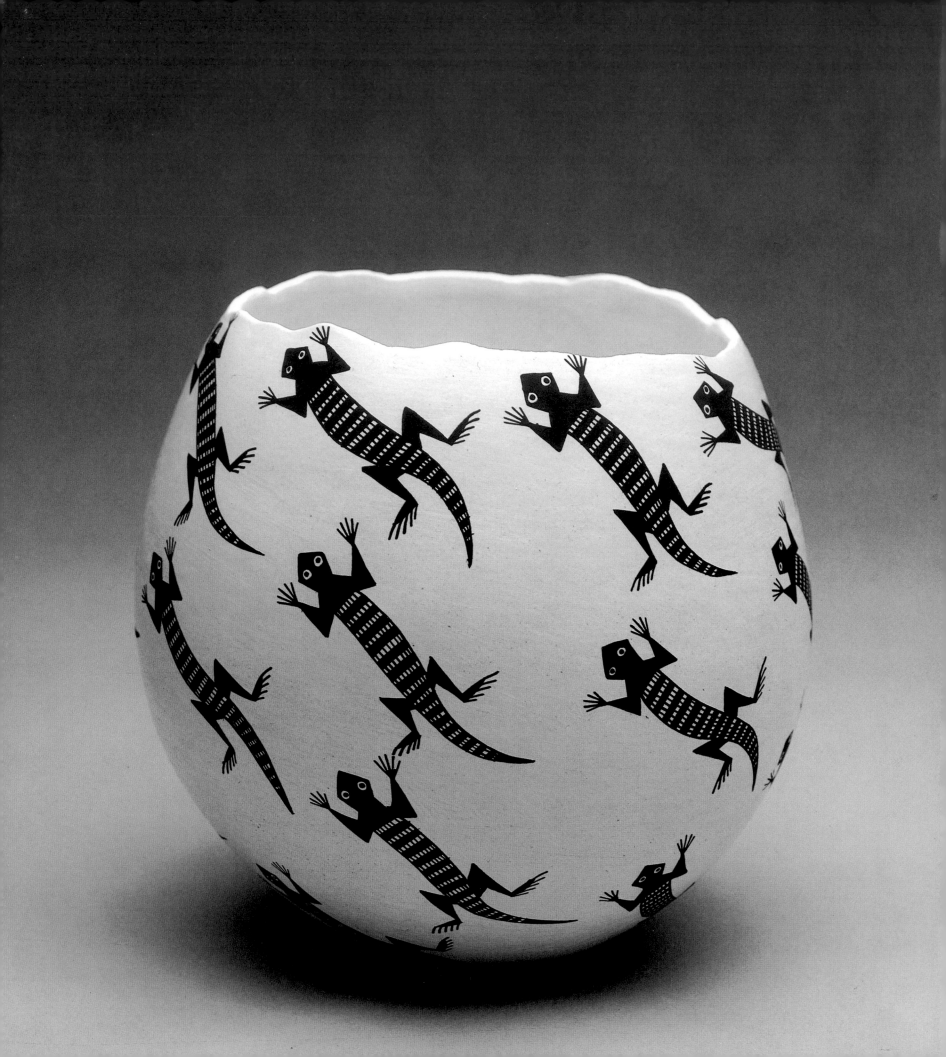

Pottery by American Indian Women
The Legacy of Generations

Susan Peterson

THE NATIONAL MUSEUM OF WOMEN IN THE ARTS
WASHINGTON, D.C.

Abbeville Press Publishers New York London Paris

Utah Colorado

HOVENWEEP NAT MON

YUCCA HOUSE NAT MON

RAINBOW BRIDGE NAT MON

MESA VERDE NATIONAL PARK

Ute Mountain I R Southern Ute Ind Res

NAVAHO NATIONAL MONUMENT

Shiprock

AZTEC RUINS NAT MON

Navajo Indian Reservation Farmington

Jicarilla Apache Ind Res

Taos Indian Reservation

GRAND CANYON NATIONAL PARK

CANYON DE CHELLY NATIONAL MONUMENT

Taos

San Juan Ind Res Picuris Ind Res

WUPATKI NAT MON

Hopi Indian Reservation

Window Rock

Santa Clara I R
San Ildefonso I R

Pojoaque I R
Nambe I R
Tesque I R

SUNSET CRATER NATIONAL MONUMENT

Navajo Indian Reservation

CHACO CANYON NATIONAL MONUMENT

Jemez I R

Zia Indian Reservation

Cochiti I R

Sante Fe

Flagstaff

Navajo Ind Res Gallup

Santo Domingo I R
San Felipe I R
Santa Ana I R

WALNUT CANYON NATIONAL MONUMENT

Laguna I R

Sandia I R

Cape Verde Indian Reservation

Zuni Ind Res

EL MORRO NAT MON

Acoma I R

Canoncito I R Albuquerque

N

PETRIFIED FOREST NATIONAL PARK

Isleta I R

S

Arizona Ramah Navajo Ind Res Laguna I R New Mexico

Historically, American Indians from all regions of the United States have made pottery, and they continue to do so now. However, most of today's prominent potters live in the Navajo nation or in the twenty existing pueblos of the Southwest, pictured above.

Exhibition Itinerary:

The National Museum of Women in the Arts,

Washington, D.C., October 9, 1997–January 11, 1998

The Heard Museum,

Phoenix, February 18, 1998–April 18, 1998

At Abbeville Press
EDITOR: Leslie Bockol
DESIGNER: Celia Fuller
PRODUCTION MANAGER: Stacy Rockwood

At The National Museum of Women in the Arts
EDITOR: Laureen Schipsi
EDITORIAL ASSISTANT: Amanda Nelson

FIRST EDITION
10 9 8 7 6 5 4 3 2

FRONT COVER: Dextra Nampeyo, Bowl (detail), see page 118
SPINE: Fannie Nampeyo, Tile (detail), see page 113
BACK COVER: (clockwise from top left)
 Lucy Martin Lewis, Jar (detail), see page 82
 Margaret Tafoya, Jar (detail), see page 91
 Jean Bad Moccasin, Vase (detail), see page 183
 Nancy Youngblood Lugo, Bowl (detail), see page 157
FRONTISPIECE: Emma Lewis Mitchell, Jar see page 136

Cataloging-in-Publication Data

Peterson, Susan (Susan Harnly)
 Pottery by American Indian women: the legacy of generations / Susan Peterson.
 p. cm.
 Published in conjunction with an exhibition held at the National Museum of Women in the Arts, Washington, D.C., Oct. 9, 1997–Jan. 11, 1998 and at the Heard Museum, Phoenix, Feb. 14–Apr. 18, 1998.
 Includes bibliographical references and index.
 ISBN 0-7892-0353-7 (hc).
 1. Indian pottery—North America—Exhibitions. 2. Indian women potters—North America—Exhibitions. I. National Museum of Women in the Arts (U. S.) II. Heard Museum. III. Title.
E98.P8P37 1997
738'.082—dc21 97-12628

This exhibition was made possible in part by generous grants from the Mobil Foundation

Contents

Acknowledgments

FROM THE NATIONAL MUSEUM OF WOMEN IN THE ARTS

The National Museum of Women in the Arts is delighted to present *The Legacy of Generations,* which celebrates the achievements of women artists in preserving and expanding upon the ancient tradition of Indian pottery. This show would not have been possible without the vision, determination, and enthusiasm of many individuals and organizations.

First and foremost, we are extremely grateful for the generous support of the Mobil Corporation, which has made the exhibition, its accompanying book, and related education programs possible. It has been a distinct pleasure to work with Lucio A. Noto, chairman and chief executive officer; Ellen Z. McCloy, manager, corporate support programs; and Marilyn J. Gould, community relations advisor.

We also wish to thank curator Susan Peterson for her expertise, which has made *The Legacy of Generations* the ambitious and far-reaching exhibition that it is. Her years of experience as a potter and teacher, and her long-term friendships with many of the women featured in the show were the keys to its success. It was a privilege to work with her on this extraordinary undertaking.

To those institutions and individuals who kindly lent their artworks, we extend our profound gratitude. They include: Dr. Garth L. Bawden, director, Maxwell Museum of Anthropology, University of New Mexico, Albuquerque, New Mexico; Dr. Bruce Bernstein, director and chief curator, Museum of Indian Arts and Culture/ Laboratory of Anthropology, Santa Fe, New Mexico; Charlene Cerny, director, Museum of International Folk Art, a unit of the Museum of New Mexico, Santa Fe, New Mexico; Michael J. Fox, director, Museum of Northern Arizona, Flagstaff, Arizona; Dr. Evelyn Handler, director, California Academy of Sciences, San Francisco; Michael J. Hering, director, Indian Arts Research Center, School of American Research, Santa Fe, New Mexico; Duane King, executive director, Southwest Museum, Los Angeles; Dr. Michael A. Mares, director, Oklahoma Museum of Natural History, University of Oklahoma, Norman, Oklahoma; David McFadden, executive director, Millicent Rogers Museum of Northern New Mexico, Taos, New Mexico; Dr. Donald J. Ortner, director, National Museum of Natural

History, Smithsonian Institution, Washington, D.C.; Louis I. Sharp, director, Denver Art Museum, Denver; Geoffrey E. Stamm, director, Indian Arts and Crafts Board, U.S. Department of the Interior, Washington, D.C.; Dr. Martin Sullivan, director, Heard Museum, Phoenix; Marjorie and Charles Benton; Diane Calabaza-Jenkins; J. Peter and Nancy Clark; Sid and Char Clark; Phil Cohen of Gallery 10, Inc., Scottsdale, Arizona, and Santa Fe, New Mexico; Buffy Cordero; Sherre Davidson; Anita Fields; Andrea Fisher and Celia Calloway of Andrea Fisher Fine Pottery, Santa Fe, New Mexico; Jody Folwell; Mr. and Mrs. William Freeman; Dolores Lewis Garcia; Carol and Charles Gurke; Eleanor Tulman Hancock; Tom Hargrove; Carmel Lewis Haskaya; Jim Jennings; Sara and David Lieberman; Georgia Loloma; Nancy Youngblood Lugo; Dennis and Janis Lyon; Nedra and Richard Matteucci; Lucille and Marshall Miller; Emma Lewis Mitchell; Jean Bad Moccasin; Dr. and Mrs. Linus Pauling, Jr.; David Rockefeller; Barbara and Frank Salazar; Judith and Stephen Schreibman; Jacquie Stevens; Martha Hopkins Struever; Lu Ann Tafoya; Theodore and Louann Van Zelst; Ruth and Robert Vogele; and Lynn and Larry Welk.

We would also like to extend our appreciation to Director Martin Sullivan and the staff of the Heard Museum, which will serve as the second venue for the exhibition, for their interest and encouragement. We are especially indebted to Diana Pardue, curator of collections, for her patient assistance in researching this book.

We wish to thank Craig Smith for traveling great distances to photograph the artists' works in situ as well as many of the loans from public and private collections. We also recognize the able efforts of photographers Tim Thayer, Rob Orr, Lee Stalsworth, Sanford Maulden, Shuzo Uemoto of the Honolulu Academy of Arts, and Allan Finkelman.

After many years and numerous projects, I continue to admire the skill and dedication of museum staff members. Those who contributed substantially to the success of this project include Susan Fisher Sterling, Rebecca Dodson Clark, Edwin Penick, Randi Jean Greenberg, Tracy Schpero Fitzpatrick, Nell Andrew, Laureen Schipsi, Amanda Nelson, Harriet McNamee, Elyse Buxbaum, Kandace Steadman, Holly Crider, Christina Knowles, Maura Scanlon, Mary Alice Nay, and Mary-Frances Wain.

The enduring tradition of American Indian pottery is meaningful to us all for it is a shared heritage. In the pages that follow, you will see that we can only stand in awe of the accomplishments of the past and eagerly await the new, as it will enrich our lives in many ways.

REBECCA PHILLIPS ABBOTT
Director

Author's Foreword

For over sixty years, I have been in close contact with the world of American Indian pottery, and with many of the most talented potters of the past few generations. I count myself very lucky to know most of the potters in this book personally. This has provided me an opportunity to hear their own explanations of their work, and to better understand their traditions and innovations.

I have been visiting Indian pueblos since I was eight years old. Between 1933 and 1939, my family drove from Nebraska to California each summer, stopping at San Ildefonso Pueblo in New Mexico on every trip. On these trips, I came to know Maria Martinez and her family, and later other Indian artists.

When I became a potter myself, the Indian connection grew. After graduating from the MFA program at New York State College of Ceramics at Alfred University in 1950, I again visited San Ildefonso during a cross-country drive to California. Maria's second son, Popovi Da, was beginning to paint her pottery at that time, and had a small shop for selling his mother's work. He gave me a painted lamp shade he had made of animal hide, and I bought some Maria vessels. A few years later, when the American Ceramic Society's national chapter wanted to honor Maria with their highest award, I was able to help them locate her; at that time, she had no telephone and few people knew where she lived. When Maria came to accept the award in Los Angeles, she and Popovi Da stayed with my family.

I began my work as a ceramic professor at the University of Southern California in 1955, and began teaching in their summer art program (called ISOMATA, at the Idyllwild School of Music and the Arts) in 1957. When the Foundation on the Arts and the Humanities (now known as the NEA and the NEH) came into being in 1965, I collaborated with ISOMATA's founding director, Dr. Max Krone, to write grant proposals for an exciting idea I had: a program of demonstrations by Indian artists. This evolved into classes of Indian arts given by Indian artists.

For our first summer program, I brought many eminent Indian artists to ISOMATA. Maria Martinez came with five generations of her family: Clara Montoya (Maria's youngest sister, who was thirty years younger), Adam and

Santana Martinez (Maria's son and daughter-in-law) and their daughter Anita; Anita's daughter, Barbara Gonzales, with her young sons Cavan and Aaron; and several other members of the family. I also brought Fred Kabotie, the famous Hopi painter and silversmith who had started the Second Mesa Hopi Indian Arts and Crafts Guild to help Hopi men and women learn a means of livelihood; Bertha Stevens, a Two Gray Hills rug weaver; Bertha's husband Fred Stevens, the youngest medicine man of the Navajo nation (the Stevenses had been recommended to me by United States Secretary of the Interior Stewart Udall); and five Papago basketmakers.

Dr. Herbert Zipper, from the University of Southern California, served as the initial director of the ISOMATA Indian program. That first summer he arranged for Maria and me to have a two-person exhibition of our individual ceramic works at the California Museum of Science and Industry. I suspect it was the first time that any American Indian potter ever participated in a two-person exhibit with a non-Indian. I was very proud!

Maria was remarkable; as arthritic as her gnarled hands had become, she could still fashion gracefully curved pottery profiles. They were no longer painted by any member of her family or pueblo, and were signed with her Indian name, Maria Poveka. Clara polished what Maria made. Maria's great-granddaughter Barbara and her daughter-in-law Santana led new groups of about forty students each week. Maria taught mostly black-on-black ware, but also polychrome, at which she had been expert early in this century.

That summer I gained a much greater understanding of American Indians. All the Indian teachers and their families were housed on the campus. We Anglos had to learn quickly about the kind of food "our" Indians needed, and other problems of their expatriate life; the students and townspeople helped.

For eight summers, classes continued at ISOMATA in this manner, until Maria's health failed. When Maria could no longer attend, I asked two other phenomenal potters to join us: Lucy Martin Lewis of Acoma Pueblo, who worked in traditional Acoma polychrome but was also an innovator in black-on-white pottery; and Blue Corn of San Ildefonso, an expert in black-on-black pottery who had also developed a distinctive polychrome color palette. These summer sessions gave me an uncommon insight into the art of Indian pottery. However, I am sure I will never be "let in" to understand everything about these unique people, no matter how many more years I know them as friends and artists.

After a few summers I realized that the pottery of American Indian artists had never been well documented. Maria's work was covered only by a book written by Alice Marriott and illustrated with line drawings in the early 1940s. To correct this neglect, I wrote *The Living Tradition of Maria Martinez,* with eighty-eight pages of

color photographs of the pottery, the process, and the people. My book—Maria's book—was awarded the National Cowboy Hall of Fame American Heritage "Oscar" as the best western art book of 1978. Understanding that no two Indian artists are alike, and that their ceramic art and techniques differ, I thought that other Indian artists deserved the same attention. With this in mind, I wrote my next book, *Lucy M. Lewis, American Indian Potter,* in 1984. Both books, I am glad to say, are still in print.

As I have learned more about these remarkable artists over the years, I have continued to share new information through magazine articles and touring. I have traveled the country with the Martinez and the Lewis families, lecturing and showing slides while they demonstrated pottery making and firing.

I am proud to have partipated in some of the most important Anglo exhibits of Indian pottery. In 1978 I curated a large exhibition for the Renwick Gallery of the Smithsonian Institution in Washington, D.C., called *Maria Martinez: Five Generations of Potters.* I compiled a definitive catalogue for that exhibition, filled with photographs and information. In 1980 I curated an exhibition and wrote a catalogue for the American Contemporary Art Gallery in New York City, featuring Fannie and Priscilla Nampeyo, Lucy Lewis, Santana and Adam Martinez, and Barbara Gonzales. In 1984 I curated an exhibition at the Kerr Gallery in New York City for Lucy Lewis and several of her children, Emma, Dolores, and Andrew.

The Legacy of Generations exhibition is indebted to the enthusiasm of Wilhelmina Cole Holladay, who was initially fascinated by the Renwick-Smithsonian exhibition in 1978. She and her husband, Wallace, had a major collection of women's art from around the world, spanning all eras. They asked me to find a black-on-black pot by Maria and Julian Martinez for their collection; they wanted a masterpiece. My search was not easy, since the Renwick exhibition had rendered all the fine Martinez pots almost priceless. However, the exceptional piece they bought is now in the collection of the museum Mrs. Holladay founded: the National Museum of Women in the Arts (NMWA), in Washington, D.C.

Most likely, the Martinez pot the Holladays bought was a catalyst for the current exhibition, which was initiated by NMWA. After Mrs. Holladay conceived of this exhibition, she discussed it with me, and I selected the twenty-eight Indian women potters based on my own experience. As curator, I spent three years searching for masterpiece examples, and another year writing this book.

For both the exhibition and this book, I have depended on help from many different people and organizations. Most of all, I am grateful to the American Indian women whose art comprises this show. Sometimes it was difficult to find

their remote and isolated homes, but they have been extremely courteous. They generously offered all they could of their time, attention, and ideas.

I have also been aided by a number of museum directors and curators in the United States, and by many art collectors, gallery owners, and scholars, to whom I am indebted. My thanks also to the collectors all over the United States who gave me a chance to view their collections, and especially to those who decided to lend to this exhibition.

Many people have been most helpful in other ways, as follows:

Bruce Bernstein (chief curator and director of the Museum of Indian Arts and Culture), Michael Hering (director of the Indian Arts Research Center, School of American Indian Research), Jonathan Batkin (CEO and director of the Wheelwright Museum of the American Indian), and their staffs; Stewart Peckham (director emeritus of the Laboratory of Anthropology), Judy Smith (curator of European and American art, Museum of International Folk Art), Andrea Fisher and Celia Calloway (Andrea Fisher Fine Pottery), Phil Cohen and the late Lee Cohen (Gallery 10), Nedra Matteucci (Nedra Matteucci Galleries)—all in Santa Fe, New Mexico;

David MacFadden (executive director of the Millicent Rogers Museum) and his staff, in Taos, New Mexico;

The late Dr. Carl Dentzel (director of the Southwest Museum in Los Angeles), who was a mentor to me from 1950 until his untimely death in 1980; and his successor, Duane King;

Dr. Russell Hartman (collections manager of the California Academy of Sciences, in San Francisco);

Dr. Richard Townsend (curator of Africa, Oceania, and the Americas at the Art Institute of Chicago), collectors Charles and Marjorie Benton, the staff at Pacific Media, Inc., Theodore and Louann Van Zelst, Robert and Ruth Vogele— all in Chicago;

Marshall and Lucille Miller of Orchard Park, Michigan;

Diana Pardue (curator of collections at the Heard Museum) and her staff, Susan H. Totty (manager of Gallery 10 el Pedregal), collectors Dennis and Janis Lyon, Jerry Collings, Stephen and Judith Schreibman, Pamela Dahlberg, Mitzi and Steve Schoninger—all in Phoenix, Arizona, and vicinity;

Geoffrey Stamm (director of the Indian Arts and Crafts Board) and his staff in Washington, D.C., who assisted with literature and information all along the way;

Dr. Charles Zug III (professor and chair of the curriculum in folklore for the University of North Carolina at Chapel Hill), whose information about historical and contemporary Indian folk artists in the north and southeast has been invaluable to me for many years;

Julie Droke (museum collections manager for the Oklahoma Museum of Natural History, University of Oklahoma);

The Ontario Crafts Council, Canada;

Tom Fresh (former director of the Indian Program at ISOMATA, in Idyllwild, California) who kept the program alive after I could no longer do it, and who has known and helped "our" Indians well;

Sue Taylor, Martha Hopkins Struever, Barbara Babcock, Dr. Francis Harlow, the late Rick Dillingham, and all other specialists and friends who have nurtured me in this endeavor;

Joan Mondale, whose friendship and help I have appreciated for over twenty years, particularly her efforts to bring this exhibition to Japan;

Craig Smith, who photographed pots in Arizona, New Mexico, and California, and the other photographers I did not work with but who served in the rest of the country;

Trudy Bruinsma, for her help with the bibliography;

Wilhelmina Cole Holladay (chair of the board), Rebecca Phillips Abbott (director), Susan Fisher Sterling (curator of contemporary and modern art), and Laureen Schipsi (director of publications) at the National Museum of Women in the Arts, and the museum's entire staff—including Rebecca Dodson Clark (registrar) and Amanda Nelson (editorial assistant);

The Mobil Foundation, for its support of this exhibition;

Mark Magowan and the staff at Abbeville Press for this book, including editor Leslie Bockol and designer Celia Fuller.

Although I retired from my professorship at Hunter College, City University of New York, in 1994, I began this Indian project while I was still teaching there. I will always be thankful to Hunter president Jacqueline Grennan Wexler, who brought me to the college to start a ceramic program in 1972, and to her successor, Donna Shalala. I am also grateful to my art department colleagues, who encouraged me in all my undertakings.

And I acknowledge, as always, the help of my children—Jill, Jan, and Taäg— and my five grandchildren—Annah, Kayley, Alexander, Calder, and Augustus—who add to my joy.

NOTE: Scholars are still debating the terms "American Indian" and "Native American." I have asked most of the Indians who are included in this exhibition which term they prefer. Generally, they have answered "American Indian," and I have respected that preference in my own wording—but "Native American" is also accepted.

The Indians themselves use the term "Anglo" in reference to any non-Indian person or culture. I use the term in the same sense throughout this book.

Introduction

Preserving Indian Traditions

American Indian women have been making pottery for over two thousand years. In this exhibition and book, we celebrate the achievements of twenty-eight potters who have preserved this important ancestral tradition while advancing the art form through their innovative ideas and masterful craftsmanship. Together, these women represent over one hundred years in the strong tradition of Indian pottery making. Individually, their approaches to their work symbolize the gradual diversification of Indian culture that has slowly taken place in the United States.

Indians work hard to maintain ancient customs. Many of the potters in this book, for instance, carry on the traditions of their ancestors, choosing to excavate the clay, make the pots, and fire them using age-old practices rather than modern methods. This adherence to tradition preserves the Indian way, which, as a culture, remains simple, religious, and often regimented according to the seasons, feast days, or the politics of tribal councils.

Yet, today's society has had its effect on Indian culture and probably will continue to do so. Life without cars, electricity, and running water has been cluttered with these modern conveniences. While once Indian people tried to keep their children out of the regimented schooling forced on them by the Anglo culture, today integrated education is encouraged, although difficult to achieve. For most Indian communities, the economy has been unstable for many years because of droughts, lack of good farmland, unfortunate social conditions, and truly lamentable governance from Washington, D.C. No longer can most tribal groups be self-sustaining.

Still, certain customs in indigenous communities have not changed: Legends, dances, and songs are handed down orally to each generation, and love of the land and of the ancestors is orally taught. The strength of centuries of tradition cements the Indian concept of life, ensuring that the Indian way will continue in some measure, in some places, in the United States.

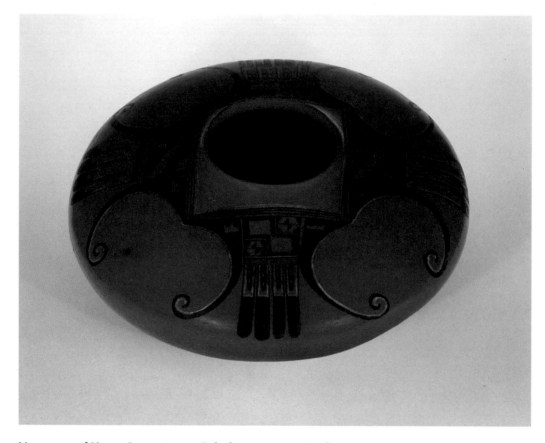

Nampeyo of Hano Jar, 1910–15. Polychrome; 7 × 15 in. dia.
Collection of the Museum of Indian Arts and Culture/
Laboratory of Anthropology, Santa Fe, New Mexico.
Photograph by Douglas Kahn

One of the most important traditions in Indian life is pottery making. With thousands of years invested in this craft, the Indian philosophy is built into each pot. It determines the composition, the form, and the decoration. Today's continuation of the pottery tradition ensures that Indian aesthetics are still flourishing. Quite possibly, pottery and other Indian arts help each tribal person mature in today's mixed Anglo and Indian environment.

Economically speaking, pottery is an affirmed asset to Indian communities. Although accumulating riches is not an Indian concept, reliance on money from pottery is a contemporary fact. The making and selling of pottery has aided in practical accomplishments—some of which, ironically, like the modern conveniences mentioned earlier, undermine Indian traditions. But this same public recognition has also enhanced the traditions of Indian artistry.

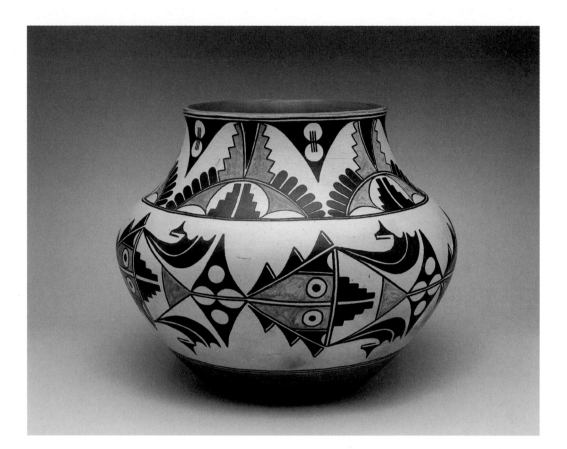

Maria and Julian Martinez Jar, c. 1925; one of Maria's largest
polychromes, this pot is said to have won a prize at the Chicago
World's Fair for being 99.5% symmetrical. 15 × 20½ in. dia.
Collection of the Museum of Indian Arts and Culture/Laboratory of
Anthropology, Santa Fe, New Mexico. Photograph by Craig Smith

A Women's Art

Indian pottery making is an enjoyable but arduous process often involving the entire
family; yet it is considered primarily a women's art. For Indian women, claywork
provides a living and sometimes fame, although fame is not sought after. If they
wanted to, some Indian women potters could compete for artistic prominence
anywhere in today's world.

The ceramics of American Indian women have evolved through the development
of time and traditional techniques into a rich and vital resource for their communities.
This is a particularly interesting notion in light of the fact that women still have no vote
in most Indian societies. Usually men are in charge of tribal religion. It is men who
constitute the tribal council, men who make the laws and determine community and
individual behavior. I remember that a few years ago when I was visiting one of the
pueblos, a potter told me that she would be leading a women's march the next day on

Santana and Adam Martinez Wedding vase, 1973; Santana rarely made this type of pot except for Indian usage. Black-on-black, 10 × 7 in. dia. Collection of Susan Peterson. Photograph by Craig Smith

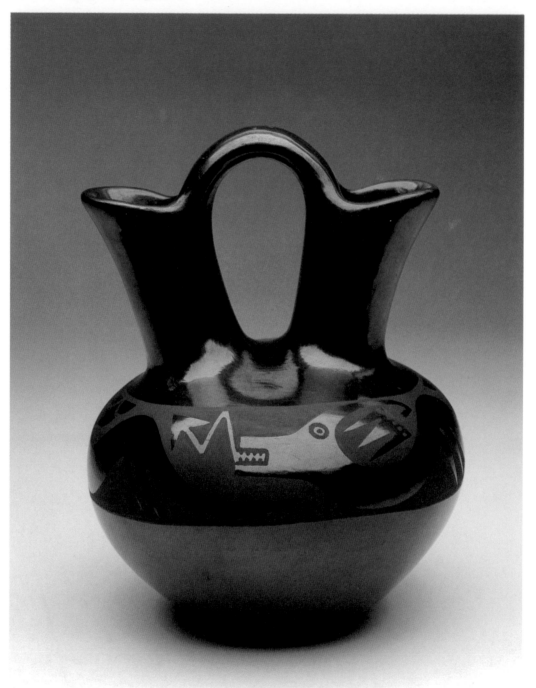

the pueblo plaza. When I asked what for, she said they were protesting a decision that the men of the tribal council had made; she asked me to come. I arrived the next day but there was no march. I was told that the women had second thoughts.

It is claywork that provides a way for Indian women to express themselves. Pottery plays a crucial role in tribal rituals and ceremonies; the physical handling of the pots provides emotional and spiritual awareness. It does not go unnoticed by anyone who participates in these customs, even if it is on a subconscious level, that it is women who make these sacred vessels. The work of their hands is always in evidence.

Indian Pottery and the Mainstream Market

Anglo culture has recognized the value of Indian art for several centuries. With the advent of the transcontinental railroad in the 1880s, tourism and access to American Indians and their arts increased, bringing fame and fortune to some Indian craftswomen. Traders appeared as intermediaries between the Indian artist and the market. Indians no longer sold pots for pennies by the roadside or in the train station.

In the twentieth century, galleries of professional quality have increased the interest in the best Indian pottery as well as other Indian arts. Such galleries exist today in almost all cities in the country, focusing on the arts of their own regional cultures and generally including pottery from the favored vicinity, the American Southwest. In the pueblo cultures particularly, some Indian artists have established their own selling galleries. Many women sell their pots from card tables outside their homes or on their plazas on feast days. Collectors have discovered that it is possible to visit Indian artists in their homes, finding this an enchanting way to understand the processes and the people.

Another important forum is the Santa Fe Indian Market, held the third weekend in August every year. It gives a number of prizes, but more importantly affords booths for hundreds of artists and allows several days of communication with the public. Other fairs, markets, and merchandising possibilities are available throughout the country.

Indian arts are being studied outside of the marketplace as well. In all parts of the United States, natural history museums and museums devoted singularly to Indian arts have allowed the general population to become better acquainted with Indian history and art. In addition, museums have elevated the best of native pottery work to the category of fine art. Native American studies are part of the curricula of most institutions of higher learning.

Awareness of Indian art and culture is increasing, to say the least.

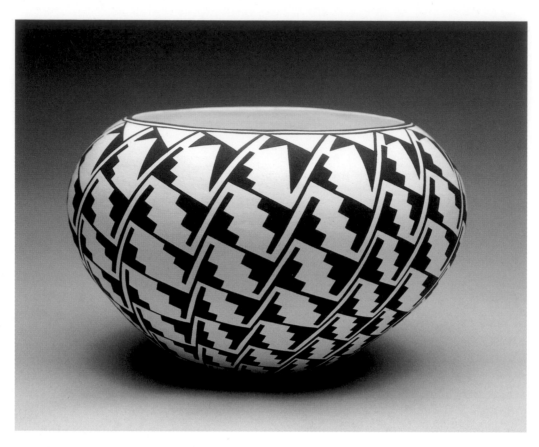

Emma Lewis Mitchell Bowl, 1996; this design recalls an earlier
Mimbres design. Black-on-white; 8 × 10 in. dia. Collection of
the artist. Photograph by Craig Smith

Understanding Quality and Authenticity

Unfortunately, the audience for Indian pottery is unaware that often pots purported
to be made in traditional fashion are not. Worse, some pots may be "greenware"
purchased from a ceramic hobby shop, decorated in commercial colors, and fired
commercially. Some galleries carry both real and "fake" Indian pots without label-
ing them as such. Fortunately more books, more exhibitions, more research, and
more publicity from the gallery owners who know the difference are increasing the
average buyer's knowledge.

This exhibition and book explore the very best of American Indian pottery.
Understanding pottery making, its history, and the women potters discussed here
will make it easier to see the merit in other good work, and to distinguish this work
from pots that are only imitations of popular Indian styles.

The Potters: Tradition and Innovation

The core group of potters for this exhibition and book are the six American Indian matriarchs who are deemed to have made the largest contribution in the field of pottery, by their own people and by the world. These master craftswomen gained respect worldwide and for decades American and international arts communities have known their names: Nampeyo of Hano, Maria Martinez, Lucy Martin Lewis, Margaret Tafoya, Helen Cordero, and Blue Corn. Their work is the foundation of the Indian pottery tradition as we know it today, so it is only fitting that it is also the foundation of this exhibition.

These six matriarchs raised their families into an understanding of the craft, and many of their children became well-known potters themselves—many more than appear in this book or in the exhibition. The twelve I chose for the exhibition are well-known and professionally accomplished offspring or close relatives of the parent six. That there are still many others, generally younger women from these families, beginning to gain fame, is impressive. That there are many more Indian women in the Southwest and in other parts of the country who are nearly equal in stature to potters in this exhibition is also impressive.

For aesthetic contrast, I selected ten avant-garde Indian women potters who I feel best exemplify nontraditional trends in Indian-style claywork. I selected these women because of their artistic abilities and innovative qualities. I also used as criteria the requirement that the women still live the Indian life and work basically in or from the traditional indigenous processes. Among these artists, I found three artists who met my prerequisites and were from outside the favored Southwest—from the Winnebago, Sioux, and Osage tribes. I was fortunate to find them, considering that the best Indian pottery art seems to be found in the Southwest today. Although the majority of women Indian clay artists in this country come from the Southwest— the twenty pueblos in New Mexico and Arizona and the Navajo nation—important Indian pottery traditions from all areas of North America should not be ignored.

There are a number of well-known potters of excellent reputation who could have been included in this exhibition, and who by and large are indebted to one or the other of the six chosen matriarchs. Among the most notable are Margaret Gutierrez's family, the Naranjos, and the Chavarrias, all of Santa Clara; the Grace Chino family of Acoma; Joy Navasie (daughter of Paqua, also called Frog Woman) and Helen Naha (Featherwoman), of Hopi; Evelyn Vigil and Juanita Toledo at Jemez; Priscilla Peynetsa of Zuni; Carmelita Dunlap as well as many members of the Maria Martinez family, of San Ildefonso; and Doris Blue at Catawba in North Carolina. In addition to the indigenous artists, there are Indian women who live in

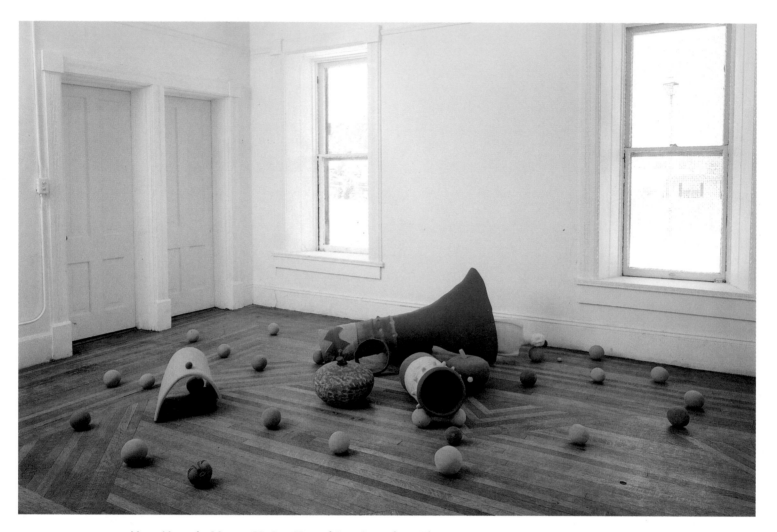

Nora Naranjo-Morse *He Just Turned Into Something Else,* 1996; this is the experimental artist's first large, multi-piece installation. Micaceous clay; 11 × 11 ft. Collection of the artist. Photograph by Craig Smith

cities rather than in Indian communities across the United States, such as Christine McHorse, Karita Koffey, Pophone, and many others. These artists often have college or art school backgrounds, and work in and out of Indian pottery concepts.

Preserving Indian Art in World Culture

The art of the American Indian is among the great traditions of the world. In fact, its value has been recognized by many important artists in other cultures—including that of Japan, which has its own remarkable clay artistry. Shōji Hamada, the great

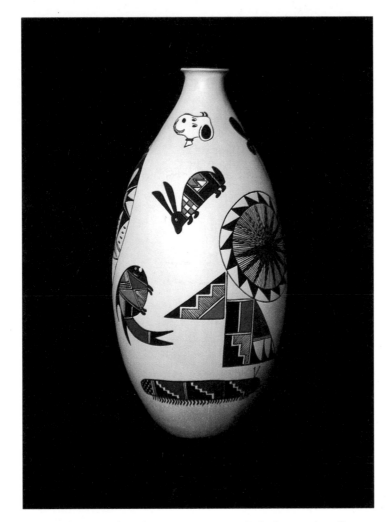

Jean Bad Moccasin "Snoopy" pot, 1995. Polychrome, low-fire white clay; 15½ × 7½ in. dia. Collection of the artist. Photograph by Stanley Szewczyk

potter who was named a "Living National Treasure" in Japan, said to me in 1976, "American Indian art is of great significance and represents an extraordinary contribution to the art of the world." I have noted in forty years of experience with Japanese ceramists and American Indian potters many similarities that permeate the living and working ideology of both cultures. Among them are a respect for and an intimate relationship with tradition, strong personal value systems, and reverence for art as part of daily life.

But American Indian pottery is a vanishing art, except for the artists in this exhibition and a few others of equal stature. In today's fast-paced society, where technology and mass production are the predominant themes, it is assumed that all

folk traditions everywhere will vanish. This is especially true concerning pottery: in the minds of many potters, the sacred clay is too hard to prospect, pulverize, and process and not worth the effort when commercial clays are available. Pigment rocks are scarce and grinding them is arduous; wood and dung firings demand much more experience and skill than modern kilns. Soon potters will choose commercially made brushes to paint designs rather than the traditional stiff brushes chewed from the midrib of a yucca leaf.

It is only the strong, uninterrupted traditions that will sustain this art. Therefore, it is fortunate for all of us that many Indian women who have chosen clayworking—whether traditional or avant-garde—still want to live the Indian life in their traditional villages. This ensures that the legacy of the matriarchs will continue to support the newer visions of those who follow. It is up to the artists of the new generation to nourish the old, while in the same breath creating the new and individual.

The thread that runs through the folk art of all peoples is a significant one. My hope is that Americans will amass collections, create documentation, and organize exhibitions to preserve American Indian pottery. These efforts preserve not only the objects themselves, but the ideas and emotions that arise from the making and studying of these objects—from holding them, touching them. These ideas and emotions fulfill endless human needs—to connect to the raw materials of the earth, to respect and honor ancestral tradition, and to experience the continuity of life and the spirit. We must understand the legacy of what the work stood for and is—an all-encompassing expression of the best that is human.

For a brief time in the universe, pure artistic influences come as comets—revitalizing traditions and fostering innovations. The timeless works of artists of innate wisdom, skill, and talent encourage others. It is in this way, as exemplified by the unusual artists and their claywork in this exhibition, that Indian art will endure.

reasons. Women were probably the gatherers (as men were the hunters), and women became the chief pottery makers.

Initially, handbuilt vessels were made solely for utilitarian purposes, with little consideration for artistry. Most very early containers were unadorned, except for the texture of the coils and pinches, or indented textures from pointed sticks. Not much attention was paid to symmetry.

Later, decorative designs began to appear on Indian pots. Anglos have long struggled to find meaning in these designs, but Indians are reluctant to verbalize their meanings. If the symbols are important rather than mere embellishment, outsiders are not likely to be privy to the potter's intent. Indians do not divulge sacred traditions, ceremonial rituals, or symbols. From the earliest times, Indian tribes have venerated life, nature, birds and other animals, humans, and gods. Realistic and abstracted interpretations of these mentors probably form the basic elements of Indian designs for all utilitarian and ritual objects.

No one knows why pottery became so important to all North and South American Indians for ceremonial use during rituals and burials. The use of pottery can be recognized in a religious and social context long before Columbus's arrival in America in 1492 and the Spanish conquest in 1540. These years, however, mark the end of the prehistoric period of Indian art, and the beginning of what is called the historic period.

Pot shard traces left behind by potters over the centuries have enabled archaeologists to determine the probable origins of excavated pot remains, since all potters prospected clay and made pots near their dwelling places. Of course, pots may have been traded among Indian villages, but when many similar pots are found in one place, they were no doubt created there.

From the beginning, Indian pots have been thinly fabricated and fragile before and during firing. Many thousands of pots were made over the centuries; thousands broke in the firing and many broke from use. To help protect the vessels from thermal shock during the sudden heating of the bonfire, some potters used ground-up, fired shards as temper in the raw clay. Other potters used volcanic ash, which they called "sand," an inert mineral that in itself is resistant to the shock of instant flame.

Historians generally believe that fired clay pottery developed because ancient people lined their woven baskets with mud-clay. When the baskets were subjected to fire so that corn or other foodstuffs could be dried, the basket burned, leaving hard, durable clay intact. It is true that many primitive pots bear texture marks indicating that they might have been made in baskets.

Still, there can only be guesswork about the origins of baskets. Did woven containers really come before clay pots? Excavations in some parts of the United

States have yielded unfired clay pots that could not have been pressed in baskets. Vessels may have been fashioned for storage or for uses other than cooking food, unrelated to the basket-pot theory. The fact that fire could harden clay may have been discovered accidentally, not necessarily in mudded-up cooking baskets.

Astonishingly, the potter's wheel was never used anywhere in either North or South America. The wheel was used for transportation and for tools, but was never adapted for clay. It may be that Indians just relished the experience of building a clay pot slowly by hand, using the painstaking method of coiling and pinching.

Over the centuries, tribal groups from different regions have developed their pottery traditions in a variety of ways. The following is a discussion of some of the most significant groups.

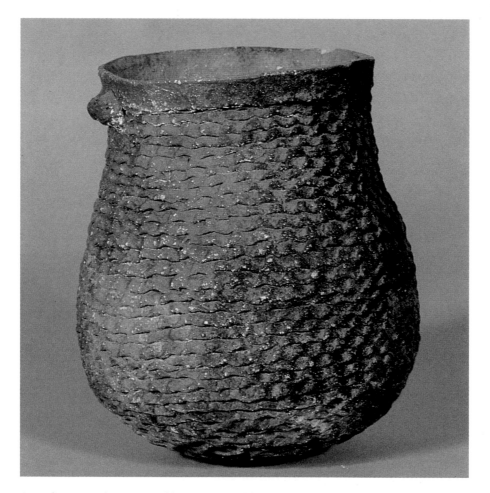

A jar from a prehistoric pueblo. Corrugated brownware;
6¼ × 5 in. dia. Courtesy the School of American Research,
Santa Fe, New Mexico. IAF.1930

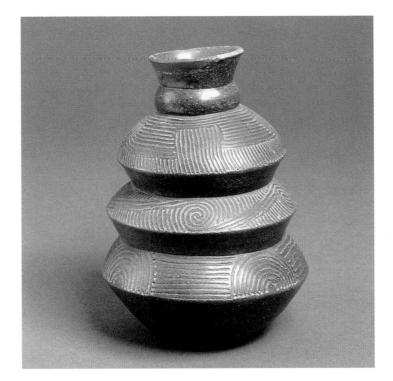

Water vessel, c. A.D. 1300; beautifully burnished and incised,
 from the Caddoan mound culture in Yell County, Arkansas.
 Courtesy of the National Museum of the American Indian,
 Smithsonian Institution, 5/6318

The Mound Cultures

Ever since white people arrived on our continent, they have wondered about the
thousands of mounds—some small, others large hills—that dot the Midwest and
the eastern part of our country. The ancient peoples who created and inhabited
these mounds have been lumped together in popular lore under the name "Mound
Builders." We now know that a wide variety of cultures built the mounds, at
different times and for different purposes. From at least 1000 B.C. to A.D. 700,
the mounds contained temples; after 700, it is thought that the flat-topped mounds
were altars or the bases of temples. Some mounds are astonishingly huge symbolic
images that can be viewed fully only from the sky.

 Archaeologists have excavated important sites constructed by the Adena
culture of Ohio and Kentucky, the Hopewell culture of Illinois, the Spiro Mound
People of Oklahoma, and the well-organized Mississippian culture that spreads over
several states. Other major sites have been excavated at Poverty Point, Louisiana,
and in Moundville, Alabama, where the first plumed rattlesnake appears on pottery.

Hundreds of other sites existed in nearly all the states, up and down the East Coast and extending west to the Great Plains. Most of the cultures that built them, however, dissolved with the Spanish conquest in the sixteenth century.

The Mound Builders lived in extravagant societies with thousands of inhabitants, making exquisite art objects from clay, wood, stone, and shell. This fantastic Mound period lasted several thousand years. It is the source of some of the greatest precontact American Indian pots, effigy figures, and fetishes ever made. The claywork was absolutely brilliant, but has no real descendants today.

Indians of the Eastern Seaboard

In contrast to the vast plains and deserts of the west, eastern North America was once dense woodland. The North American woodlands extended from Labrador across northwestern Canada into Alaska; from the Great Lakes they extended south, through Kansas and Oklahoma and down through Louisiana and Florida. Along the eastern seaboard (both north and south), woodland Indian tribes lived farming and hunting lives. At one time, several hundred tribes existed in this region and ranging into the Midwest; today the most familiar of them are the Iroquois, Algonquin, Kickapoo, Choctaw, Chickasaw, Cherokee, Creek, Seneca, Seminole, Oglala, and Osage.

Most of these Indians made religious accessories from wood or bark, which they carved or painted. They made beautiful canoes and barges, and they drew and painted on animal skins. They built "longhouses" for socializing and meetings, and their wooden dwelling places were plastered with mud and grass. They did fine quillwork and appliqué. Basketry and beadwork, rather than clay pottery, became an important medium for artistic expression.

The woodland Indians used clay pots mainly for cooking. Their pottery was handbuilt and functional, and pieces were either burnished plain or textured casually with a stick. None of the women potters became known for their work. In this century, however, a few Catawba and Cherokee women have achieved a measure of fame with their traditional pottery.

The Southeast: Catawba and Cherokee Cultures

The Catawba and Cherokee tribes are neighbors today—although they were enemies centuries ago—in the region of the Blue Ridge Mountains and the Carolinas.

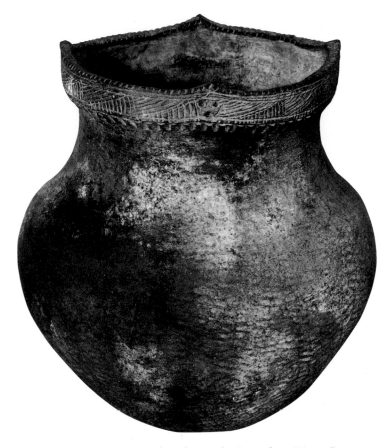

An Iroquois pot, c. 1550; found near the Sacandaga River. Courtesy of the New York State Museum, Albany, New York.

The Catawba Reservation, near Rock Hill, South Carolina, is now home to about three hundred people. For the last two hundred years, these two tribes have intermingled and intermarried. Eventually the Cherokee gave up their pottery traditions to the Catawba.

In the East, Catawba pottery is one of the few clay arts still practiced with the same traditions that have existed for centuries. Clay is prospected in secret places in deposits near the Catawba River. Beautiful pots that were made in this region a thousand years ago during the Mississippian mound culture are, in some ways, similar to the tribal pots made today. Interestingly, some Catawbas intermarried with blacks, and African influences are frequently apparent in the work. Doris Blue, who died in the 1980s, was the last full-blooded Catawba Indian potter.

Catawbas make pottery in the same fashion as other indigenous cultures. Pinched or rolled-out bases support coils, which are smoothed and then scraped. The surface is polished with "rubbing rocks," which, as in other Indian societies,

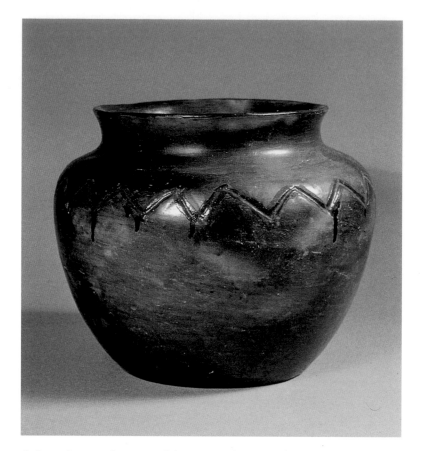

A Catawba pot. Courtesy of the National Museum of the American
Indian, Smithsonian Institution, 2184

are passed from generation to generation. Sometimes fired-clay press-molds are used. The most typical shapes include fat three-legged "gypsy pots," stemmed peace pipes, simple and short wedding vases with two wide spouts, and pitchers. Decorations incorporate drawings or carvings of the rain serpent, frogs, turtles, and other animals, and feathered headdresses like those worn by the Plains Indians.

Catawba firing methods vary somewhat from the southwestern pueblo outdoor style. Pots are warmed initially in the kitchen oven to 500°F. An open fire is started outside, perhaps in the backyard, and is allowed to burn down before the warm pots are placed on the hot coals. More fire is added on top of these wares; then it is allowed to burn down before more pots are placed on top. The piling up of pots on coals in a number of layers gives the gray clay a variety of smoked and mottled colors, from beiges and oranges to blues and blacks, as the oxides in the clay unite with the fire. Finally, the burning pyramid is covered with pine chips, leading to oxygen reduction that causes blackened spots. The soft, lustrous patina derived in this way is different from anything found on other Indian pottery made today.

Indians of the Midwest

In the northern Midwest, the Crow, Blackfoot, Arapahoe, Cheyenne, Comanche, Sioux, and Apache Indians prevailed. In these cultures, fantastic beadwork, quillwork, and intricate basketry became high arts in which women excelled. Their pottery was mostly utilitarian; it was regarded in aesthetic terms only secondarily.

The Southwest: Pueblo and Navajo Cultures

Southwestern Indian culture has changed little over the centuries, unlike anywhere else in Indian America; it is vital and timeless. The Southwest can boast the oldest

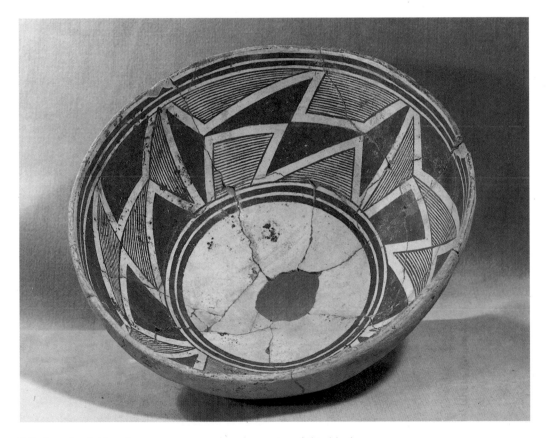

Mimbres burial bowl, c. A.D. 1000–1150; the center of this black and white bowl is broken to allow the deceased's spirit to escape. With its fine line design, this bowl is representative of the ancient Mimbres shards that inspired Lucy Martin Lewis and other modern potters. School of American Research Collections in the Museum of New Mexico. Photograph by Arthur Taylor

continuous record of habitation on the continent, outside of Mexico. By the beginning of the Christian era, three primary southwestern cultures were forming: Hohokam (probably the antecedents of today's Pima and Papago Indians in Arizona), Mogollon (of which the Mimbres culture was the highest achievement), and Pueblo (which climaxed in the eleventh century in the Four Corners area of Colorado, Utah, Arizona, and New Mexico). Most of these ancient cultures vanished by the twelfth century, but the Pueblo and Navajo cultures continue today.

Today, Southwestern pottery made in the existing twenty pueblos in New Mexico and Arizona, and by the Navajos in Arizona, remains one of the greatest expressions of ceramic art in the world. The continuity of these Indian cultures is assured as long as their belief systems remain intact.

The Pueblo Indians

Through sheer strength of character and endurance, the Pueblo Indians survived the Spanish conquerors, the degradation of conquest, and the plagues that spread from Anglo diseases. Once the United States took over the land colonized by the Spanish, all other Indians in this country were repatriated to remote lands unfit for habitation or agriculture—at a great cost of life and emotional upheaval. The struggle for existence continues to this day, particularly in the pueblos. By and large, Pueblo people have not integrated and intermarried with Anglos, but have stayed in their assigned, segregated areas. Pueblo Indians remain within their boundaries on restricted reservation lands, with the pueblo at the center of their lives as the core of ceremonial activity. This cocooning has allowed these communities to preserve their traditions and customs like no other Indian group.

Pueblo has two meanings. Literally it means "groups of houses." These houses are built of adobe clay or lava rock, and are plastered with lime and straw for stability. Long logs of lodgepole pine, called *vigas*, are dragged to the pueblo from miles away to serve as support beams for the roofs. But *pueblo* is also a concept; those who belong to a pueblo are obligated to participate in the ritual life of the community when they are asked. Indians who live on the reservation, but not in the pueblo, are not obliged to serve, though most do so when asked.

Pueblo people put down roots and do not move. They observe rigid cultural restraints, such as not marrying outside the pueblo, in order to maintain membership in the group. They preserve a secretive and closely guarded barrier against all outsiders. Most pueblos are small, with populations ranging from several hundred to a few thousand. Frequent ceremonies serve to continue the oral teaching of each

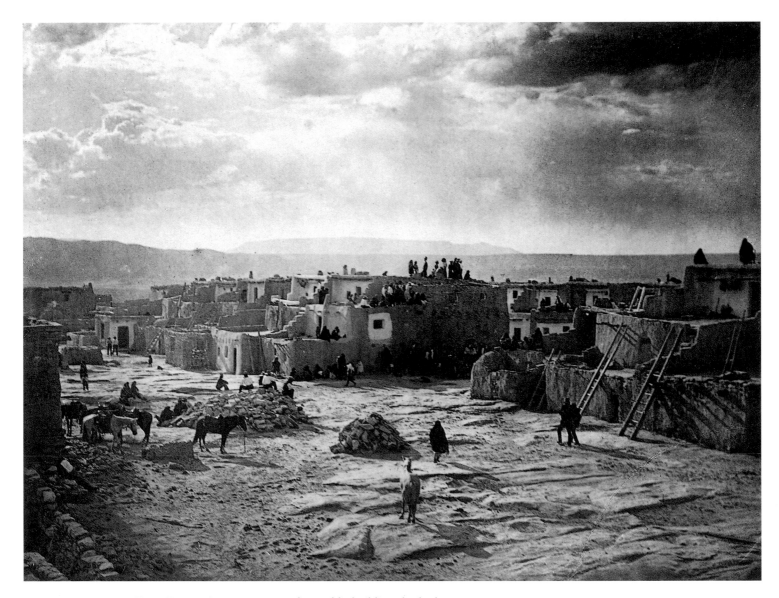

Feast Day at Acoma, c. 1900; the pueblo buildings look almost
identical today, about a century later. Photograph by
E. S. Curtis

pueblo's heritage. Dances, songs, and legends are taught to every child as early as
possible. All Indians preserve their culture with "powwows" and "doings," but
Pueblo Indians are more intensely occupied with the preservation of ritual than most.

Clay vessels have been made for storage and household use in these stationary
societies for at least two thousand years. Each pueblo has developed a style of form and
decoration indigenous to its needs and beliefs. These varying styles have been histori-
cally documented and attributed to particular pueblos since the Spanish conquest.

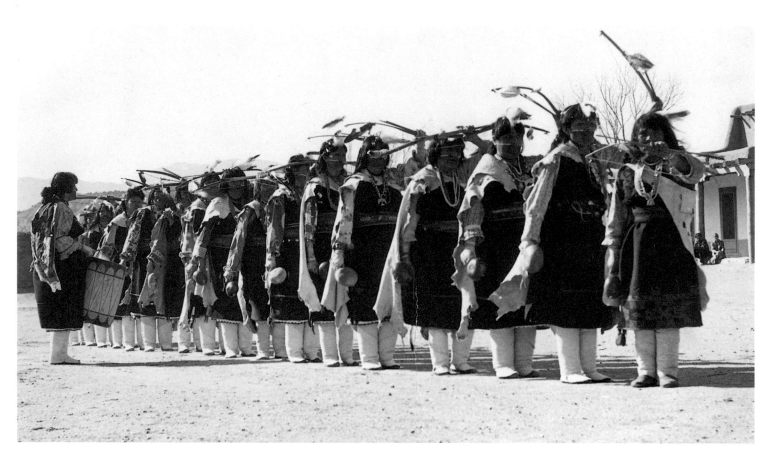

A "Woman's Dance" at San Ildefonso in 1920. Maria Martinez
is the drummer.

Traditionally, Pueblo Indians prospected clays from their own secret ancestral
clay sources. Most pots were smoothed to create burnished backgrounds for designs,
which were painted with pigments made from residues of boiled plants or finely
ground metallic rocks. Brushes were cut and shaped from the chewed ends of twigs
or yucca fronds. Glaze was almost never used for a vitreous coating, nor was the
potter's wheel ever used for fabrication. The pots were hardened in an open outdoor
bonfire reaching 1,300°F. These antique methods are preserved today.

The railroad greatly affected Pueblo pottery culture, bringing curious and
inquisitive tourists within reach of the artists. Soon, a great deal of Pueblo pottery
was being made for sale as souvenirs. Traders were the middlemen; some settled
near the reservations and set up trading posts that became famous. Fairs and markets,
especially at Gallup and Santa Fe, promoted Indian pottery. Shops selling only pottery
sprung up all over the Southwest. Among the most important merchants was the
Fred Harvey Company, which sold Indian pottery in its chain of lodges, shops, and

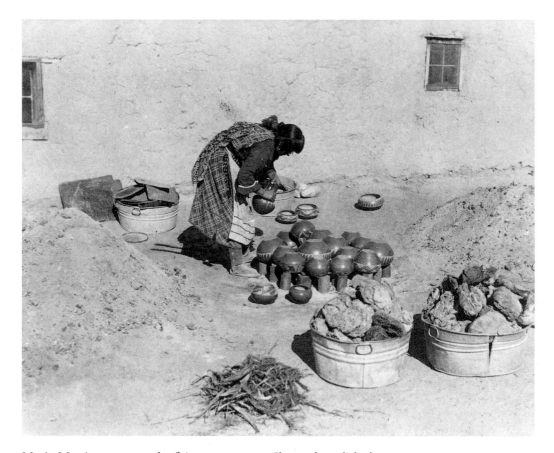

Maria Martinez prepares for firing, c. 1920–25. She stacks polished
and decorated red clay pots upside-down on a grate, under
which juniper kindling will burn. Then she will cover the
pots with cow chips and old license plates. It appears that
Maria intends these pots to fire red; if she intended them to
be blackware, she would use wood ash from the nearby piles
and dried horse manure to smother the fire. U.S. Department
of Interior, Indian Arts and Crafts Board

restaurants at railroad stations, national parks, and other key tourist locations
throughout the West.

Beginning in the 1920s, the best women potters were encouraged to sign their
work, and soon they were the subject of much public acclaim from the outside
world. At the same time, serious collectors of Indian art began to emerge, buying
the best work.

All of these selling possibilities brought some spectacular Indian women artists
to national attention, as did the endorsement of art and history museums. Dr. Edgar
Lee Hewett of the Museum of New Mexico and his colleagues at the Heye Foundation
in New York and the Smithsonian Institution in Washington, D.C., sought out the

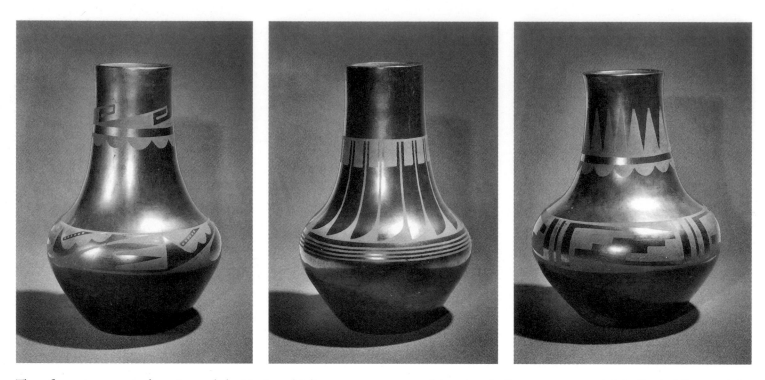

These five pots are part of a series made by Maria and Julian Martinez around 1924. They were acquired by John D. Rockefeller, Jr., while on a 1926 trip to the Southwest with his son, David Rockefeller (who has kindly lent them to *The Legacy of Generations*). Kenneth Chapman, a scholar of American Indian art, accompanied the Rockefellers on their trip as a mentor and guide. He suggested to Maria that she sell these pots to Mr. Rockefeller, who already had an abiding interest in American Indian art. Four of the pots are among the first black-on-black wares that Maria and Julian ever made.

best Pueblo women potters, purchased and exhibited their work, and hired the artists to demonstrate. A number of extraordinary women artists flourished in this atmosphere of encouragement.

From these roots, dynasties began. Newly famous Pueblo pottery matriarchs, such as Nampeyo of Hano and Maria Martinez, realized the monetary potential of pottery as they also recognized the demise of their old ways due to drought and encroaching modernization. These women and others like them showed their progeny that pottery could be a source of income to help sustain their way of life. Pueblo culture and pottery culture help each other survive.

The Navajo Nation

The Navajo Reservation, fourteen million acres of high plateau stretching from Northeastern Arizona and northwestern New Mexico into southeastern Utah, is guarded by four sacred mountains: Blanca Peak, Mount Taylor, the San Francisco

pot had cooled, hot melted pitch from piñon trees was poured or rubbed in a thin coating over the vessel, inside and out. This unusual technique distinguished the look and aroma of Navajo pottery.

Traditional pots were otherwise undecorated for centuries, except for textures that occurred in the fabrication, or the application of small symbols made of the same clay. Navajo tribal society was tightly controlled, and medicine men imposed restrictive behavior regulations upon the women making pottery. Possibly, the discipline imposed on Navajo women shows in the conservative nature of their pots.

In the 1880s, the railroad crossed America and the first Anglo-run trading posts came to the Navajo reservation. Use of cash money instead of the barter system brought the Indians access to Anglo cooking products made of metal and plastic, diminishing the need for utilitarian pottery and undermining native tradition. Navajo women still made pottery for ceremonial use, but the lack of production reduced the stimulus for making any kind of pottery. At the same time—while artistic pottery from the southwestern pueblos was reaching a high degree of popularity—traders rejected the traditional Navajo pottery, calling the dark-brown, pitch-coated, utilitarian wares "mud pots." Tourist markets for Navajo blankets and jewelry were more profitable than the market for this kind of pottery.

Another change occurred when curators from nearby museums began to notice a few emerging clay artists, who were taking traditional Navajo techniques to new levels. Rose Williams was the first traditional Navajo potter to break into the museum markets and fairs in the 1950s. She built cylindrical jars two to three feet tall, a quite exceptional size for handbuilt bonfired pottery. Her daughter, Alice Cling, was one of the first Navajos to sign a pot.

Today Navajo pots are usually fired outdoors, one pot at a time in an open pit, with juniper wood both under and over the pot. The fires are allowed to burn hard for several hours. The pitch for coating the pots is gathered by children or families from piñon trees in an arduous process. Of course, everything about this process is arduous: digging the clay, grinding it to powder, coiling and pinching the clay into shape, gathering wood for the fire, tending the fire, and applying the hot liquid sap to the finished pot.

The Navajo tradition of making illustrative symbolic sand paintings for healing ceremonies has given inspiration to some pottery decorations, although it is against traditional rules to use them. It is difficult for Indians to use sacred symbols for design; feelings of reverence and ancestral respect impose strong limitations. Still, tribal background is inevitably an important decorative resource. The *Yei bichai*, representing the mythical Holy People, are particularly prominent subjects in

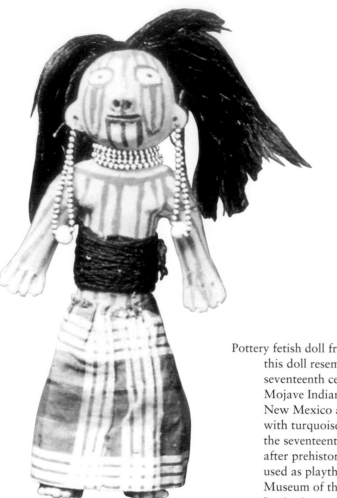

Pottery fetish doll from Yuma, Arizona, c. 1950; this doll resembles figures made during the seventeenth century by the Maricopa and Mojave Indians in California and on various New Mexico and Arizona pueblos. Decorated with turquoise, stone, shell beads, and cloth, the seventeenth-century figures were modeled after prehistoric figures, and were probably used as playthings. Courtesy of the National Museum of the American Indian, Smithsonian Institution, 3528

Navajo art. These appear often on pots by Lorraine Williams; she leaves a portion of the design unfinished so the *Yei* spirit can escape.

Today, most Navajo potters live in the Shonto–Cow Springs area of Arizona, where there is still a good clay source. Many of the potters in this and other areas are related directly, by marriage, or by clan. Traditional ways are handed down or handed sideways, still the best methods of passing on customs. Some of the women potters have actually conducted classes for other Navajo women. The revival of interest, spurred by the success of Alice Cling, Lorraine Williams, and a few others, has gradually increased pottery production both for the market and for ceremonials. Among the best-known Navajo potters working today are Christine McHorse and Lucy McKelvey; they have joined other young clay artists from many Indian backgrounds, living and working in cities without the traditional tribal restrictions, but forging new concepts based on their cultures.

West Coast Cultures

Pottery was produced for functional and ceremonial purposes by all Indian groups on the West Coast; some of them developed unusually individual claywork styles. However, accomplished artists in other traditional crafts (notably basketry and wood carving) were the ones to become famous in this region, and were sought after by collectors. These works varied from group to group.

Like the Indians of the Southwest, the sparse populations of West Coast Indians in California were influenced by Spanish conquistadors and missionaries. Unlike the Southwest Indian tribes, however, the Maidu, Yurok, Karok, Miwok, Pomo, and Mono cultures of California were great basket makers rather than potters. Still, some West Coast tribes did delve into clay—for instance, the Maricopa and Mojave Indians, who did develop an interesting claywork style.

Some of the world's finest sculpture originated on the Northwest coast, but it was not in clay. The magnificent wooden totems and masks of the Tlingit, Haida, Inuit, and Kwakiult are legendary and are generally carved by superbly talented men in these northwestern tribes.

In Conclusion

In an essay in *The World of the American Indian* (National Geographic Society, 1993) the uncommon professor, poet, and historian N. Scott Momaday summed up the nature of Indian aesthetics: "In my experience Indian art, in its highest expression, is at once universal and unique. It is the essence of abstraction, and the abstraction of essences.

"The Indian's perception is humane. It is centered upon an ideal understanding of man in the whole context of his humanity; it is therefore an ethical perception, a moral regard for the beings, animal and inanimate, among which man must live his life.

"I believe that the American Indian is possessed of a vision that is unique, a perception of the human condition that distinguishes him as a man and as a race. I suggest some aspects of this perception which seem to me definitive. In terms of these considerations—the sense of place, of the sacred, of the beautiful, of humanity—the Indian has had and continues to have a singular and vital role in the story of man on this planet."

Materials, Tools, and Techniques

The materials, tools, and techniques of pottery making have existed for thousands of years and are still in use. Clay, available all over the world, was probably the first material that allowed ancient man to be really creative with form and decoration. Most American Indians and their ancestors have always used the common surface clays, as the geologist calls them, of the land they live upon. These natural clays generally fire gray, buff, red, or brown and are easily prospected on the skin of the earth.

Natural clays vary in color and texture and can be associated with specific sites. Archaeologists and other scientists have been able to identify particular early peoples and the approximate historical periods in which they lived by the look of the clay from which objects were made. Clay is the only material on earth that, when properly fired to bonfire temperatures or above, lasts forever, even if the piece is broken. Therefore, analyzing clay artifacts is often the only way for scientists to study ancient man.

Some Indian groups, notably the Anasazi and Mimbres of yesterday and the Acoma of today, have found a secret source of a grayish kaolin-type clay that fires nearly white. It is hard to imagine where the Indians find this rare white clay in their red-earth surroundings. It is more difficult to work and more vulnerable in fabrication and firing than darker clays, but those who know where to find it have been attached to it for generations.

If clay is found on the surface of the ground, it may need only sieving to remove sticks and stones. Occasionally two or three clays, found close to each other, are mixed together for their peculiar properties. The secret white-clay source of the Acoma region in New Mexico is supposedly mined deep in the earth, comes in hard rock form, and has to be ground on a metate or in a rigged machine such as a coffee grinder, into fine powder. Fine dry clay is mixed with water to a plastic, workable state and is used more or less immediately.

Some potters mix the dry clay powder with water to a proper consistency on a cloth or a board and knead it like bread into a workable mass, making only enough

Typical of many American Indian potters, Santana Martinez
learned her art from her family. The daughter-in-law of
Maria and Julian Martinez, Santana was first "apprenticed"
to Julian as a painter. After Julian's death in 1943, she
began painting for Maria herself.

Around 1949, Santana and her husband Adam began
to make their own pottery—Santana fabricating and
decorating the pots, Adam gathering the wood and manure
for firing the pots.

I took the following photographs of Santana working
at San Ildefonso Pueblo around 1975. They appear here
courtesy of Kodansha International and *The Living
Tradition of Maria Martinez*.

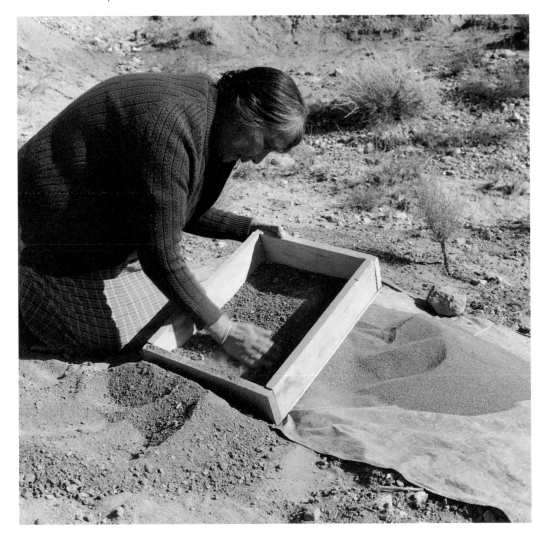

Santana prospects two kinds of red clay from the San Ildefonso
reservation. On site, she sifts the two clays together and
strains out rocks and impurities. She then carries the refined
clay home in flour sacks. She will mix the clay with an equal
amount of volcanic ash and water for immediate use.

clay for the size of the piece to be built. On the other hand, if the natural clay is full of impurities, it will probably be mixed with water into a slurry-liquid condition so that unwanted particles can be screened out easily. This may be accomplished by pouring the liquid clay through an old curtain or a fine-meshed sieve, and then drying it on newspapers to a working condition. Lucy Martin Lewis foot-wedged her wet clay on the floor, stomping on it in her brown oxfords. Dolores Lewis, as well as many other Indian potters, wedges her clay mixture with her bare feet.

To the Indians, clay is rare, precious, and sacred. In the last few hundred years, Indians have often referred to clay as "mother earth." Among most Indian cultures, a certain amount of ceremony is associated with clay gathering, and children may be told to eat some of the raw clay "for the spirit." During the pot-making process, all the scrap clay is kept for reuse. Clay that is pinched off the coils or scraped in the smoothing—even the dust from sanding—is carefully caught in an apron or on newspaper and mixed with the next batch. Part of the reason is that old clay is like old wine: it works better. Part of the reason is that clay is mother earth.

Throughout the ages, various inert materials such as sand, dirt, grass, volcanic ash, basaltic rock, ground pottery shards, pulverized bones, and the like have been added to the clay to make it more resistant to the thermal shock that occurs in firing. The added material, called "temper," also increases the archaeologist's ability to distinguish where and when a clay article was made. At San Ildefonso Pueblo in New Mexico, the age-old practice of mixing the local clay fifty-fifty with volcanic ash found on the pueblo renders outdoor bonfirings almost immune to "blowups" of the pottery.

All primitive cultures fabricate clay by hand in similar ways. Indians, who have lived periodically out of doors, needed cooking pots with round bottoms to sit in the rocks of a fire, narrow-footed storage vessels to rest in the sand, and *ollas* with indented bases for carrying on the head. Pots were often begun with a flat slab of clay or a rosette of coiled clay laid into a potshard that was shaped in the desired form, called a *puki* in the Tewa language and a *huditzi* in Keresan, with the proper outline made for the purpose. These various molds are still in use by traditional Indian potters.

When the base of the pot has been formed, ropes of clay coils are added one by one, successively making the vessel taller and wider by the positioning of one coil against the previous one—laid on the outside of the previous coil to widen the pot, toward the inside to curve it in, and straight up to ascend vertically.

As the pot grows, the potter will pinch with her fingers to make the wall thinner, and use a tool cut and contoured from a gourd to refine the form. The process of making the form can take several days or many weeks depending on the size and

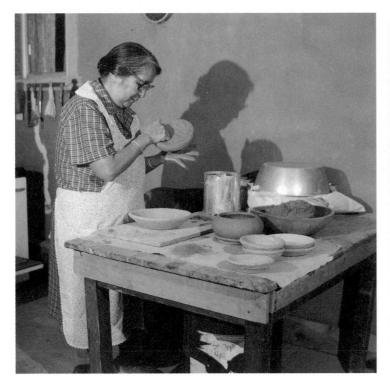

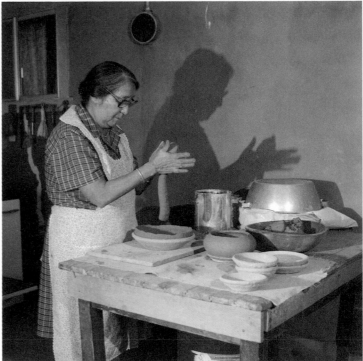

Santana fists out a pancake of plastic clay and places it in the *puki* (a bisque pot or clay shard) to form the base of a new pot. Note the finished and smoothed pot in another *puki* and the bowl full of workable clay on the table.

Santana rolls a long coil between her palms. She will add it to the pinched clay edge of the base.

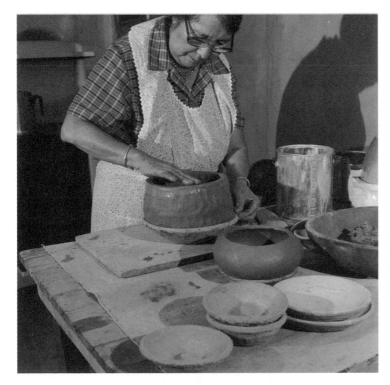

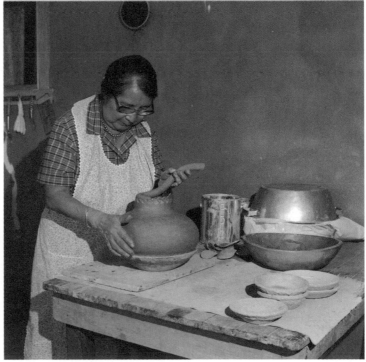

She adds coils one after another, pinching and stretching them upward into a cylindrical shape.

The cylindrical form is pushed out from the inside with a gourd tool as Santana turns the *puki* round and round against the table. She adds more coils to extend the neck of the jar.

complexity of the shape. When the work in this wet stage is finished, the pot is set aside to dry. (Santana Martinez tells of a time she made pots and set them outside in the sun to dry, when a sudden rainstorm arose and reduced the clay shapes to mud.)

In traditional pottery technique a smooth exterior is usually desirable, especially if a design is to be painted on the surface. The pot is carefully scraped with a sharp tool such as a tin can lid, then sanded smooth, and in some cultures water-polished with a wet stone. Ancient cooking pots, though, were often left with the mark of a tool as a decorative texture.

It is a mystery that the Indian potters on this side of the world, from Canada to Argentina, never used the potter's wheel and still don't. It is generally accepted that the Egyptians, Mesopotamians, and Chinese used the potter's wheel at least as early as 5000 B.C. Western Indian cultures throughout time used the wheel for transport but not for pottery. Modeling clay on a platform of several stones that were hand-turned, or turning the pot manually on its base, was as close as these people came to what Anglos know as the technique of "throwing" clay on a fast-moving potter's wheel. Thousands of years of claywork without a wheel show strict attention to tradition and resistance to change, affirming the importance of ritual in the methods employed by historically anonymous craftspeople.

By the same token and with only a few exceptions, glaze, which forms a true glassy coating in firing, has not been used on American Indian pottery. Ancient cooking wares were generally left without any embellishment or surface attention other than a texture from the hands of the maker or of a tool. As pottery became more useful in ceremonies and then for the tourist market, polishing or burnishing the clay with a river-washed stone to produce a shine was accepted practice. Pressing of the molecular structure of the clay surface during the arduous rubbing causes the pots to be more waterproof, and the sheen remains after the low-temperature firing.

Many Indian cultures polished the pots and then added painted designs using pigments made from the boiled juice of certain plants or metallic-oxide rocks ground to fine powder and mixed with water. Some cultures polished their pots using a liquid slip of another clay to get a better shine or a different fired color. All this is the result of centuries of testing the natural materials. Even with the test of time, natural materials vary in their composition and therefore in their color and quality; Indians never know until after the fire if they have made the correct choice.

Most of the prehistoric pottery from tribes in the eastern and midwestern United States was polished directly on the clay without an added slip coating. Often, decorative drawings were scratched through the polish, revealing the duller surface below. Prehistoric southwestern pottery of Anasazi and Hohokam cultures seems to have been of rag-rubbed white clay, brushed with plant and rock pigment designs,

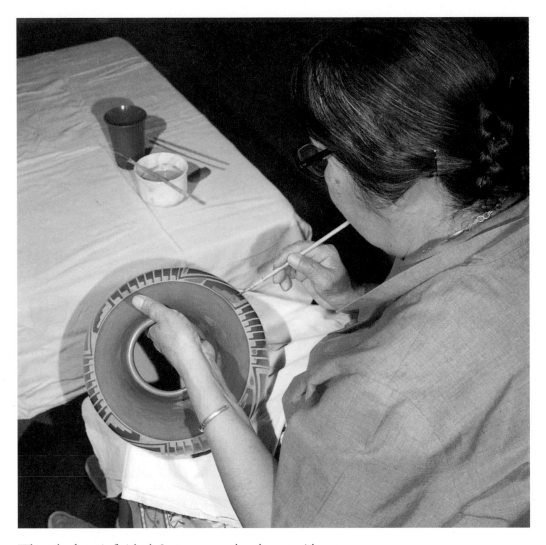

When the form is finished, Santana smoothes the pot with water.
After it dries, she sands it to make it even smoother. Then she
applies a red slip, which she burnishes until it shines. Santana
paints the design with a more refractory clay, which will turn
matte in the fire.

and smoked gray in the bonfire. The Spanish conquests of the 1500s brought birds
and flower designs to our western Indians, and a polychrome pottery style using
these motifs developed. In this century, in about 1910, Maria Martinez and her
husband, Julian, of San Ildefonso Pueblo, New Mexico, developed a "black-on-black"
style that used a dull surface pattern against a polished background. Perfecting the
mirrorlike shine on the surface of their pots and developing the intense black color
during the firing made this couple famous around the world.

Brushes for decorating have been fashioned for centuries from yucca fronds in
desert areas, or from other plant types found elsewhere in the country. The spine of

a leaf or frond, or a supple twig, will be chewed for several days, then cut with a knife into the length (usually two to four·inches) and the width that the potter needs for particular strokes. Several different brushes of this type are always on hand. It is hard to imagine that this stiff, unwieldy brush has been used to make some of the extraordinarily complicated designs we see on traditional Indian vessels. Sometimes the artist uses a commercial watercolor brush to fill in the outlines that were drawn using the yucca frond and a very steady hand.

Pigments for decorating traditional Indian pots vary, from plant materials to metallic-oxide-containing rocks to colored clays. Many of the southwestern pueblos

Santana is stacking her "kiln." Old tomato juice cans support the metal grate over the wood kindling. Red pots are turned upside-down and will be covered with old metal license plates and cow chips for insulation.

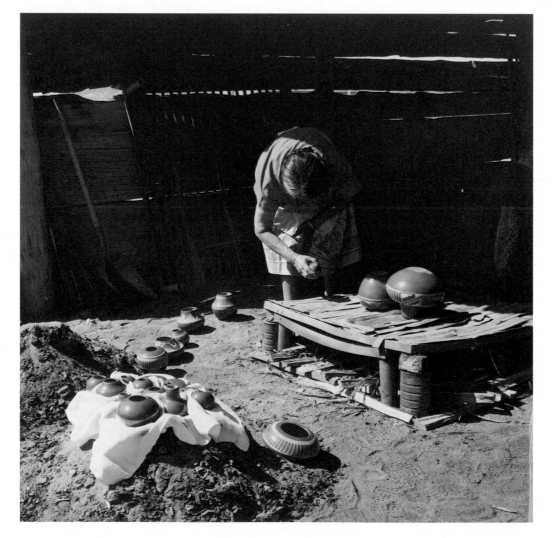

use the Rocky Mountain bee plant, a wild spinach, for black painting. Huge piles of spinach are boiled down to a sticky black residue called *guaco*, poured onto a cornhusk, allowed to harden, and stored. For brushwork, the mixture is moistened with water in the same way Japanese sumi paint is made. Some pueblos traditionally use this same *guaco* only as a suspension agent to hold their black metallic pigments on the clay surface.

Natural clays make up most of the color palette for polychrome wares of the northern pueblos. Clays can be yellow, buff, gray, and varying shades of red, but it is hard to tell before firing what the resulting hue will be. To repeat colors, Indians need to keep track of the exact source for each pigment. The southern pueblos like Acoma and Laguna use hard rocks and rocky sludge found locally that contain black iron oxide, red iron oxide, manganese dioxide, titanium, uranium, and combinations of these. Rocks are painstakingly ground on stone metates into powder, then painted on burnished surfaces. Sometimes a liquid slip of another clay is used over the clay body of the pot, for reasons of color or ease of polishing with a river washed stone. If the piece is decorated or carved, this is done last.

Techniques of firing pottery in the open air vary with almost every Indian group. To keep the natural color of the clay and pigments of the decorations, a fire with an excess of oxygen in the atmosphere is essential. For smudged, smoked, or completely blackened wares, a reducing fire in which all oxygen is eliminated is required. Fuel is also different among the Indian groups. Some potters use wood, usually juniper, mesquite, or pine; others use animal dung from cows, deer, and squirrels, which have a relatively high BTU content.

Where wood is the fire source, dried cow chips may be piled over the ware to form an enclosure for insulation—in effect, a kiln. In this case, pots are set on an elevated grill under which stacks of short sticks of wood are placed. Sometimes the pots are protected by a wire cage or screen before the cow chips are laid igloofashion over the entire bier. If animal dung is the fuel, it is usually placed directly on the ground under the first layer of pottery and over the entire mound; a few wood sticks are inserted at the base of the pile to get the fire going, or the whole thing may be doused with kerosene and ignited.

Indian pottery fires are very short compared with Anglo firings of earthenware, stoneware, or porcelain in gas or electric furnaces. An open fire, or bonfire, will never achieve more than 1,300°F, the lowest temperature at which clay can become chemically hard and somewhat resistant to breakage. Anglo firings in enclosed insulated furnaces, called kilns, fueled with gas or electricity, require six to ten hours to reach temperatures ranging from 1,800°F for porous pottery to 2,500°F for porcelain. Most Indian bonfirings last from only forty-five minutes to several hours,

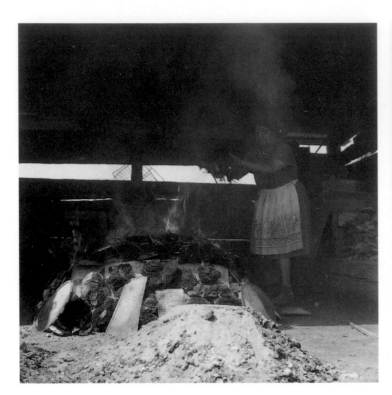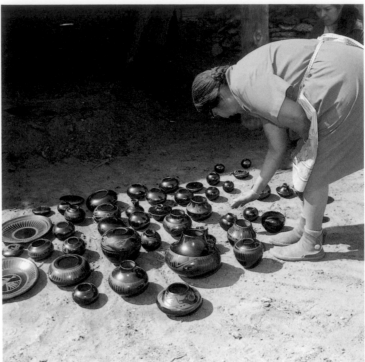

The wood is lit, and is allowed to burn hot and hard for about forty-five minutes. For a black firing, the flames are smothered with dried horse manure and wood ash to keep out all of the air.

When the smothering has gone on "long enough"—whatever that means!—the ashes are stirred with the "poking stick." Then the pots are lifted out of the ground. Santana will dust off the wood ash, under which every pot is a shiny jet black.

depending on the group of wares being fired or the size of the work. Large vessels or sculptures are often fired alone and require a longer, slower burn.

At Acoma Pueblo, the Lewises—using white clay and black or polychrome designs—allow the cow dung chips that they use for fuel to smolder until they become blackened and disintegrate to ash. The pots cool as the chips shrink and the ashes fall away. At San Ildefonso or Santa Clara Pueblos, where polished pottery may be blackened by smothering the flaming mound of pots with dried horse manure at just the right time during the firing, the pots must be extracted from the ashes as soon as possible, or the shiny surface will dull. Huge pots fired one at a time must cool slowly, but not too slowly, or the clay surface and even the color might change.

Outdoor firing of pottery tests the potter's experience and skill. Among Indian groups, firing is a special ritual and is usually a communal activity because the process is so arduous. The kind and size of wood or kindling is important to the way the fire will burn. Indians may travel many miles for the right wood. Cow chips or other dung, used either as fuel or as a covering insulation, must be gathered in

the proper size and shape and dried a certain way for a certain length of time. Manure for smothering in the black firing must come from horses that have eaten grass instead of hay, so that it will have a high enough carbon content to turn the pots from iron red to black.

Because Indian pottery prices have escalated demonstrably over the last decades, each pot or sculpture is understandably precious to the artist who depends on her claywork to be the main monetary support of her family. Choosing how to fire clayworks—whether in the traditional bonfire or in a modern kiln—has become an issue to many Indians. Black pottery almost always has to be fired in the Indians' traditional manner outside for smothering, but polychrome, black-on-white, and red wares can be fired in electric or petroleum-fueled kilns more slowly and with less damage. Today many well-known Indian potters are choosing the easier and safer Anglo way of firing in kilns. Some of the important Indian pottery families decry this practice and adhere only to the traditional methods.

It is easy to tell a bonfired from a kiln-fired ceramic work. An outdoor low-temperature firing with dung or wood results in a claywork that is porous, clunky, and fragile. Kiln-fired pots reach a higher temperature, even for earthenware, and generally will ring if they are thumped. There is usually a characteristic unevenness to the clay color and surface of bonfired pots due to the variation in outdoor fuels and the weather conditions on the day of the fire. Some Indians refer to the splashes of color changes and markings as "clouds." Kiln-fired pots look just the same all over. Indians who fire outdoors think it gives a more natural and spiritual feeling to the work, and some cling to the method regardless of color desires for this ethereal reason. Usually gallery owners and collectors of important Indian claywork prefer one of these looks or the other, caught up in the visual stimulation without even considering the argument about tradition.

Among Indian artists, the controversy over firing technique is a question of heritage versus practicality: should they hold on to traditional firing methods, which are usually complicated and inefficient, or fire according to simpler, more modern methods? It is also an argument over the importance of process versus result. Some of the avant-garde potters in *The Legacy of Generations* exhibition fire in a variety of ways for the pure joy of changing their techniques and for the differences that result. Some of our exhibitors fire slowly in gas or electric kilns because of the complexity or the extraordinary size of their work. These artists are likely to continue using both traditional and modern firing methods, and perhaps even other nontraditional techniques. In response to a changing world, they will employ whichever methods best facilitate their quest to make beautiful and remarkable pottery.

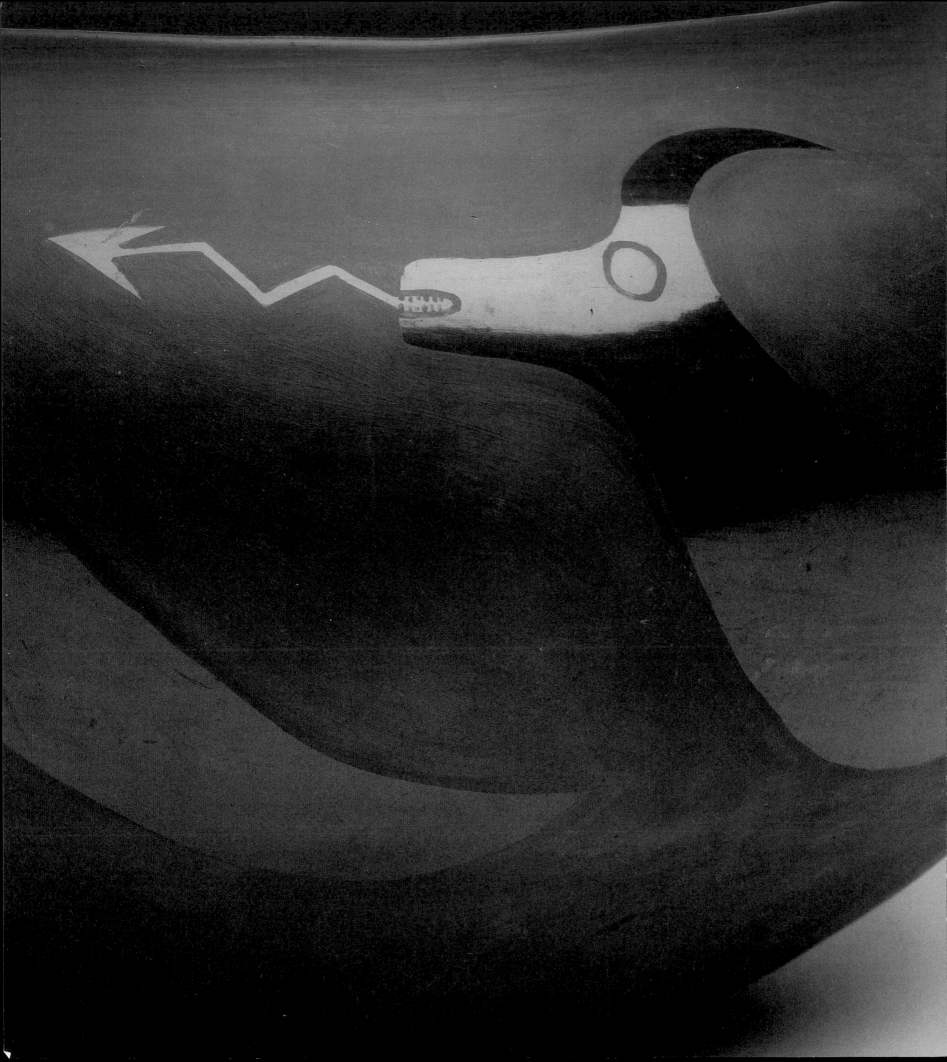

The Matriarchs

Nampeyo of Hano

Maria Martinez

Lucy Martin Lewis

Margaret Tafoya

Helen Cordero

Blue Corn

Fannie Nampeyo
Dextra Nampeyo
Santana Martinez
Barbara Gonzales
The Lewis Women
Emma Lewis Mitchell
Dolores Lewis Garcia
Carmel Lewis Haskaya
Lu Ann Tafoya
Grace Medicine Flower
Nancy Youngblood Lugo
Elizabeth "Buffy" Cordero-Suina
Diane Calabaza-Jenkins

Maria and Julian Martinez (detail, opposite) Jar with *avanyu* design, c. 1918–19. Black-on-black; 11½ × 9⅝ in. dia. Millicent Rogers Museum of Northern New Mexico. Photograph by Craig Smith

American Indian pottery, whether for domestic use or tourist consumption, is rarely created through solo effort; rather, it is a communal craft. Still, there are recognizable styles and character- istics that can be attributed to artists of remarkable ability.

Among these special artists are six women whom I consider the matriarchs of nineteenth- and twentieth-century American Indian pottery. Born between 1860 and 1920, each of them was devoted to her native traditions, to her art, and to her people. The pottery they made reveals uncommon talent, vitality, and vision; their life stories reveal persistence in the face of adversity, modesty in the face of adulation.

These craftswomen lived and worked during an extraordinary time in history. Their communities were facing great change, and had to fight to maintain the strength of their traditions in the face of increasing influence from the outside Anglo world. At the same time, the Anglos were presenting new opportunities for Indian artists to show their art to the world. The six matriarchs were at the heart of these changes. While enthusiastic tourists from the new transcontinental railroads sought to make celebrities out of the unassuming potters, the craftswomen steadfastly continued to educate the new generations within their families, passing down the traditions they had been taught by their own mothers and grandmothers. And as they did so, they created wares of surpass- ing and lasting beauty.

Matriarchs are the special women whose eyes see more than most eyes, whose hands are more deft, whose thoughts are more creative, and whose hearts are one with the earth. These six women were the foundation of a great tradition, inventing for the future while revering the past.

Nampeyo of Hano

Born in Arizona around 1860, Nampeyo was the first American Indian woman to gain personal recognition for her pottery, though she did not sign her work. Her revival of ancient firing and painting traditions influenced the art of her entire Hopi-Tewa pueblo in the late 1800s. She gave her people a new direction, bringing them an era of prosperity and renown.

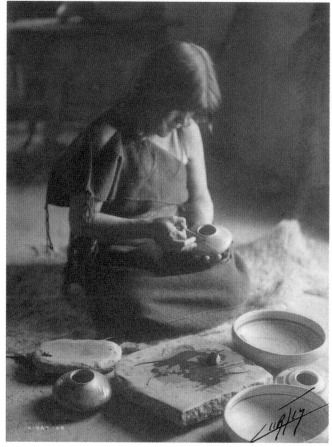

Photograph by E. S. Curtis. Courtesy of the Heard Museum

Hano, a Tewa-speaking village at Hopi First Mesa in northern Arizona, was founded sometime after the 1680 Pueblo Revolt by a group of Indians who abandoned their pueblo near Santa Fe, New Mexico, and moved to Hopi. It is said that the peace-loving Hopi invited these known Tewa warriors to live with them for protection. Today the Hano group persists separately from the Hopi pueblo and from the Tewa relatives in New Mexico. Into this colony Nampeyo was born in about 1860 to her mother, White Corn, and her father, Quootsva. Customarily for Hopis, the child assumes the clan of the mother, so Nampeyo became Tewa Corn Clan, as are all her descendants. Nampeyo was the first Indian artist to be identified and known by name.

Nampeyo was born about twenty years before Maria Martinez, who was born at San Ildefonso Pueblo, New Mexico—another Tewa-speaking village. Nampeyo and Maria were and probably still are the foremost of the American Indian potters given individual acclaim for their claywork. Nampeyo never signed her pottery; at the instigation of "the museum people," Maria began signing in about 1925, after she was already renowned. Although to a certain extent the careers of the two women paralleled, it is safe to say that Nampeyo followed a more commercial route. She was a truly skillful and prodigious potter making both large and small wares, and was kept busy supplying the Fred Harvey Company's numerous stores for many years.

Reputedly, Nampeyo received criticism from Hopi women for being famous, as did Maria forty years later at San Ildefonso. Traditional Pueblo Indian behavior excludes notoriety, which probably accounts for these denunciations in some measure. In Nampeyo's case, I have heard something like this at Hopi: "Nampeyo did not invent pottery; pottery did not belong to her. She was not the first potter. Other women taught her and her husband Lessou to paint and shared their knowledge of the clay and firing and helped in many ways." However, Nampeyo had the energy and creativity to put her ahead of all the others.

As a child, Nampeyo lived at Hano with her parents and her brothers, Tom Polacca, Kano, and Patuntupi. No one went to school. Nampeyo could not read or write English, and of course her own language was never written. There were as yet no trading posts where food could be bought. It was an arduous life. Children helped in all the chores of collecting water, grinding corn, planting the meager crops, hunting rabbits, and keeping up the Indian rituals and ceremonies. But almost everyone made pottery for use or for ceremonial purposes.

It is said that Nampeyo began her famous revival of the prehistoric Sikyatki-style polychrome, indigenous to her vicinity, when her husband, Lessou, brought home shards from an excavation site where he was employed by the archaeologist J. W. Fewkes. Sikyatki had been a village at the base of First Mesa where exceptional pottery was produced in the twelfth century A.D. However, some scholars speculate that Nampeyo had studied the ancient pieces she found herself and was already developing her own pottery painting under the influence of the amazing swirls and lines she saw on the Sikyatki shards.

It was not easy in those days, nor is it easy in these days, for a pueblo potter to deviate from the traditional forms and designs that had ceremonial roots. Hopi was an especially isolated and conservative pueblo. Nampeyo took the basic patterns from the ancient painting she saw on the shards, used the style ingeniously in her own way, and influenced a whole pueblo then and now; many followed. That she did not sign her work has caused controversy for one hundred years. Only well-documented provenance can attest to real Nampeyos; scholars are continuously debating the attributions to Nampeyo as they study intently the skill of the potting and the turn of the brushstroke on a piece in question.

Nampeyo was very popular in the West, partly because photographs of her making pottery were used on many brochures advertising the Santa Fe railroads' western vacation packages. She gave countless pottery demonstrations and saw many visitors at the Grand Canyon Watchtower and Hopi House. Numerous accounts of Nampeyo's pottery-making process have been written by those who witnessed her performances first hand. Nampeyo prospected her clay in the

traditional way at Hopi, pulverized it on a stone metate, slaked it in water, and removed the impurities—according to some accounts by squeezing the clay through her toes—and added fine sand for temper. The clay, ready for working, went with her wherever she was demonstrating.

Nampeyo was exceptionally adept at working the moist coils of clay into the various shapes. She particularly favored a low, wide, flat, disk-shaped form with a curving shoulder that came into a narrow opening, her own rendition of an ancient Sikyatki vessel. Large pots were worked in a *puki,* the shard of a broken pot with a rounded interior, and small pots were begun from a lump of clay held in the palm and pinched into shape. The artist, more concerned with experimentation, never paid the attention to symmetry of form that Maria Martinez did. It is said that Nampeyo worked so quickly that spectators would gasp.

The roughly finished, bone-dry piece was sanded smooth with a stone. Frequently, Nampeyo would apply a different liquid clay slip to coat the pot as a background for painting; then she would polish it with a waterwashed pebble. The mineral content of the various natural clays found at the pueblo determined the color the piece would be after the bonfiring. The warm yellows, tans, oranges, and reds so characteristic of traditional Hopi pottery are a direct result of the amount of iron, manganese, and titanium oxide in the clays.

Pigments for painting the designs were, and still are, minerals found as sludge in the desert or as metallic rocks that can be ground fine, mixed with water, and applied with a yucca brush. Nampeyo made yucca brushes of different sizes by cutting and shaping them with a sharp tool after the frond was chewed supple. Her splendid, gracefully flamboyant painting is one of the clues by which authorities seek to verify her pots.

Even with her fame from the railroad brochures and the Harvey Company stores, Nampeyo was not known to the museum scholars in Santa Fe. Fred Kabotie, the famous Hopi painter, told me how he brought Dr. Edgar Lee Hewett of the Museum of New Mexico in Santa Fe to visit with Nampeyo in 1922. In Fred's words: "We borrowed cars and bed rolls for going up there [to Hopi]. It took four or five days anyway. I remember we spent a night at Grants, barely made it, so rainy. We went through Gallup, then third night at Steamboat, over the hill between Window Rock and Ganado. No road but end up in a Navajo hogan. Most of the time Hewett was walking. The Model T had no power. We would go up the hill backwards with the car. We found Nampeyo. She had some pottery with wonderful painting on it sitting on a stack of corn, some broken. Dr. Hewett had men from Washington [Smithsonian Institution] and New York [Heye

Foundation]. Those men bought all the potteries, even broken. My, my! Hewett thought they were so good he even bought the broken ones."

Nampeyo's firing was accomplished in traditional fashion: a bed of sand on dry ground was overlaid with dried sheep dung; then rocks or old shards were laid to cradle the pots that were placed above; shards were spread to cover the mound of pottery; and finally a layer of dung was spread to cover the whole dome. After igniting, the dung smoldered to ashes in less than an hour, and the pots were removed hot with a stick and wiped clean with a cloth. Dextra Nampeyo remembers from her childhood seeing her great-grandmother Nampeyo wash her hair before every firing. By tying it with a bandana, she would keep it wet to ward off the heat.

Nampeyo met many famous people in her career, some of whom commissioned pots, such as the architect Mary Colter, Ole Solberg of the Ethnographic Museum of Oslo, Norway, and William Howard Taft. The few documented works of Nampeyo found in museums today are generally the result of specific encounters with individual collectors. The famous potter was the subject of photographs by untold numbers of tourists, but also by the great photographers of the day, Edward S. Curtis and A. C. Vroman.

Nampeyo had been diagnosed in her youth with untreatable trachoma by an Anglo doctor, and by 1920 her eyesight was diminishing noticeably. But lack of sight did not seem to diminish her art. Nampeyo's hands could remember the shapes she used to make. She began to add tactile decoration, such as corrugated coils that she textured with a pointed stick, in place of some of her painting. Ruth Bunzel, the anthropologist, wrote in 1925 that Nampeyo was making "only dignified pieces in the best traditional style. Technically her work is superior to that of any other Hopi potter."

Nampeyo's youngest daughter, Fannie, tells of painting her mother's pots when Nampeyo could no longer see. When I visited Fannie in 1980, she told me about painting Nampeyo's pots. "My mother had no idea she was important, no more important than anybody. But I think she worked harder!" Even at this time, more than one hundred years after her mother was born, Fannie herself did not really understand the importance of the Nampeyo legacy. Nampeyo died in 1942, but today more than forty of her direct descendants make excellent pottery, according to Indian art dealer Martha Struever.

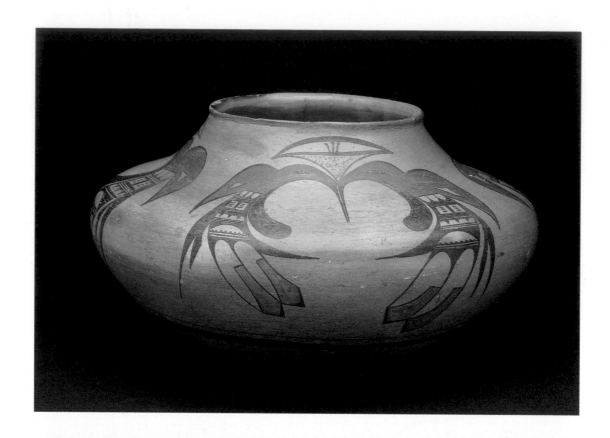

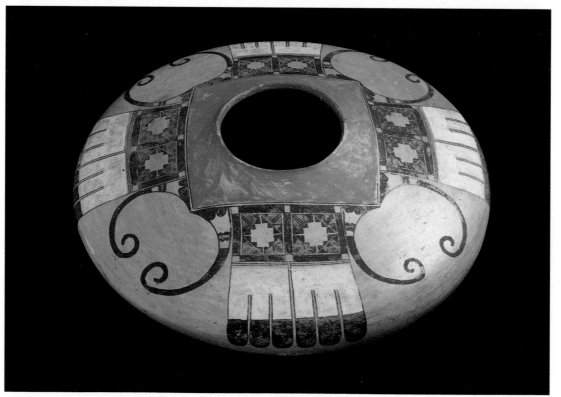

Nampeyo of Hano (opposite, top) Jar, c. 1900. Polychrome; 7½ × 15 in. dia. Collection of Dennis and Janis Lyon. Photograph by Craig Smith

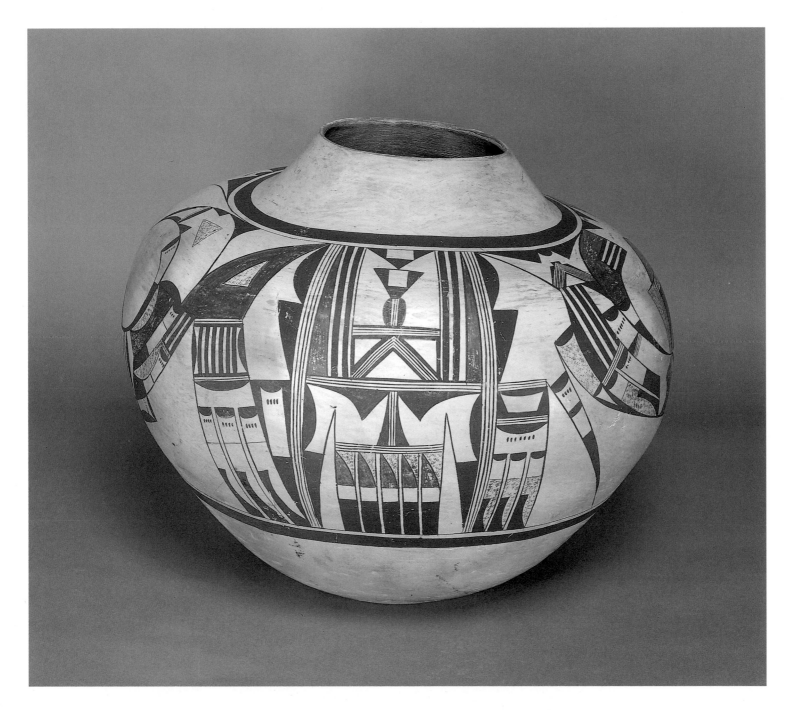

Nampeyo of Hano (opposite, bottom) Bowl with eagle tail design, 1903. Polychrome; 6 × 15⅜ in. dia. Collection of Martha Hopkins Struever. Photograph by Craig Smith

Nampeyo of Hano (above) Jar, c. 1890–1930. Polychrome; 16½ × 20 in. dia. Department of Anthropology, Smithsonian Institution, Catalogue No. 361892

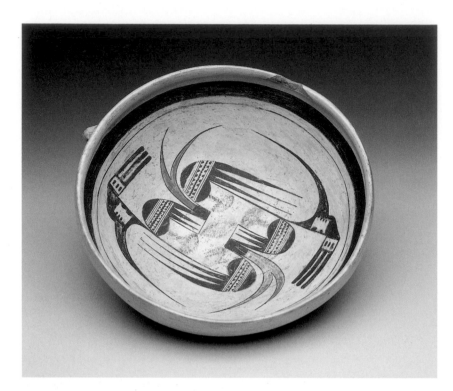

Nampeyo of Hano Bowl with bird design, n.d. Polychrome; 3 × 10⅛ in. dia. School of American Research, Santa Fe, New Mexico. Photograph by Craig Smith

Nampeyo of Hano (below) Bowl with migration design, c. 1915–16. Polychrome; 8⅜ × 18½ in. dia. School of American Research Collections in the Museum of New Mexico. Photograph by Craig Smith

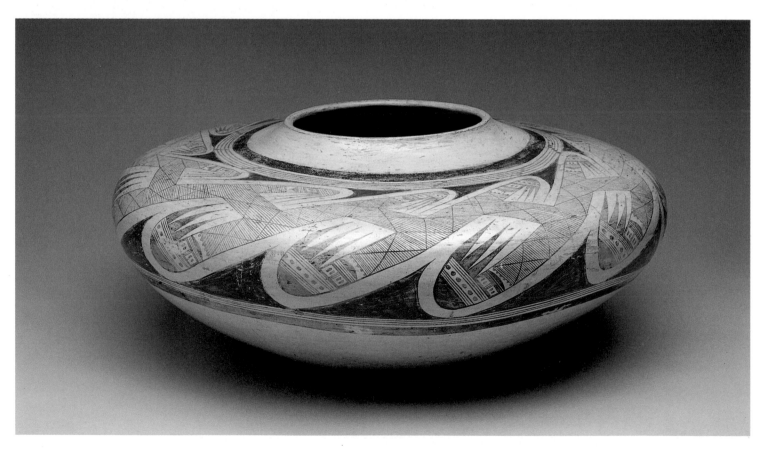

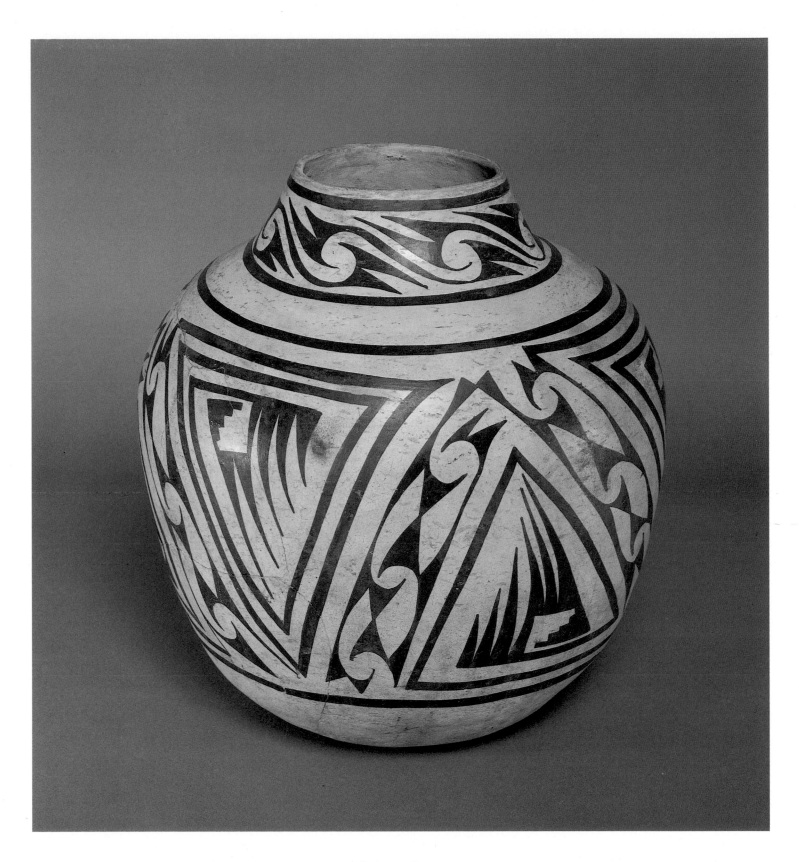

Nampeyo of Hano Jar, c. 1890–1930. Black-on-white; 17 ×
15½ in. dia. Department of Anthropology, Smithsonian
Institution, Catalogue No. 158143

Maria Martinez

Born around 1880, Maria Martinez was destined to become the most famous of all American Indian potters, with a career spanning eighty-five years. She and her husband Julian created the first black-on-black ware, forever changing the economy of San Ildefonso Pueblo, their New Mexico home. Maria's widespread popularity drew attention to many other forms of American Indian art.

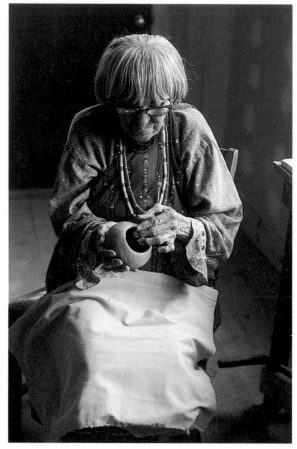

Photograph by Susan Peterson

Maria told me some years before she died that she was the most famous Indian, "not counting Geronimo!" She was more correct than she knew. Maria Montoya Martinez, whose Indian name was Poveka, is arguably the most noted of all Native Americans of this century. Stories about her are legion, and her gregarious, generous personality endeared her to millions during her lifetime. "I was born for people," she confided. "I like people. I don't hide."

There is no record of Maria's birth year at San Ildefonso, and she was never concerned about her age. She had a certificate of baptism dated 1887, and she told me she thought she might have been about seven years old at the time. She died in 1980 after a short illness. She had been making pottery most of her long life and almost until the end.

Maria grew up with the traditional polychrome pottery of her village. She learned claywork from her aunt Nicolasa, and by the time she was thirteen years old, Maria was acclaimed by her people for her exceptional skill. In 1904 she married Julian Martinez, who was an acknowledged painter on hides, paper, and walls, and then on Maria's clay. The couple spent their honeymoon demonstrating pottery at the Louisiana Purchase Exposition, the Saint Louis World's Fair, the first of many expositions they attended together.

Maria was the matriarch of five generations of potters and was honored with more prizes than she could remember. She first became famous in the second decade of this century for her shiny, jet black pottery with matte black painted decorations. She and Julian had developed these wares as a result of a request from Smithsonian

Institution and Heye Foundation archaeologists to copy two-thousand-year-old black shards unearthed during an excavation in 1908 at the nearby site of Puye.

The ancient tradition of blackware in the southwestern United States is delineated by the late Dr. Bertha Dutton—who served for forty-four years as research associate under director Dr. Edgar Lee Hewett of the Museum of New Mexico, Santa Fe—in an afterword in my book *The Living Tradition of Maria Martinez*. When Maria made her first blackwares by smothering red clay pots during a bonfiring, she was following Dr. Hewett's instructions, and did not realize that the technique would become her life's work. Santa Clara Pueblo had made plain black pottery for generations. But Maria's artistry and skill and Julian's painting caused a revolution.

Maria had to be convinced that black pottery was part of her heritage as well as the polychrome pottery she had seen handed down in her village and had been making for years. She told me that she and Julian persisted in firing blackware experimentally to improve the polishing and the painting, which was done with more refractory clays to achieve the matte decoration. Maria hid the pots under her bed. Dr. Hewett continued to bring visitors to the pueblo to see the Martinez pottery but would have to prod Maria to produce the blackware from under the bed. Eventually she acquiesced, saying, "Well, black goes with everything!"

Maria's parents, Tomas and Reyes Peña Montoya, had five daughters at San Ildefonso, in the following order: Maximiliana (Ana), Juanita, Maria, Desideria, and Clara. Each made her own pottery and sometimes helped and decorated for Maria. The youngest sister, Clara, who was born about the same time as Maria's second son, lived with Maria after their mother died following Clara's birth. Clara became an excellent pottery polisher, helping with the family's redwares and blackwares. Most of the early polychromes that the girls made were for ceremonial purposes. Examples of all the sisters' work can be found in museums today.

Maria and Julian continued to make traditional polychrome ware, with black and one or more other hues on backgrounds of white or tan. Redware was also perfected at San Ildefonso. Clays were prospected from natural soil on the reservation and varied in their metallic oxide chemistry; this, coupled with the open-bonfire process, caused gradations of red to orange. Maria made red pots painted with black designs, as did her well-known cousins Tonita Roybal and Martina Vigil Montoya. Maria also made another kind of redware; after she and Julian developed matte painting on shiny pots that were usually smothered in the fire to black, they forgot the smothering occasionally, leaving the pots to remain oxidized red. The traders termed these beautiful rare magenta-red pots "red-on-red" as opposed to "black-on-black."

Maria and Julian had four sons, Adam, Juan Diego, Popovi Da, and Phillip. Adam married Santana Roybal in 1926; together they lived with Maria and Julian. Adam looked after his younger brothers, the horses and the fields, and Santana began to "apprentice" Julian in decoration. Sometime after Julian died in 1943, Maria moved into Adam and Santana's house, and Santana painted and signed with Maria before Popovi Da became the painter for his mother's pottery. Then Santana and Adam began a long collaboration in their own red and black pottery making.

Maria always dressed in Indian costume, a traditional pueblo manta—sleeveless and caught only at one shoulder, made from bright printed cotton—over a blouse with sleeves touched with lace and braid, all sewn by members of her family. She usually wore a handwoven red, green, and white Hopi sash wound twice around her waist. She loved sunny-colored shawls from various cultures, accepted them heartily as gifts, and wore one around her head or shoulders every day. Often this was augmented with turquoise jewelry or long necklaces of red beads and black jet, silver earrings, and bracelets. Maria loved to "look pretty," she said.

There is no word for art in Maria's native tongue, the Tewa language. Indigenous pottery is a communal effort, a shared effort, a family effort; Maria, then Maria and Julian, did not sign their polychrome pieces or the first blackwares. Around 1925, Dr. Hewett persuaded them that the pottery would sell better with their signatures, but in those days signing the pots meant nothing to Maria. At that time she signed "Marie" or "Marie/Julian." During the twenty-some years that she worked with Popovi after World War II, she signed her pieces "Maria and Popovi Da." At the end of her life, when she worked alone without decoration, she signed her Indian name, "Maria Poveka." She and Julian showed anyone who was interested at San Ildefonso how to make the black pottery that was becoming so famous, and did not prevent anyone from signing Maria's name to their work. I have seen many "Marie" or "Maria" signatures on pots that were not made by the matriarch.

As the work of Maria and Julian progressed during the 1920s from traditional polychrome to blackwares, their output became prodigious. In earlier years, Maria had sold her pots at the railroad station in Albuquerque and in various Santa Fe markets with other Indian potters. Now the couple was aided by Dr. Hewett's promotional efforts at the museum, and by his colleague Kenneth Chapman, who illustrated the first book about Maria and Julian's black pottery in 1925. Buses brought tourists to the pueblo to see Maria. Collectors clamored for her pottery. At the request of some patrons, she and Julian made many objects not traditional in the ceramic art of the pueblos, such as trays, candle holders, ornamental vases, and dinnerware sets.

"I used to make big pots for $1.00 or $1.75," she confided to me. "One day the museum asked me to make a pot two-feet tall for a special person and gave me $8.00." All Maria's pots were sold as fast as they were made. Julian would take only the very best pots to sell, the most perfect ones, and in the 1930s, thirty pots brought about $60. "Long time we never thought of keeping pottery of mine or giving it to the children," Maria continued sadly, knowing now that her old pieces are extraordinarily valuable. "We didn't think of that."

Maria's diligence and skill—albeit with the help of many—and eye for form, and Julian's imaginative and dexterous painting, were perfect complements of each other. Their best works are refined and sophisticated artistic statements.

Maria didn't go to school, but she spoke Spanish and English in addition to her own language. Her son Adam once remarked, "Maria may not read, but she sure sees everything!" Maria told me the story of her "doctor's degree." When her son Popovi informed her that the University of Colorado wanted to award her a doctorate, she said, "Tell those men I don't want to be a doctor. I never medicate anyone." But she went to Boulder to receive the honorary degree for artistic achievement. She wore a regulation cap and gown in the ceremony, but in the end removed the gown so people could see her beautiful Indian costume. She took the cap home.

Maria participated in many world's fairs, from the time of her youth. She and her family spent a year at the 1915 Panama California Exposition in San Diego, where "they built me a Taos Pueblo to live in instead of San Ildefonso, and everyone wanted to go home, but I told them we have to stay," said this dedicated woman. Among other accolades, Maria laid the cornerstone of Rockefeller Center in New York City. "Someone from a museum in Germany," she recalled, came to make a cast of her hand; Malvina Hoffman sculpted her head. The American Ceramic Society gave her their highest honor, and the governor of New Mexico awarded her a gold medal for her achievements. There was a huge exhibition, *Maria Martinez: Five Generations of Potters,* which I curated, at the Renwick Gallery in Washington, D.C., in 1978. She acquired a second doctorate from Columbia College in Chicago, and she posthumously received the first Lifetime Achievement Award ever given by the Southwestern Association on Indian Affairs, with ceremonies for the public and for Maria's family at the Indian Market in Santa Fe in August 1995.

Maria was a unique artist with an engaging personality that contributed to her legacy. Her own history is an example of the Indian ideal of conformity as a way of life. Feted by the outside world, she chose without hesitation to remain on the pueblo and to enclose her family in a traditional culture. Maria's uncanny inner knowledge made her fully aware of the implications of her commitment, and she understood the Indian obligation to guard one's own cultural resources.

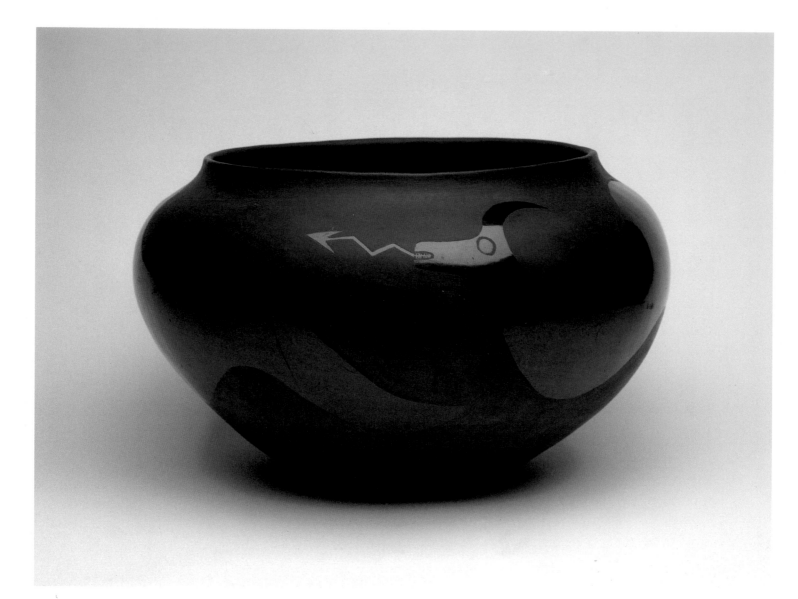

Maria and Julian Martinez Jar with *avanyu* design, c. 1918–19.
Black-on-black; 11½ × 9⅝ in. dia. Millicent Rogers Museum
of Northern New Mexico. Photograph by Craig Smith

Maria and Julian Martinez (opposite) "Cartier" jar, 1935.
Black-on-black; 15 × 18½ in. dia. Collection of Lucille and
Marshall Miller. Photograph by Tim Thayer

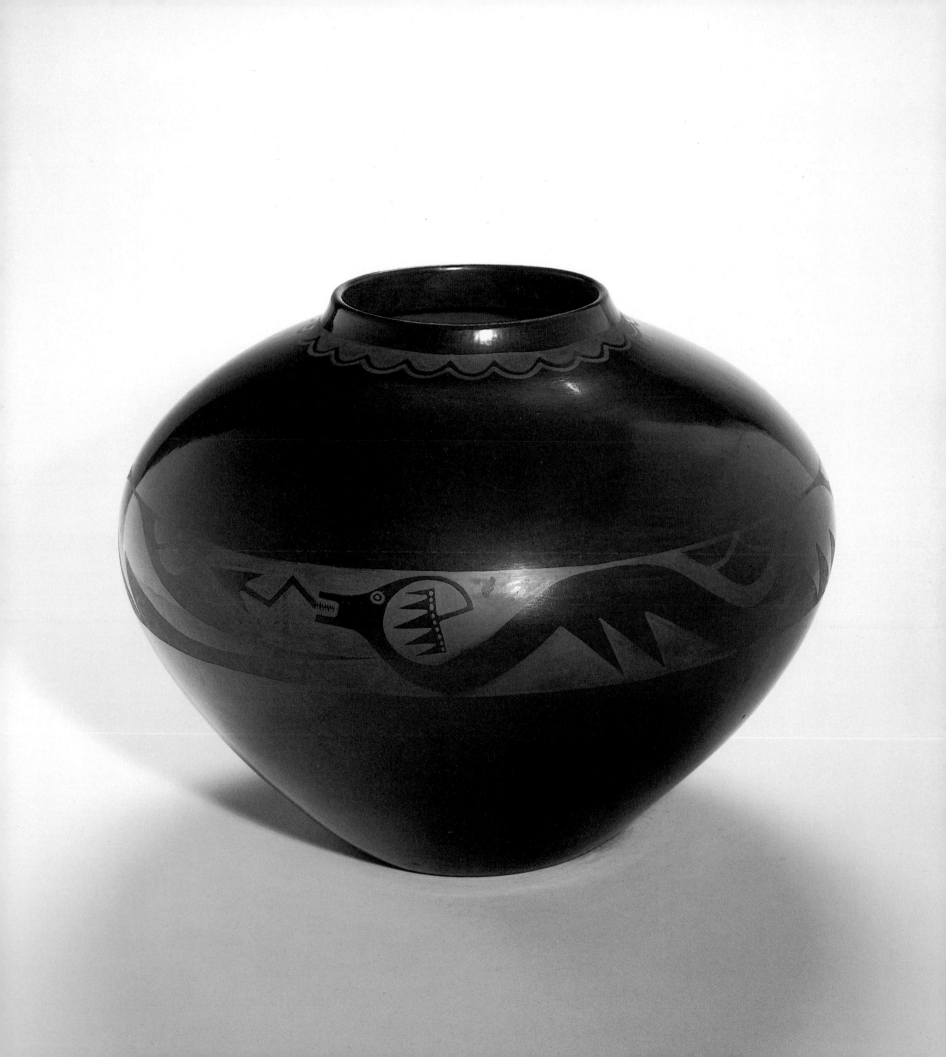

Maria Martinez Black-on-black place setting, c. 1930–40. Silverware by Frank Charlie and Eckley Yazzie, 1933. California Academy of Sciences, Elkus Collection. Photograph by Susan Middleton

Maria Martinez (opposite) Four black-on-black place settings, c. 1930–40. California Academy of Sciences, Elkus Collection. Photographs by Craig Smith

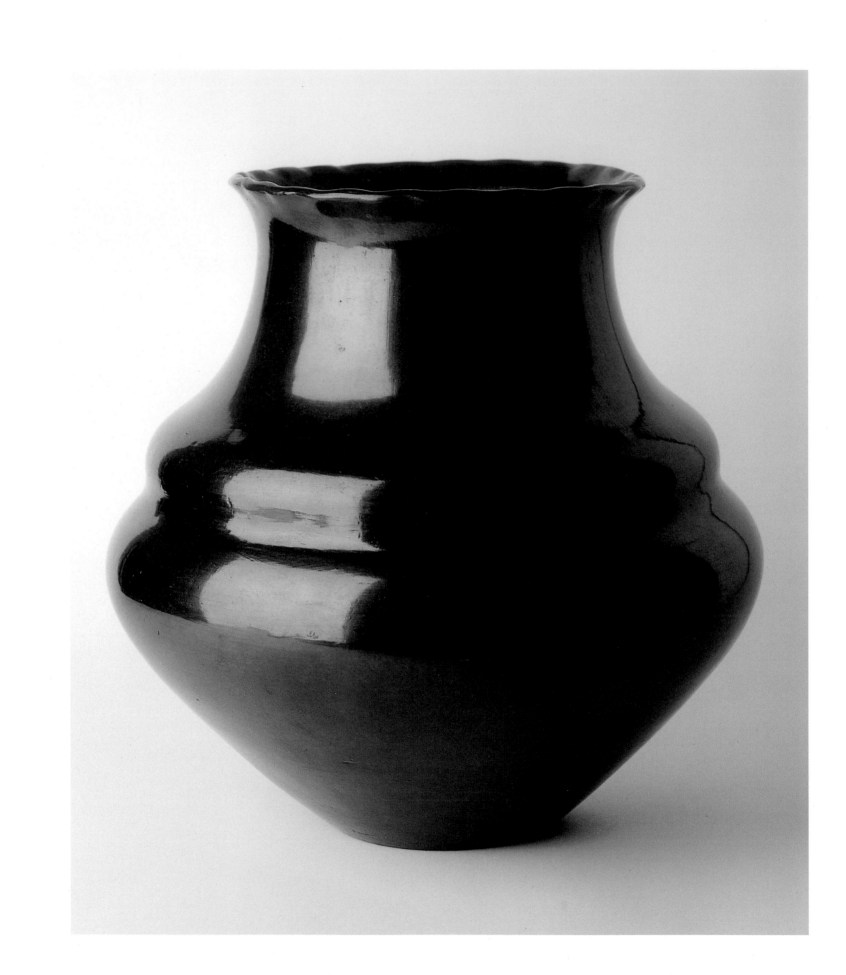

THE MATRIARCHS

Maria Martinez (opposite) "Terraced" jar, c. 1930–40.
Blackware; 15½ × 15⅝ in. dia. California Academy of
Sciences, Elkus Collection. Photograph by Craig Smith

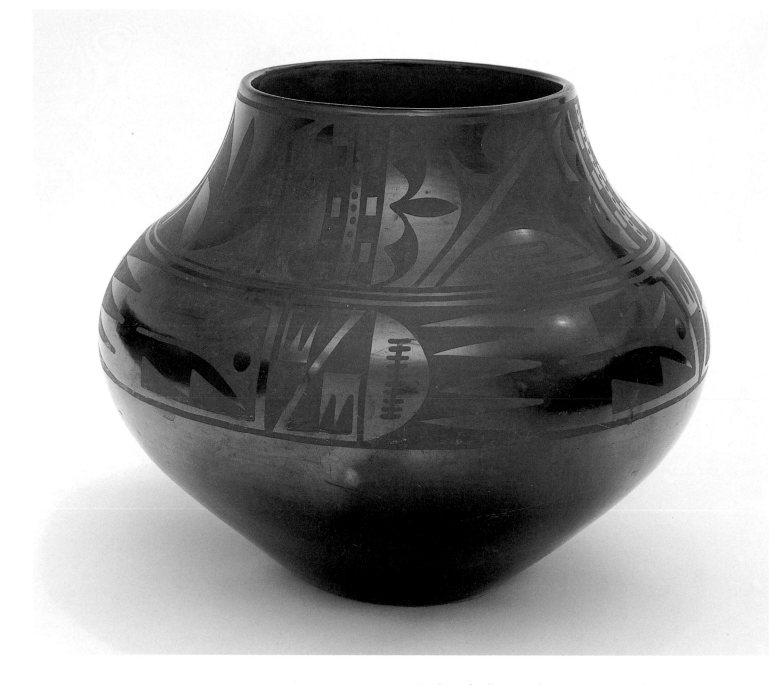

Maria and Julian Martinez Jar, c. 1939. Black-on-black;
11⅛ × 13 in. dia. Collection of the National Museum of
Women in the Arts. Gift of Wallace and Wilhelmina
Holladay. Photograph by Lee Stalsworth

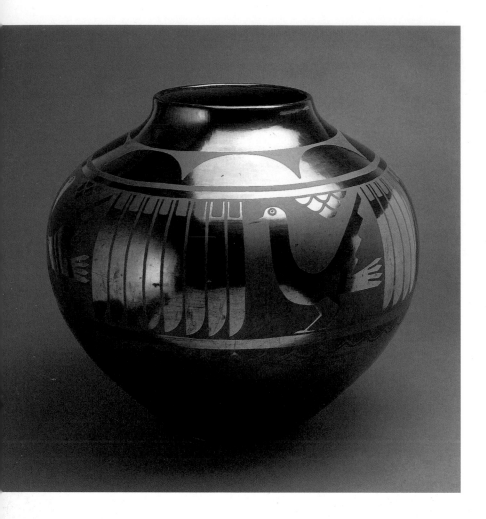

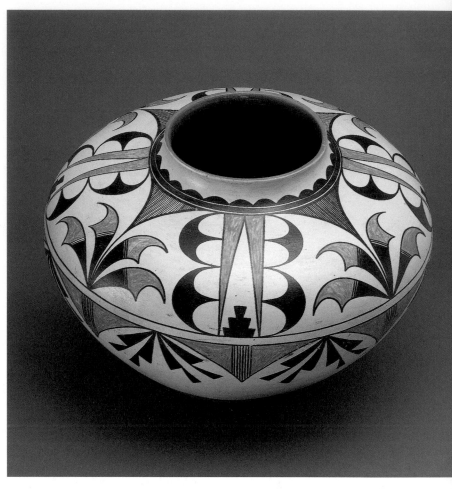

Maria and Julian Martinez Jar, 1930–40. Black-on-black; 17³/₈ × 20³/₄ in. dia. School of American Research Collections in the Museum of New Mexico. Photograph by Blair Clark

Maria and Julian Martinez Jar, c. 1925. Polychrome; 14⁷/₈ × 12¹/₂ in. dia. Collection of the Museum of Indian Arts and Culture/Laboratory of Anthropology, Santa Fe, New Mexico. Photograph by Blair Clark

Maria Martinez Bowl, 1947. Red-on-red; 9½ × 16 in. dia.
Oklahoma Museum of Natural History, University of
Oklahoma. Photograph by Sanford Mulden

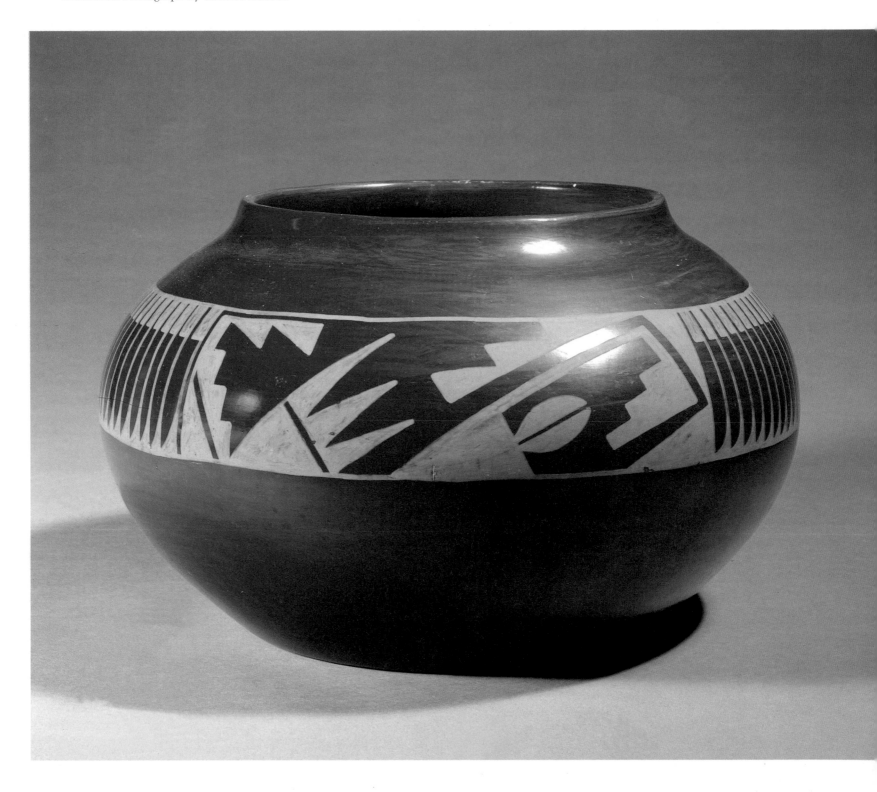

Lucy Martin Lewis

Lucy Martin Lewis was born around 1890 on the isolated Sky City mesa in Acoma Pueblo, New Mexico. Considered the most innovative of the matriarchs, she was inspired by the tiny shards of ancestral pottery she discovered. In turn, her sophisticated pottery has become an inspiration for generations of modern potters.

Acoma Pueblo's Sky City sits on top of a rock mesa five hundred feet off the ground. Reputed to be the oldest continuously inhabited settlement in the United States, Acoma has no running water or electricity, and not so long ago there were only stone steps for access. Now most of the pueblo members live below this mesa in several surrounding villages—McCartys, Acomita, San Fidel, and others. Many families have ancestral homes up on the mesa and return there often for various rituals and feast days.

Lucy grew up on the mesa and did not go to school. She had two brothers, who farmed and took care of the livestock with their father. Lucy helped in the home, took part in the ceremonial life of the pueblo, and began as a youngster to make pottery in the customary manner. When she was seven or eight she taught herself clay and firing techniques by observing her great aunt, Helice Vallo.

I never cease to marvel at how much time in these people's lives is devoted to traditional pursuits. Many days of preparing food, making costumes, and learning the rituals are required for each of the frequent and devout observances. Pottery making must be sandwiched in. As a "venerable old one" in her later years, Lucy's spiritual and healing role in the pueblo was particularly demanding.

Grants, the town nearest to the pueblo, about twenty miles away, was a coal and mining center. When the railroad was a vital form of transportation at the beginning of this century, Lucy went to Grants with her mother to sell pottery instead of selling by the roadside. The mother and the young girl left before sunup with their horse to get to town by ten or eleven o'clock to sell pots to the passengers. Lucy laughed when she told me about the kind of pots she made in those days, gesturing with her hands to show me several shapes and sizes. For instance, she made "little ash-bowls that had twisted handles or bird heads and places for a cigarette." She also made Easter bowls that were like small baskets with scalloped edges, some with places for a cigarette. She said these pots were very easy to sell for a few cents each.

Growing up on the mesa, Lucy saw sacred pots in the *kiva*, a place reserved for secret rituals. These pots were decorated with parrots, flowers, and rainbows, the

legacy of the Spanish conquest in the 1500s. There was no access to museums at isolated Acoma, so Lucy was not aware of any other style of pot, historical or contemporary. Lucy said, "Nobody famous ever came to Acoma." In a way, this comment is what eventually made me realize the unique quality that made Lucy so important, at least in my terms: Whatever inspiration Lucy got, she got between the Great Beyond and herself. No archaeologist, museum director, or well-known collector ever came to Acoma—as they did to Maria Martinez at San Ildefonso—to expose Lucy to other Indian pots or to offer advice and direction.

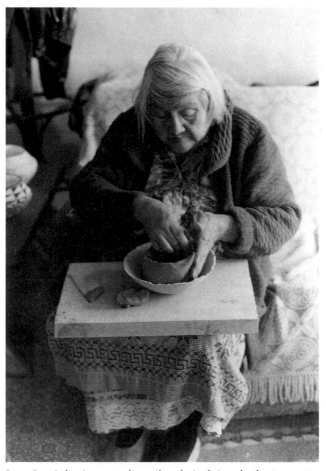

Lucy Lewis begins a pot by coil and pinch in a *huditzi*, c. 1980. Photograph by Susan Peterson

She saw only the pots in the *kiva* or the pots used in the household for gathering water or storing grains. Lucy lived only on the pueblo. She didn't travel to powwows or fairs. But she walked on shards, kicking them up from the dust on the mesa or at neighboring Chaco Canyon, the sacred area that these Indians believe is the seat of their ancestry. Lucy noticed that the tiny one- or two-inch shards she picked up at Chaco were the same kind of shards she collected at Acoma, with the black fine-line decoration on a white clay of the eleventh-century style we sometimes call Mimbres.

From these shards she independently invented her own special way of making pots. No other Indian potter, to my knowledge, has achieved the originality and artistry that Lucy begat without any outside help or inspirational guidance. Lucy and her husband, Toribio, had nine children. Lucy assisted with the chores of farming and harvesting, as well as attending to all the household needs. Although she had no schooling, she saw to it that the first six of her children were sent away to Indian schools, and the last three to Anglo schools. Because Lucy's children were either babies at home or were at school, she had no one to help her make pottery. She did all the aspects of Indian claywork herself—gathering, grinding, mixing, shaping, painting designs, and firing.

Acoma clay is prospected from a secret, sacred place somewhere on the reservation. I believe it is an impure kaolin (china clay). Porcelain objects are made from

the same geological type of clay but are fired to 2,300 or 2,400°F instead of the Indian bonfire temperature of about 1,300°F. Hence, this clay is exceptionally fragile in the raw state and very vulnerable to cracking during polishing or in the open fire. It fires a whitish color, or gray-white if there is smoke in the fire.

One of Lucy's pot-making daughters, Dolores, has said of the clay, "We believe in the power of the clay. We ask our own people to taste the clay and to taste the white slip. When we give demonstrations, we also ask the students to do that. It smells so good, it tastes so fresh. We make a prayer when we take the clay and when we use it. The pots are spirits. This clay is sacred. You can eat it raw and you are going back to it when you die."

Acoma potters do not add volcanic ash to minimize thermal shock and resulting breakage during the firing process, as is customary in some pueblos. Traditional Acoma potters do add shards from ancient pots that are found all over the reservation, grinding them into fine powder on a stone metate in the same manner as corn meal is pulverized. The ground shards are added to the kaolin clay. In this way the Indians believe they are adding something of their ancestors to the new pots.

Old Acoma household pots were often "corrugated" in the mode of ancient pots, built up of thin coils, one on top of the other, with no smoothing, no polishing, and no decorating. Lucy affected this style for a few pieces periodically because she enjoyed the association with the ancestors. She was proficient in the colorful decoration that Acoma pottery had inherited from the Spaniards, with black, brown, yellow, and orange designs on the polished white slip—clay whiter than the body clay, prospected in another secret spot. Lucy devised her own parrot and rainbow design in these colors.

She also used a "heart-line deer" design that was particularly meaningful to her because permission to use the design had been given to her by the officials at Zuni Pueblo and because it was a historically important symbol in that village. But her most significant legacy is the striking style of black-on-white painting that she devised from the line drawings she saw on the small shards of her ancestors. This includes her so-called "fine-line" or star pattern, the zigzag spike or lightning pattern, and all the variations of these.

Lucy painted totally by eye and freehand, sometimes waving her brush in the air within inches of the surface of the piece to plan how the design would go. She had a specific painting stance: body rigid, the pot held gently. The thumb and first finger grasped the stub of the three-inch long yucca-frond brush hard enough to whiten the knuckles. Muscles stiff, her arm moved only from the shoulder. Sometimes the tip of her little finger would drop to the pot, steadying the movement. The brush was dipped in pigment for every stroke. The yucca point went down against the pot,

her arm pulled the brush line, and her hand lifted quickly at the end of each stroke. Lucy planned the starts and stops of these elaborate mazes of lines in her mind, then applied the pigment.

Another interesting aspect of Lucy's innovations lay in her innate ability to create empty space in just the appropriate places, defining the pottery form. These were significantly placed embellishments, not just allover decorations. For instance, a plain white background with black geometric shapes cascading down from the lip of a piece and reappearing here and there asymmetrically on the pot surface was one of Lucy's important contributions to pottery making. In Anglo terms, this was perfect handling of positive and negative space. Hers was a sophisticated eye.

Lucy did not submit to any competition until 1950. When she did, she took several first prizes instantly and came to the attention of Dr. Edgar Lee Hewett, director of the Museum of New Mexico, who admonished her to sign her pieces. Lucy continued to win blue ribbons and certificates. Though she became more renowned, she remained her shy, stoic self, unmoved by public acclaim.

In 1983 she received the governor of New Mexico's award for Outstanding Personal Contribution to the Art of the State, and in the same year the Woman of Achievement award from Northwood Institute, Houston, Texas. Her work, with that of family members Emma, Dolores, and Andrew, was exhibited in a major exhibition at the Kerr Gallery, a fine-art venue in New York City. In 1986 she visited and exhibited in Hawaii, because she thought "there might be some connection between the Hawaiians and us," at the invitation of the Honolulu Academy of Fine Arts. She was accompanied by Emma, Dolores, Andrew, her oldest child, Ivan, and his wife, Rita from Cochiti Pueblo. I was honored to join them on the trip. Lucy was awarded the Gold Medal from the American Craft Council, and in the last year of her life, 1992, the College Art Association gave her their Gold Medal.

From the beginning, Lucy was imbued with something out of the ordinary. She had an energy, an artistic impulse, a penetrating aesthetic sense, an exuberance, and great skill. Her pots are personal visions. Seeing them, we sense the power of this revolutionary woman who, quietly and alone, dissolved the restraints of her society and found her individual vista.

Lucy Martin Lewis Jar with lightning design, 1962. Black-on-white; 8½ × 11½ in. dia. U.S. Department of the Interior, Indian Arts and Crafts Board

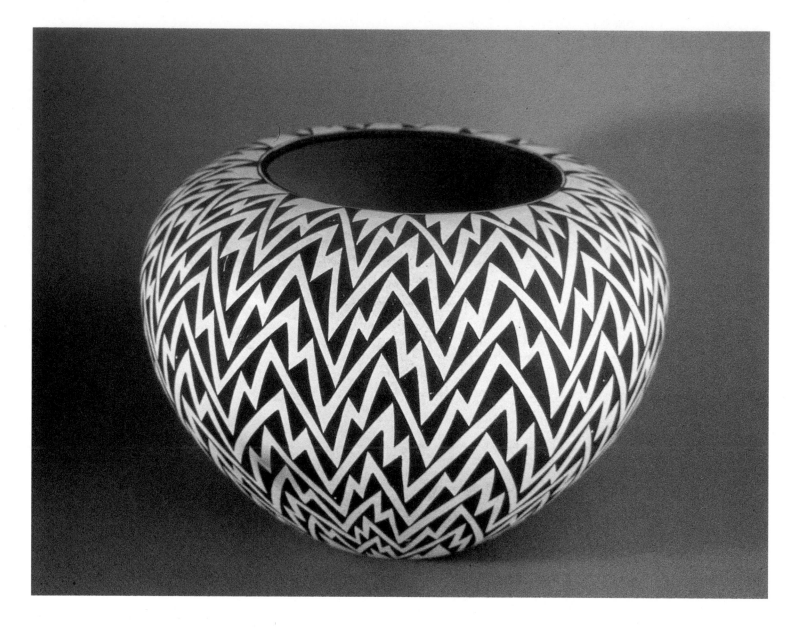

Lucy Martin Lewis (opposite) Bowl, 1910–20. Black-on-white; 6 × 11¾ in. dia. School of American Research, Santa Fe, New Mexico. Photograph by Craig Smith

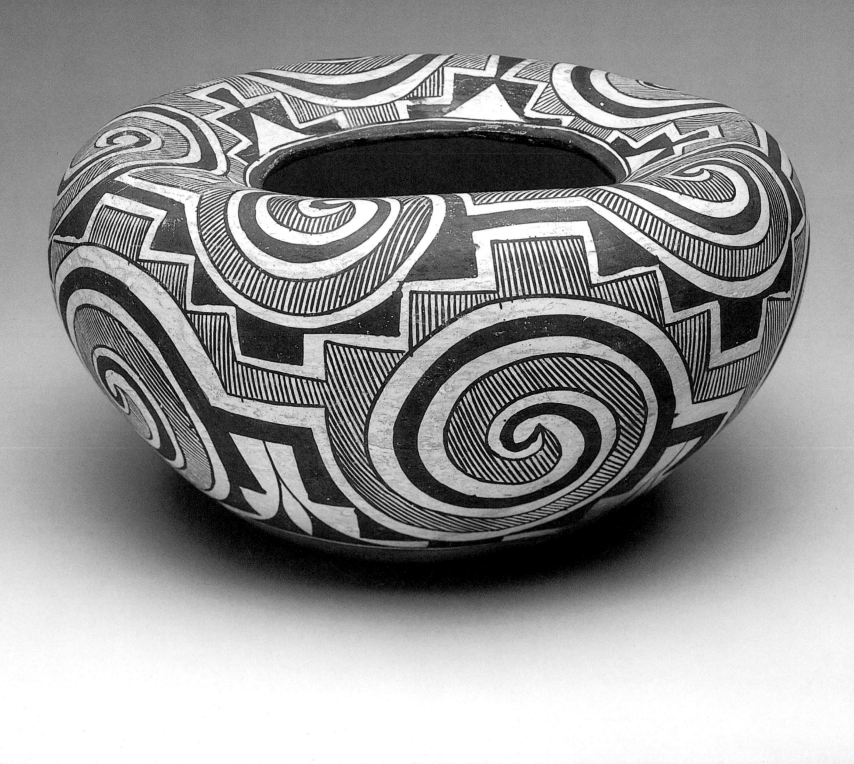

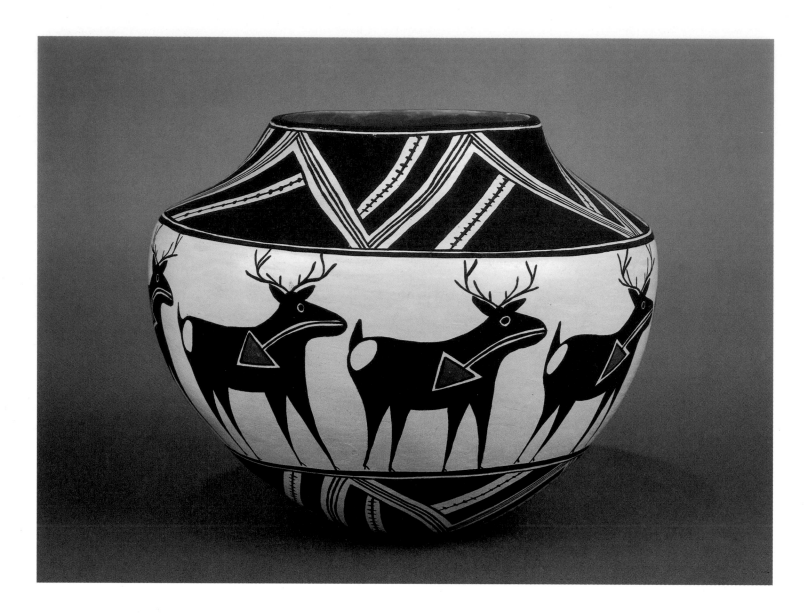

Lucy Martin Lewis Jar with heart-line deer design, 1986.
Polychrome; 7⅝ × 9⅜ in. dia. Collection of Dr. and Mrs.
Linus Pauling, Jr. Photograph by Shuzo Uemoto, staff
photographer of the Honolulu Academy of Arts

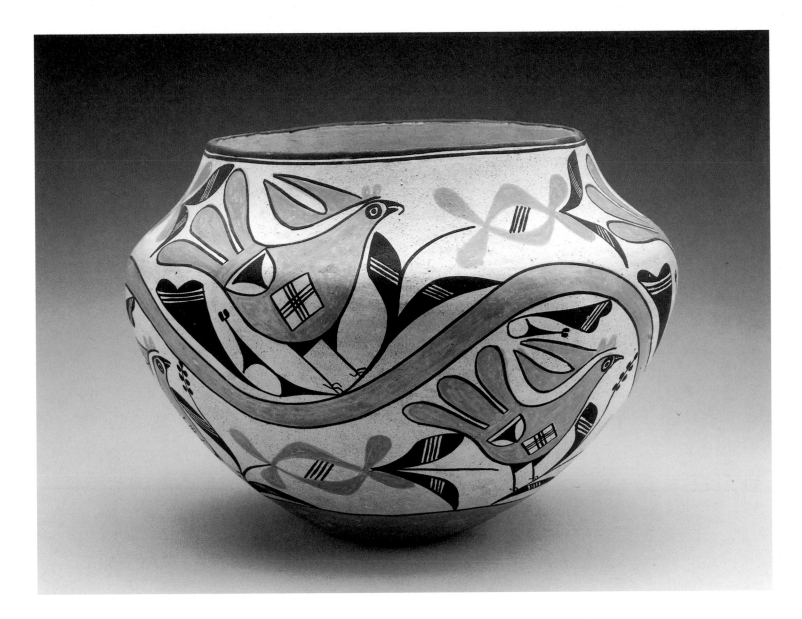

Lucy Martin Lewis Jar with parrot design, 1968. Polychrome;
7½ × 10 in. dia. Collection of Lucille and Marshall Miller.
Photograph by Tim Thayer

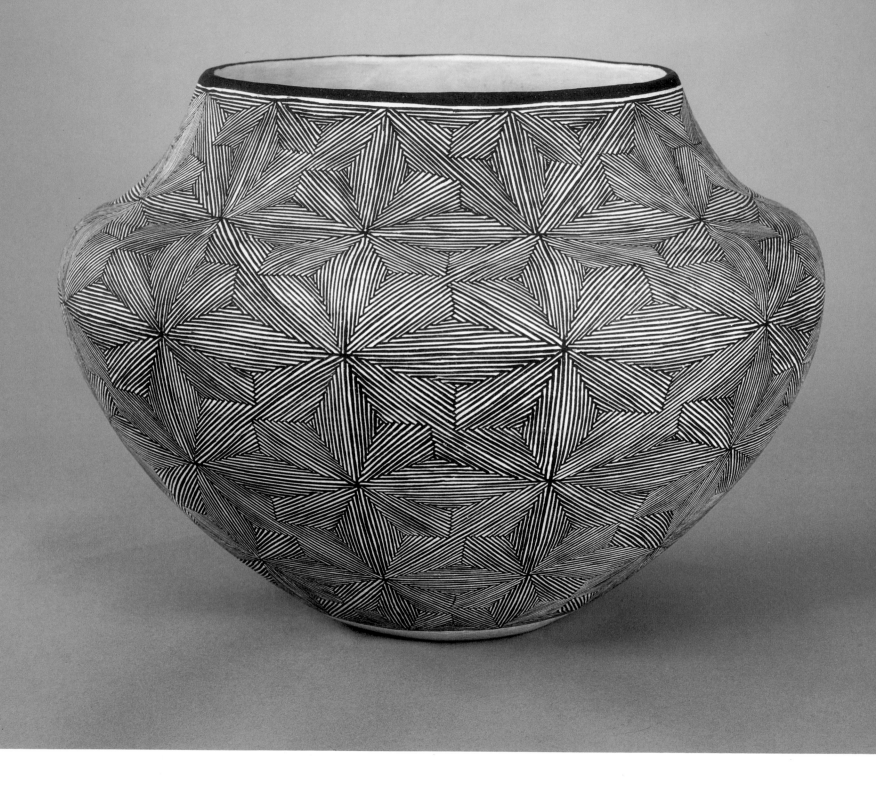

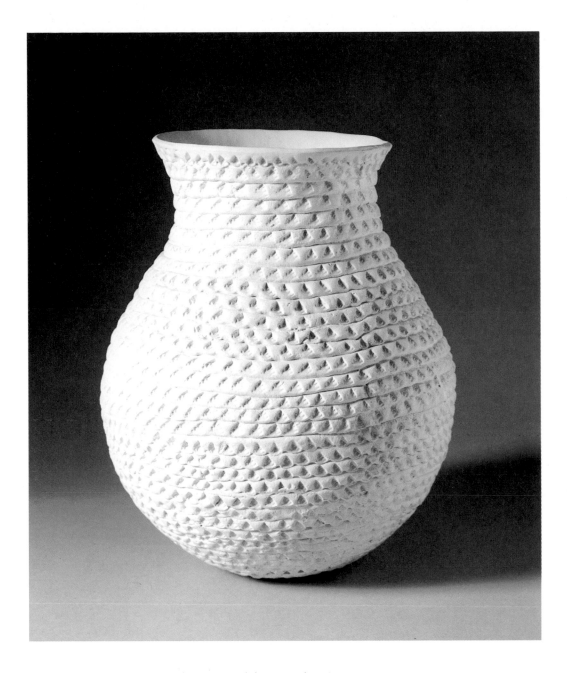

Lucy Martin Lewis Vase with corrugated design, n.d. 10¾ × 9 in. dia. Collection of J. Peter and Nancy Clark. Photograph by Rob Orr

Lucy Martin Lewis (opposite) Jar with fine-line design, 1983. Black-on-white; 9½ × 12 in. dia. Collection of the National Museum of Women in the Arts. Gift of Wallace and Wilhelmina Holladay. Photograph by Lee Stalsworth

Margaret Tafoya

Born at Santa Clara Pueblo around 1904, Margaret Tafoya created pottery that was incredible in its size, form, and degree of perfection. Instead of painting her work, she conceived of a direct carving method for decorating redware and blackware. Many now-famous potters, including family members, have acknowledged this still-practicing potter as their most important mentor.

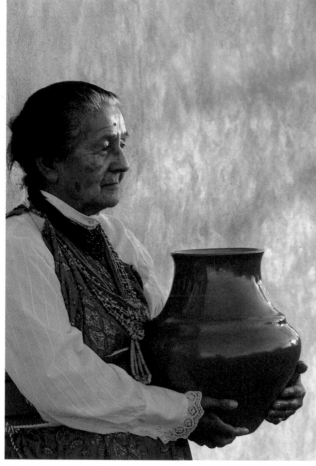

Photograph by Susan Peterson

The daughter of a potter named Sara Fina and her husband, Geronimo, Margaret became one of the most famous of all potters and spawned a great dynasty in American Indian ceramics. Sara Fina was an illustrious potter who signed most of her work. Both mother and daughter were extraordinarily important to the development of the art of the simple, plain black pottery that has been made in this pueblo for generations.

"Margaret was really innovative," says her granddaughter Nancy Youngblood Lugo. "Potters of her generation didn't know that they were artists in the beginning. They just did what they did; it was part of life."

Margaret remembers working in clay from the time she was a child, influenced of course by her mother but also by her aunt, Santana, and her oldest sister, Tomasita. Because Margaret was in primary school at the pueblo, she could be at home and near the clayworkers. Later she attended Santa Fe Indian School as a boarder, so she had only summers to work with her mother. After the tragic death of Tomasita during the 1918 flu epidemic, Margaret retired from school and worked with Sara Fina in pottery. In 1924 she married Alcario Tafoya from the same pueblo. They lived with Margaret's parents and began to make pottery together.

In the neighboring pueblo of San Ildefonso, Maria Martinez and her husband, Julian, were already well known; Maria as a potter and Julian as a painter. Their oldest son, Adam, married Santana Roybal in 1926; the couple lived with Adam's

parents; and Santana proceeded to learn to paint decorations on pottery from Julian. In those days the Tafoya family and the Martinez family were friends, according to what Maria told me, and visited frequently. Margaret's husband, Alcario, seems not to have signed the pottery with her, but he was a partner in the various pottery processes all along.

It was not Sara Fina's or Margaret's way to seek public recognition. Pueblo tradition taught them to be neither seen nor heard, which is one reason for Sara Fina's relative obscurity. Margaret, in spite of herself—perhaps due in part to her prolific skill and in part to the artistic fame of some of her children, grandchildren, nieces, and nephews—became famous and sought after.

Margaret and Alcario, with some of their family, performed Indian dances at the Royal Gorge resort in Colorado for ten summers beginning in 1952, yet they did not demonstrate pottery making. It is of interest to note that Nampeyo demonstrated pottery at the Grand Canyon for the Fred Harvey Company, and Maria Martinez, Lucy Martin Lewis, Blue Corn, and Juan Quezada and their families went to the University of Southern California's ISOMATA campus, in Idyllwild, California, for a number of summers. It is very rare that Indians and Anglos have the chance to learn from each other in an intimate situation such as these encounters provided.

Margaret is known for her extraordinarily large storage jars that were like her mother's—tall ovate forms and rounder shapes with broad shoulders rising from narrow bases. Margaret has retained the distinction of making the largest and most beautiful jars of any woman in the Southwest, besides Maria Martinez and perhaps Margaret's own daughter Lu Ann.

Sara Fina began the family's use of the imprint of the bear paw, a symbol that historically had been pressed into wet clay pots at Santa Clara. Generally, the indented outline of a bear paw is the only embellishment on the burnished surface of a Tafoya vase. For a short time, Margaret made polychrome pottery and painted designs on red and black wares, a style that had been developed at San Ildefonso, Santa Clara, and other pueblos. After this experimental period, she returned to her own style.

The work of both Sara Fina and her daughter is acclaimed for the elegance of their plain, highly polished veneers on simple graceful forms. Margaret also carves deeply into the shiny clay facade, leaving a relief design of polished clay against the matte, unpolished clay. She fires in the oxidizing open fire for an iron red color or in the manure-smothered fire for the carbon-depositioned black. Depending on the chemistry of the slip coating and the carbon or oxygen content of the firing atmosphere, the red color can vary from orange to magenta to bronze.

The rounded bases of Margaret's large jars are worked in big *pukis*. She can

make only one truly huge jar in a year, because of the months of drying time and weeks of polishing time, following the months of clay gathering, mixing, and fabricating, to say nothing of the difficulty and risk of outdoor firing. Margaret is amazingly fast and skillful in her technique, but large claywork just can't be accomplished hurriedly.

Margaret told me some years ago that all her materials come from her own reservation: "It's important to come from here." She uses two different clay slips to coat vessels for polishing, depending on whether the pot will be fired for red or for black color. This art of prospecting and using natural materials, where the result cannot be seen until after the final firing, is mind-boggling to say the least. It is difficult for artists who use refined and tested store-bought products to comprehend this attention to the task of finding the same source of organic substances generation after generation, or of developing substitutes when nature's supply is exhausted.

To this day, Margaret's progeny adhere to the belief in natural materials and outdoor firing. From 1925 to 1947 Margaret had eight children—Virginia Ebelacker, Lee Tafoya, Jennie Trammel, Mela Youngblood (deceased), Toni Roller, Lu Ann Tafoya, Mary Archuleta, and Shirley Tafoya—all well-known potters. There are many grandchildren, great-grandchildren, and other relatives who are also potters, some of them famous.

Numerous honors have been showered on Margaret as well as various members of her family. She has been awarded prizes at the Santa Fe Indian Market since she entered. She was given one-person exhibitions at the Wheelwright Museum, Santa Fe, the Denver Museum of Natural History, the Colorado Springs Fine Art Center, and the Taylor Museum. In 1984 the National Endowment for the Arts elected her Folk Artist of the Year. In 1985 the governor of New Mexico conferred on Margaret the state's highest honor for Outstanding Achievement in the Arts, which had been previously awarded to Maria Martinez and Lucy Martin Lewis. At the ceremony in the capitol rotunda, Margaret said, in keeping with her humble manner, "I never thought I'd be here. Thank you very much."

Margaret Tafoya (opposite) Wedding vase with bear-paw imprint, 1973. Blackware; 12½ × 8½ in. dia. Collection of Theodore and Louann Van Zelst. Photograph by Rob Orr

Margaret Tafoya Wedding vase with carved design, late 1940s.
 Redware; 15 × 9½ in. dia. Collection of Jim Jennings.
 Photograph by Lee Stalsworth

Margaret Tafoya (opposite) Canteen with bear-paw imprint,
 1980s. Redware; 9½ × 9½ in. dia. Collection of Jim
 Jennings. Photograph by Lee Stalsworth

Margaret Tafoya Jar with bear-paw imprint, 1960s. Blackware;
29 × 25½ in. dia. Collection of Lucille and Marshall Miller.
Photograph by Tim Thayer

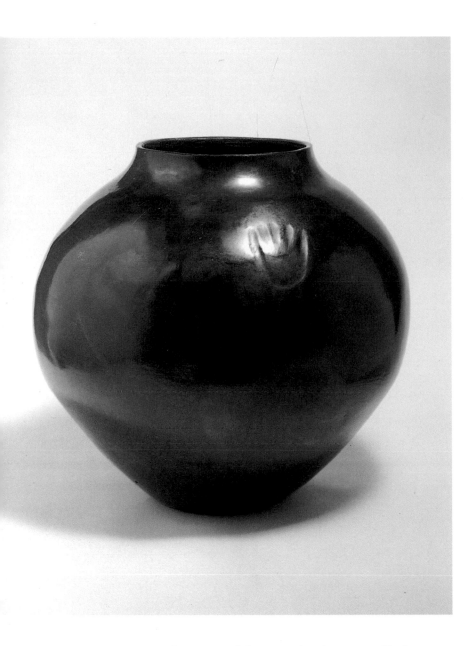

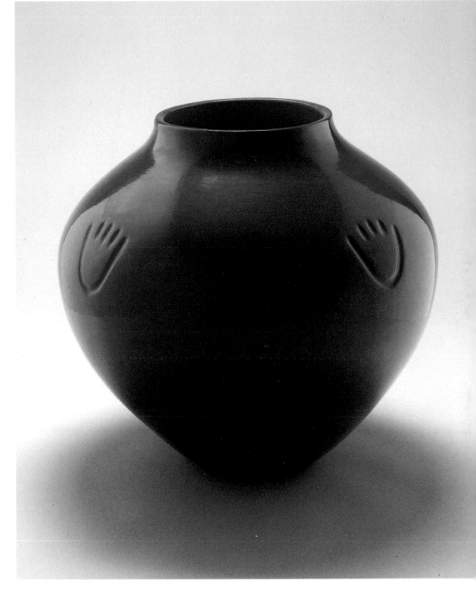

Margaret Tafoya Jar with bear-paw imprint, 1930s. Blackware; 19 × 21 in. dia. Collection of Marjorie and Charles Benton. Photograph by Rob Orr

Margaret Tafoya Jar with bear-paw imprint, 1978. Redware; 21 × 19 in. dia. Collection of Lucille and Marshall Miller. Photograph by Tim Thayer

Helen Cordero

Helen Cordero, born around 1915, took American Indian pottery in a new sculptural direction. Drawing upon the heritage of her Cochiti Pueblo home, she transformed traditional pottery figures into the distinctive clay "Storytellers" that today are copied by the thousands.

For at least two thousand years in North and South America, prehistoric clayworkers made human effigy figures, animal figures, pitchers in the shape of animals, duck canteens, and bird pots. These early figures abound in Indian and natural history museums in the United States today. Without any written record of the cultures from which these objects came, scholars surmise that some of the figures were probably toys, many were likely used in ceremonial rituals, and some may have been made just for fun.

Since the Spanish conquest of the Southwest in the 1500s, Cochiti Pueblo potters in New Mexico have produced a remarkable variety of clay figures, in addition to making pots. For several centuries after the conquest, Cochiti developed a distinctive style that expanded the portfolio of ancient sculptures to include what we might call caricatures of the persons with whom they came in contact in everyday life. Potters modeled figures such as cowboys, priests, and tourists. Over the years, Indians have been and continue to be influenced by these stylized historical-period figurines, which have been handed down in their families or used, perhaps, in pueblo ceremonies.

Historical-figure making stopped in the 1700s and was almost accidentally revived by an Indian woman who enjoyed working with clay but disliked making pots. Helen Cordero was an astonishing forty-nine years old when she created her first Storyteller figure with children in 1964, when Santa Fe–based folk art collector and internationally known designer Alexander Girard commissioned the piece— Helen's first large figure sculpture. Today that particular Storyteller doll—as this type of image came to be called with universal affection—with five children attached to the figure, resides in the Alexander Girard Wing at the Museum of International Folk Art in Santa Fe.

Many other potters have followed in Helen's footsteps. She was so famous that she opened a new direction for Indian pottery, and still the market never seems to be saturated with Storytellers. The fame that Helen generated eventually with her own Storyteller figures would make one think that she had been making them all

her life. Not true. As a young woman she made pottery in the traditional pueblo fashion, but was never satisfied with her coil-built vessels, which she felt she never got sufficiently symmetrical. Eventually one of her relatives suggested she try pinching out clay animals and people, which in fact pleased Helen more than the pots. She made hundreds of little sculptures.

It was these "small people" that Girard bought from Helen at first. Then he encouraged her to make more sizable hollow-built figures. Helen had made small "singing-mother" images that Girard liked, and he asked her to make a large figure with children. This sparked Helen's memory of her grandfather, Santiago Quintana, who was a gifted raconteur, always surrounded by children. So Helen made the first Storyteller doll as a man, remembering her grandfather, and attached the children in clay to various parts of his body. "His eyes are closed because he's thinking; his mouth is open because he's singing," Helen explained.

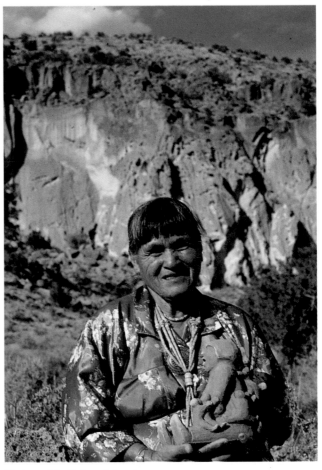

Photograph by Barbara Babcock

In addition to the popular Storytellers, Helen made images of singing-mother figures, nativities, drummers, Hopi maidens, turtles with children on their backs, and the rare Nightcriers. She improvised a "children's hour" with a male Storyteller and individual figures of children sitting on the floor around him. Her work caused an unprecedented pottery revival in her own and other pueblos, as the public clamored for Indian figurines. Today entire galleries are dedicated to Indian Storyteller figures. The demeanor of Helen's characters is serious, and they were fabricated in the traditional pueblo manner and finished in the outdoor bonfire. Subsequently, many potters began to debase the Storytellers and other figures by making them appear cute and frivolous. This was never Helen Cordero's way.

She shaped the hollow figures by pinching out the body parts—head, arms, torso, legs, and so forth—sticking them together with liquid clay slip, and refining them with gourds and wooden tools. When the figures dried, after about three weeks, they were sanded and a white clay slip was applied and lightly polished. Then features were painted with black Rocky Mountain bee plant residue and

colored clays. This traditional Cochiti slip, like that of Santo Domingo, will patina with age into yellowish white, and sometimes it will crack or spall. The bonfiring took place outside, one figure at a time. Helen sculpted her Storyteller dolls as both men and women, but said "real" storytellers are always men: "At home no women are storytellers."

Unfortunately, like vessel makers at some pueblos, Storyteller makers at Cochiti are using commercial clay and commercially prepared ceramic pigments, because these make the clayworking easier than working with natural materials that are full of impurities. Some Indian potters don't even bother with fired-on mineral pigments but use ordinary nonpermanent paints for the decorations. They also fire in gas or electric kilns. These less expensive commercially produced figurines make it difficult for Indian artists who are devoted to sustaining the customs and traditions of Indian clayworking.

In 1976 the Heard Museum in Phoenix, Arizona, honored Helen with the first one-person museum exhibition ever devoted to clay figurines by an Indian artist. At the Santa Fe Indian Market her booth was crowded before sunrise with collectors waiting to buy. At Cochiti she was always deluged with orders. Her Storytellers were featured in many magazines and on the covers of some, and her own story of how she came to make the dolls was frequently told.

Helen's personality was at once naive, genuine, and generous. One of her good Anglo friends, Ruth Forrest of Venice, California, tells of Helen's calling a limousine to go shopping in Albuquerque when she had made money from a figure. She enjoyed fame—when she discovered that she was famous. Despite several real tragedies in her lifetime, she continued to create dolls to keep up her spirits. Helen Cordero died in 1994.

Helen Cordero (opposite) Drummer, 1969. Polychrome; 11¼ × 4¼ × 8 in. Girard Foundation Collection, Museum of International Folk Art, a unit of the Museum of New Mexico. Photograph by Craig Smith

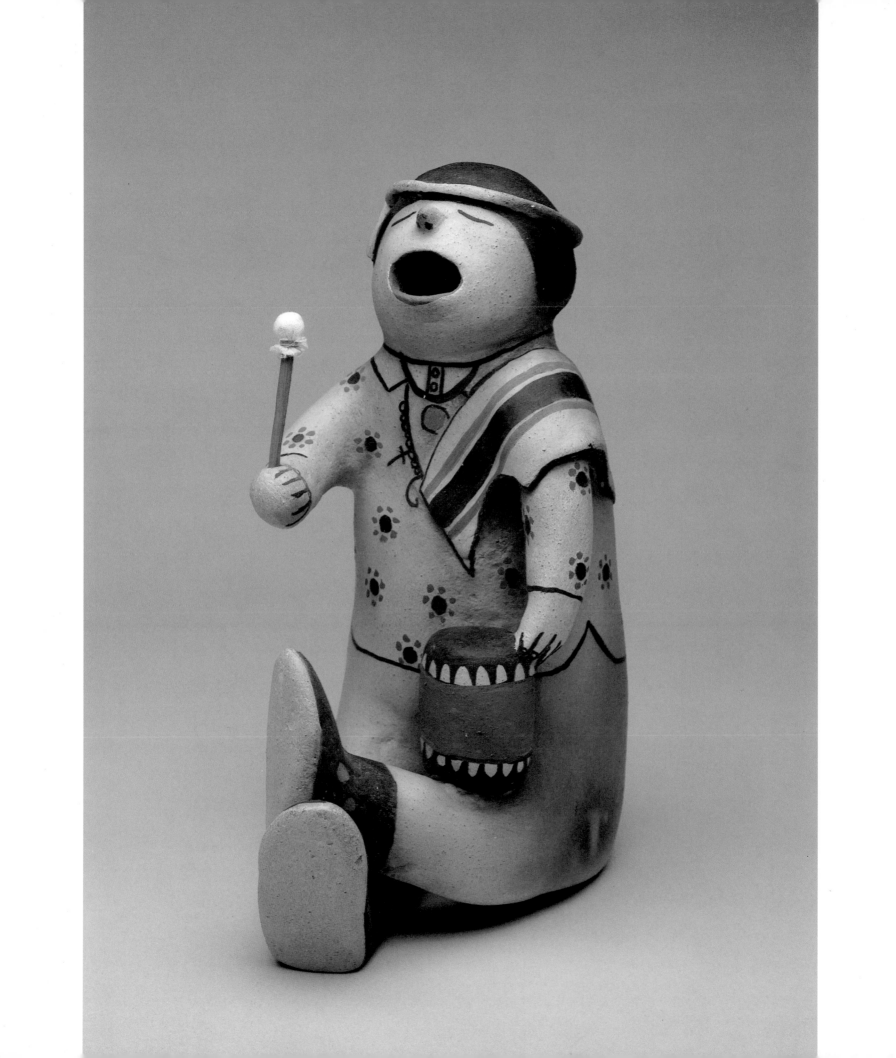

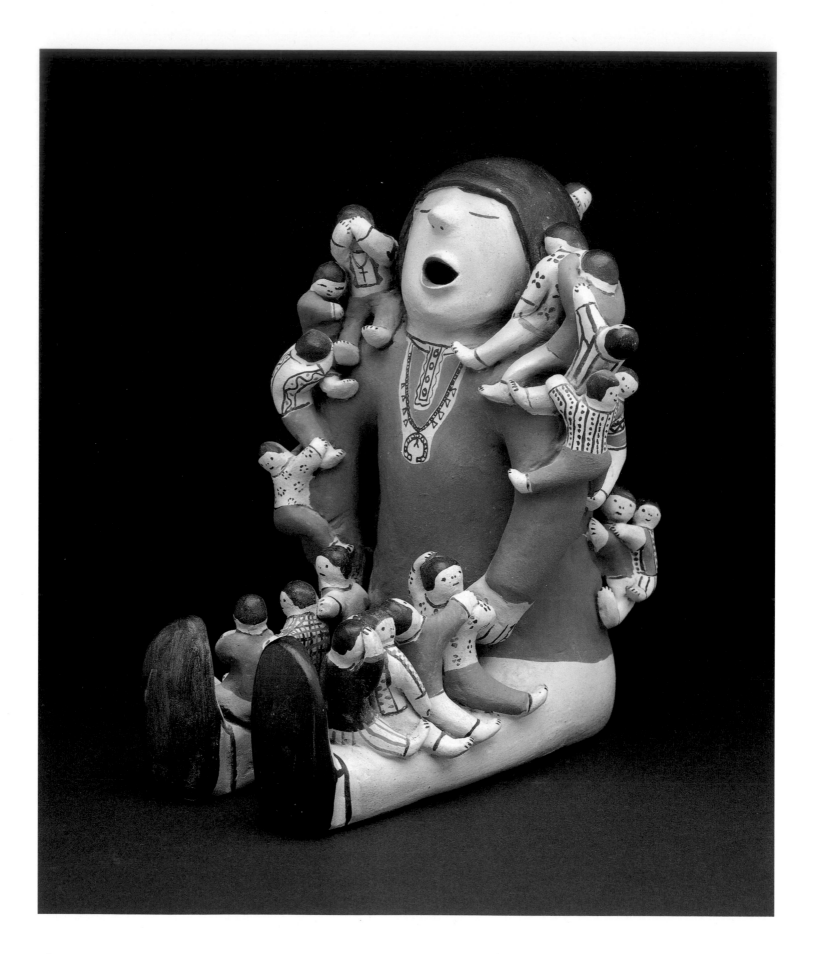

Helen Cordero (opposite) Storyteller, 1972. Polychrome; 12 × 9 × 10 in. Collection of Dennis and Janis Lyon. Photograph by Craig Smith

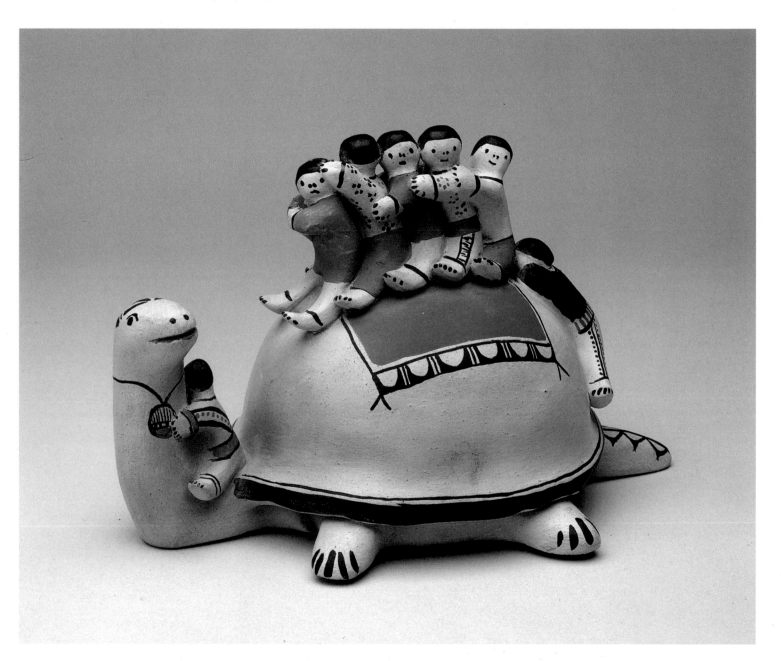

Helen Cordero Turtle with children, 1979. Polychrome; 7⅝ × 10¼ × 7½ in. On loan from the Museum of International Folk Art, a unit of the Museum of New Mexico, Santa Fe. Purchased with the aid of funds from the National Endowment for the Arts and the International Folk Art Foundation. Photograph by Craig Smith

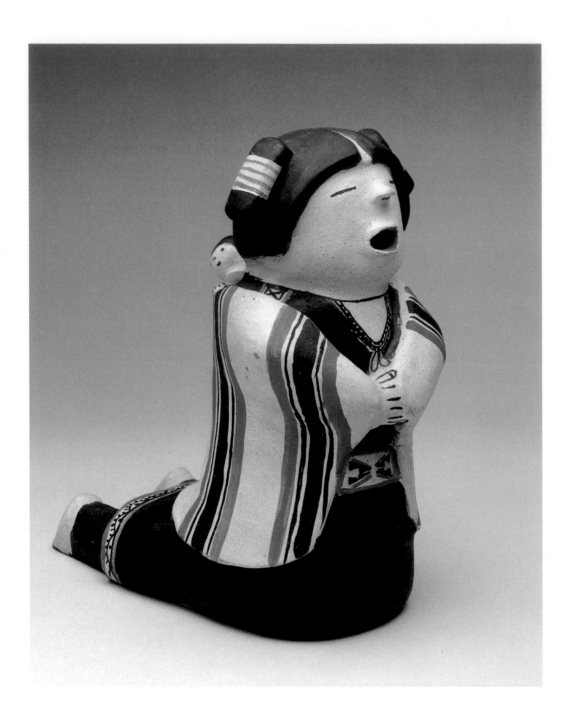

Helen Cordero Hopi maiden, n.d. Polychrome; 9⅝ × 8⅝ × 4½ in.
School of American Research, Santa Fe, New Mexico.
Photograph by Craig Smith

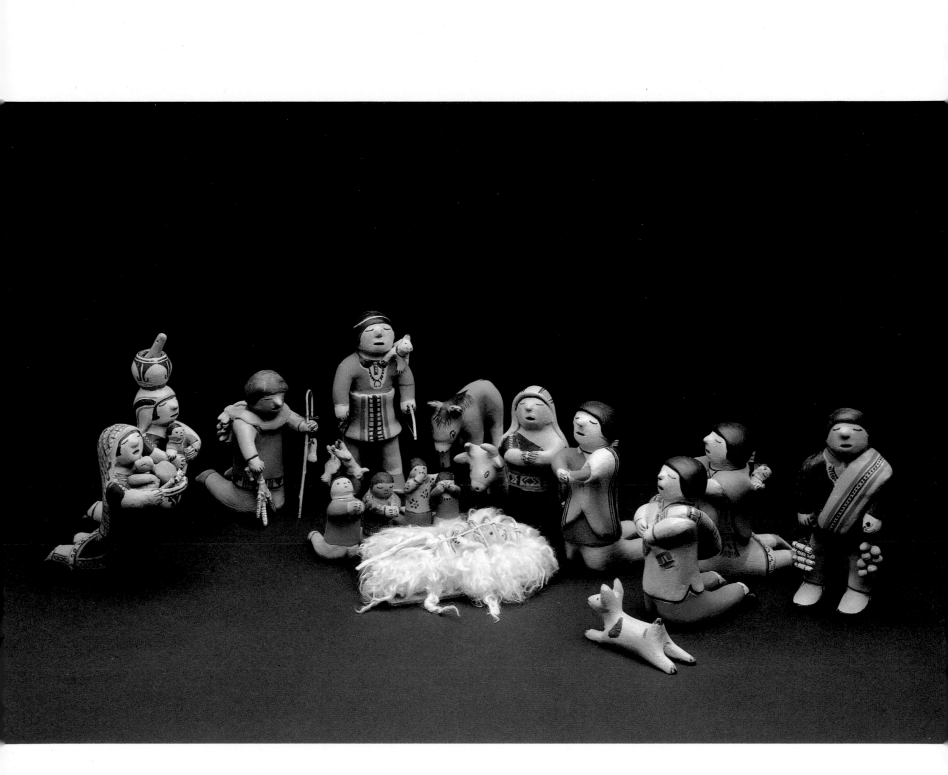

Helen Cordero Creche, 1972. Polychrome; creche,
5½ × 6 × 5½ in.; figures range from 2½ × 2 in. to
7¼ × 4 in. Collection of Dennis and Janis Lyon.
Photograph by Craig Smith

Blue Corn

Blue Corn, a San Ildefonso potter, was born around 1920. Continually prospecting and experimenting with clays of varying hues, she introduced unusual new colors to the traditional American Indian palette. Her elevated sense of design, her perfectionism, and her exquisite craftsmanship give her work an exciting, distinctive look.

Until she was seventeen, Blue Corn lived on the same pueblo as one of the most famous American Indian potters, Maria Martinez. Younger than Maria by perhaps forty years, she tried not to be influenced by the famous matriarch, and "went her own way." She strived to develop individual techniques.

Blue Corn said she never watched Maria work, and that when they talked together, it was not about pottery. Blue Corn prospected her own clays in places other potters had not found, and gained fame and prestige for her many varieties of polychrome colors and for her fanciful designs abstracted from traditional ones she saw on pueblo pots in museums.

Blue Corn attended Indian school in Santa Fe until her parents died and she was sent to relatives in Southern California. At twenty she married Santiago Calabaza, a silversmith from Santo Domingo Pueblo, and they settled at San Ildefonso, where ten children were born. During these years, Blue Corn, who was given this name by Maria's sister at the naming ceremony, honed her pottery technique to near perfection.

Her first polychrome wares were what she called "eggshell" color, a delicate beige, on which she painted tans, yellows, greens, and blacks. These pigments may have been various clays mixed with metallic oxides, or, perhaps, boiled plant residue such as the ones other Indians have used to dye yarns. In any case, the natural sources for her marvelous colors were her secret.

In about 1976, when Maria and her family had been coming to the University of Southern California's summer campus (called ISOMATA, at Idyllwild, California) for about eight years, Maria's health was failing, and she could not return. Maria had taught both polychrome and black-on-black each summer during the four week-long sessions for our students. I decided to invite two women to replace Maria: Lucy Martin Lewis, who was the foremost person in Acoma polychrome and black-on-white pottery, and Blue Corn, who did both black-on-black and her own polychrome.

At ISOMATA, hundreds of students from this country and around the world learned about Indian pottery and Indian people. My university summer program continued with these women until the school underwent a change in focus in 1985.

Photograph by Virginia Garner

Blue Corn's children helped her with the firing and sometimes with the painting of her pots. She told me that she always tried to make duplicate pieces of her most important wares in case one would crack or blow up in the bonfire. Imagine doubling the already difficult task of making one pot!

Very ill now, Blue Corn's own time as a potter is over. Her legacy is in her children and in the many brilliantly colored polychromes and the stunning black-on-black pots—each with its own phenomenally well executed painted designs—that remain in collections all over the world.

Her contribution to her own pueblo and to Indian pottery art in general, to my mind, has been a release of the spirit of freedom and the marvelous variety of her pieces. She has shown the way for others to experiment with color and pattern. Her achievement in attaining perfection in shape and decoration and the excitement of her explorations will continue to be an inspiration to others.

Blue Corn Plate with turtle design, 1970–77. Polychrome; 2½ × 14 in. dia. The Heard Museum, Phoenix, Arizona. Photograph by Craig Smith

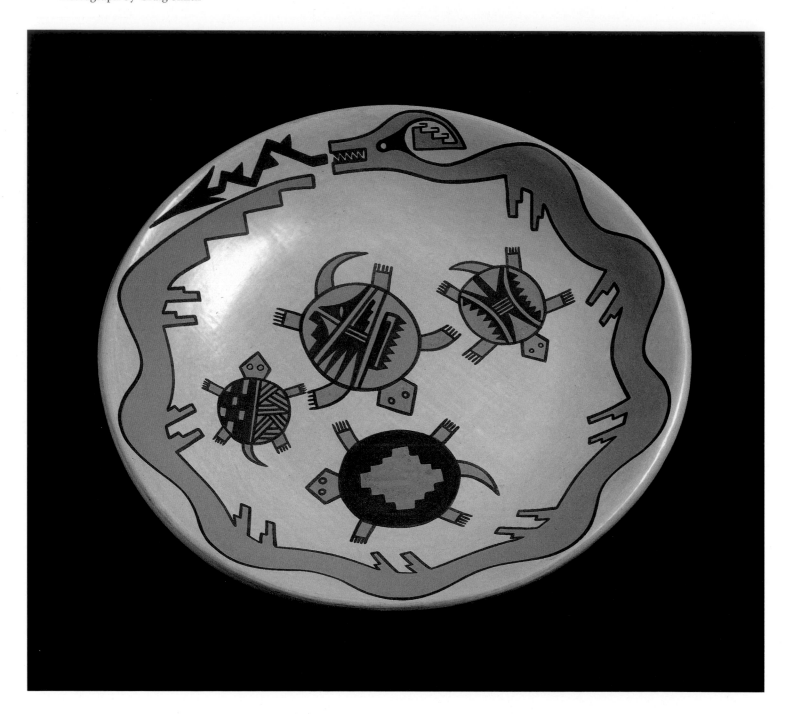

Blue Corn (opposite) Jar, c. 1970. Polychrome; 6½ × 12½ in. dia. Collection of Marjorie and Charles Benton. Photograph by Rob Orr

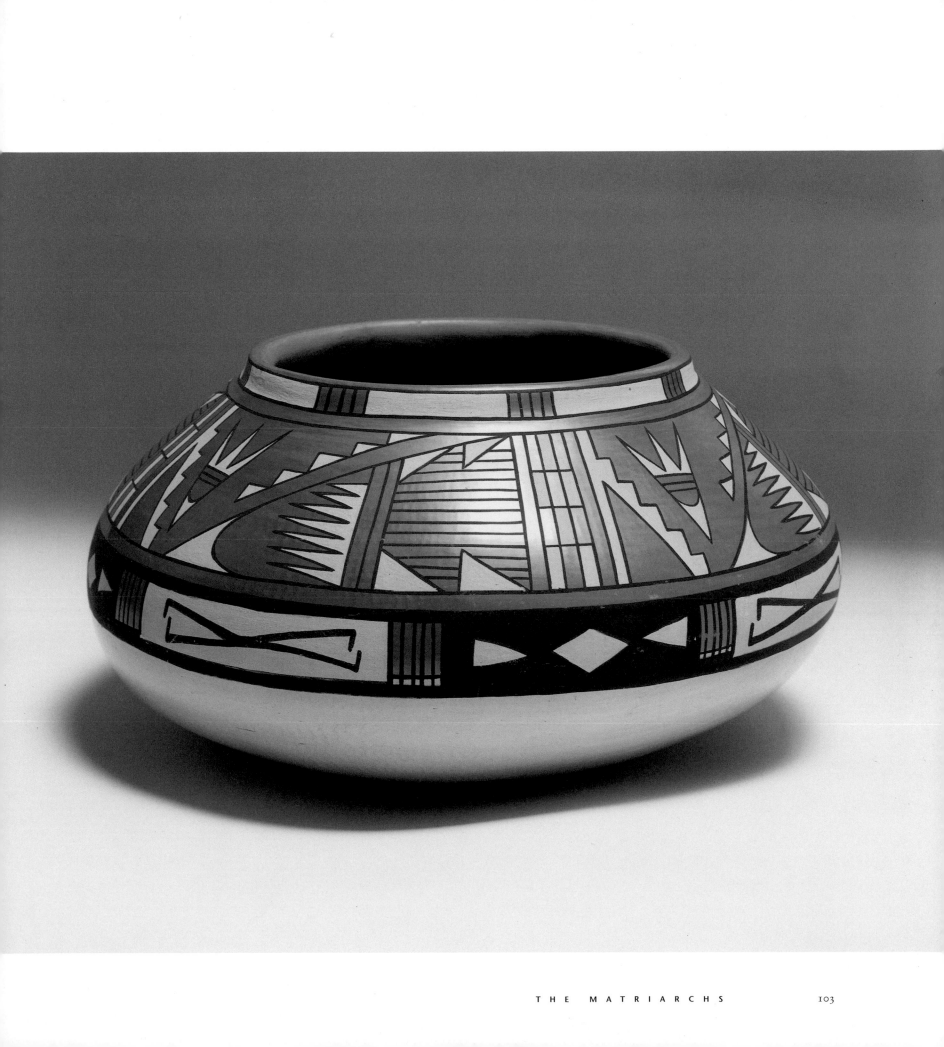

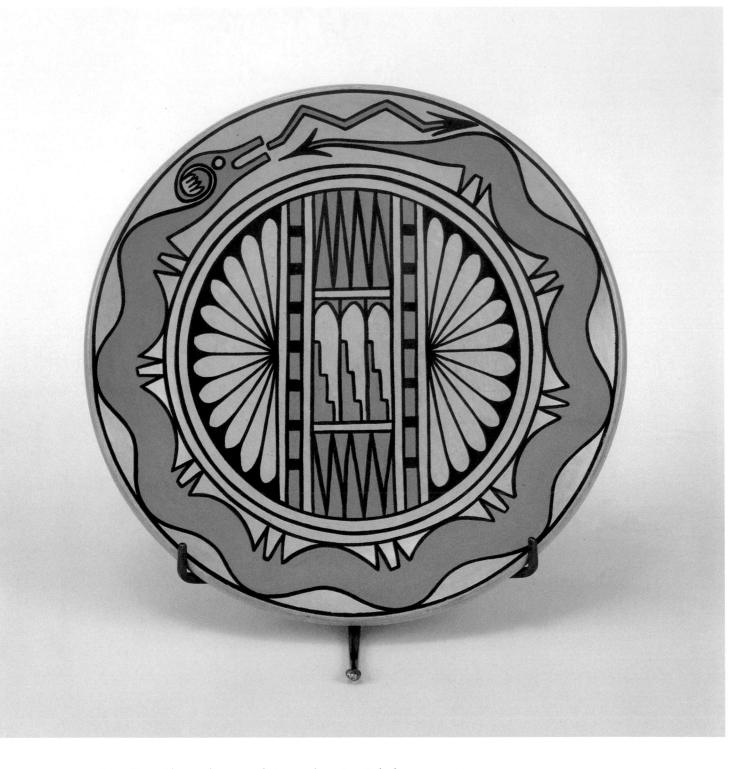

Blue Corn Plate with *avanyu* design, early 1980s. Polychrome;
11¼ in. dia. Collection of Jim Jennings. Photograph by
Lee Stalsworth

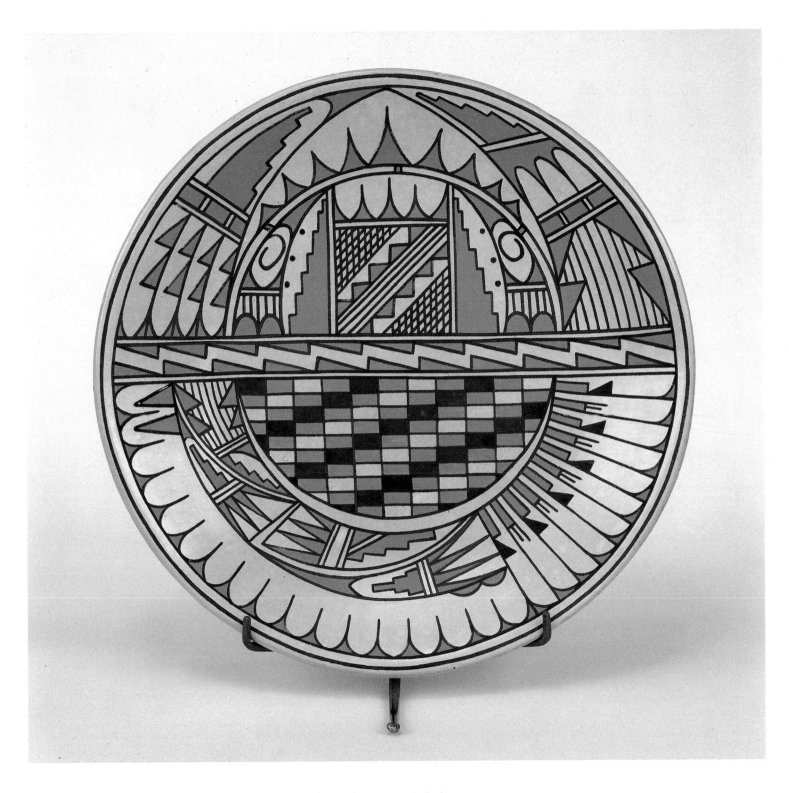

Blue Corn Plate with geometric design, late 1970s. Polychrome; 14½ in. dia. Collection of Jim Jennings. Photograph by Lee Stalsworth

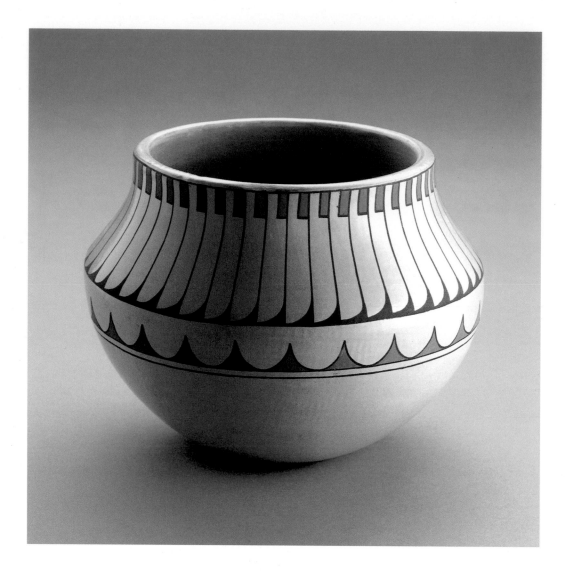

Blue Corn Jar with feather design, 1978. Polychrome; 6½ × 9 in.
dia. Collection of Ruth and Robert Vogele. Photograph by
Greg Gent

Blue Corn (opposite) Bowl, 1985. Black-on-black; 8 × 8¼ in. dia.
Collection of Marshall and Lucille Miller. Photograph by
Tim Thayer

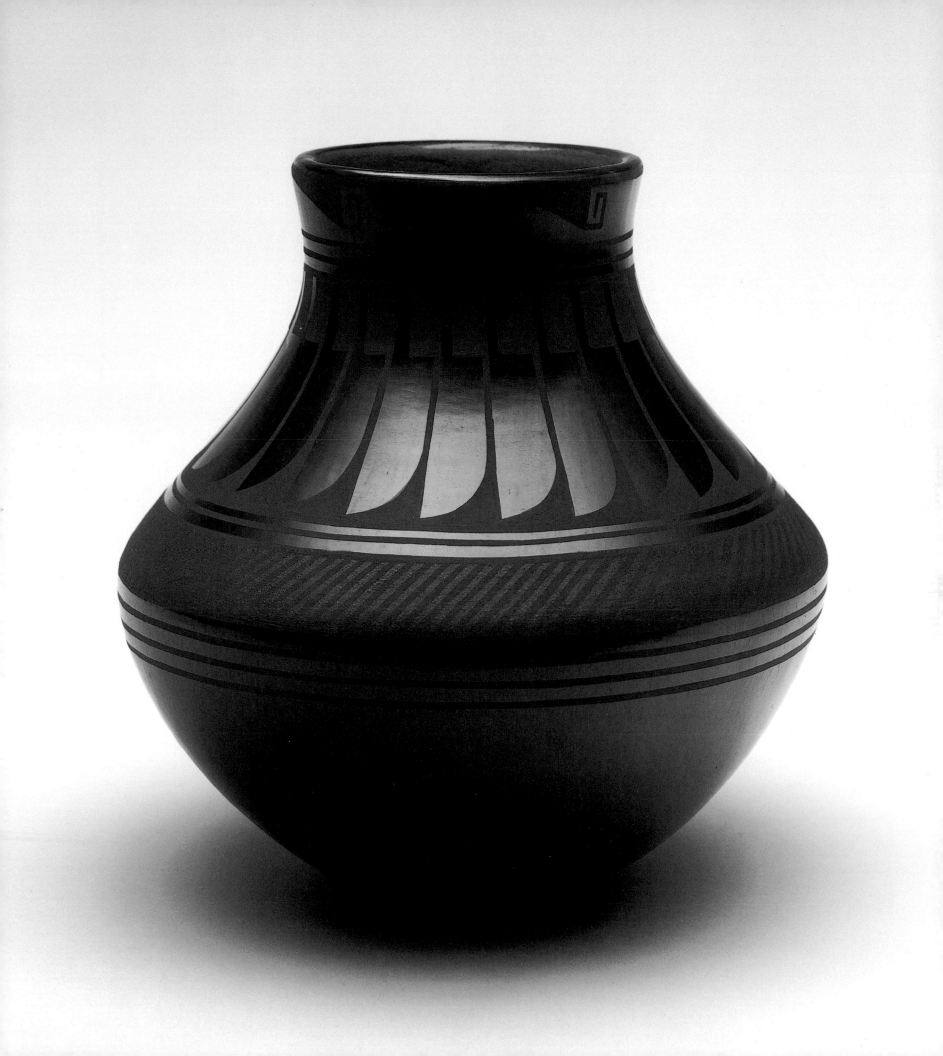

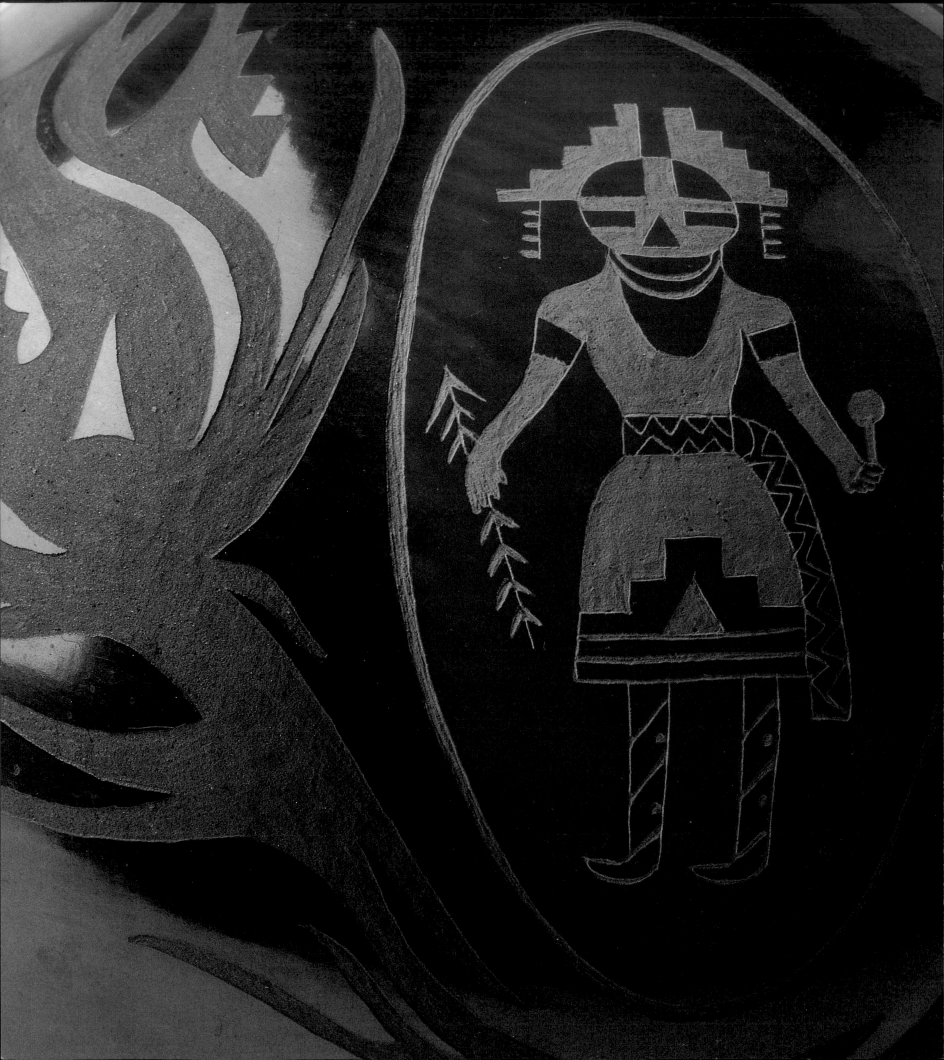

The Matrilineal Line

Nampeyo of Hano
Maria Martinez
Lucy Martin Lewis
Margaret Tafoya
Helen Cordero
Blue Corn

Fannie Nampeyo

Dextra Nampeyo

Santana Martinez

Barbara Gonzales

The Lewis Women

Emma Lewis Mitchell

Dolores Lewis Garcia

Carmel Lewis Haskaya

Lu Ann Tafoya

Grace Medicine Flower

Nancy Youngblood Lugo

Elizabeth "Buffy" Cordero-Suina

Diane Calabaza-Jenkins

Many of the best-known American Indian potters in the United States are relatives of the matriarchs: daughters and daughters-in-law, nieces and cousins, granddaughters and great-granddaughters. Like many other Indian women they have risen to the challenge of maintaining their ancestral heritage.

Drawing upon the market for good American Indian art, the increasing interest of serious collectors, and the acquisition of fine Indian pottery by major museums and galleries, potters from the matrilineal line have helped keep traditional work alive. Because they were taught directly by the best craftswomen, they have worked confidently and with great technical competence. They have resisted the temptation to replace authentic, traditional techniques with quicker and easier methods—the shortcuts made possible by modern technology, such as kiln-firing and commercial pigments.

Following in the artistic footsteps of the matriarchs has made many potters of this generation feel overshadowed. Still, some craftswomen have found that the struggle for recognition brings a deeper understanding of the traditions and aesthetic principles they inherited. They were committed to the styles and methods of their mentors—but as their expertise grew, their individual ingenuity started to shine through. Gradually, a few of them became almost as famous as the matriarchs.

The descendants featured in this exhibition are representative of many in other American Indian families; they are all devoted to carrying on the heritage of their ancestors. Quietly but with determination, these new generations of women have taken responsibility for maintaining the high standards of tradition.

Grace Medicine Flower (detail, opposite) Jar with incised red design, 1972. Red and blackware; 9 × 8 in. dia. Collection of Dennis and Janis Lyon. Photograph by Craig Smith

Fannie Nampeyo

Nampeyo of Hano's youngest child, Fannie Nampeyo, was born around 1904 on her mother's Hopi pueblo in Arizona. Her work reveals the high quality and artistic assurance to be expected of an artist raised by the craft's original matriarch. The smooth, golden surfaces of Fannie's pots are ideal for her elegant painting.

I visited Fannie at Polacca on First Mesa with Fred Kabotie, the famous Hopi painter who convinced the United States Bureau of Indian Affairs to allow him to develop and direct the Hopi Indian Arts and Crafts Guild at Second Mesa. The guild is a unique place where young men of the pueblo can learn silversmithing, and young women can learn selling. Fred took me to see Fannie when I was curating an exhibition of her work for the American Contemporary Art Gallery in New York City in 1980.

"I helped my mother," Fannie told me, "and I helped my father, who polished. When mother's eyes were no good, I helped to paint. I made my own pottery when I was about twenty-five, before mother died."

Fannie made pottery by working the clay in a *puki* to form the round base, adding coils to continue the shape, using gourd tools to thin and refine, and smoothing the surface with water. Hopi clay is very fine grained, and Fannie added no ground shards or sand or volcanic ash for temper, which allows for the distinctively smooth surface that provides a delicate background for her painting. For black pigment Fannie ground hematite rock (black iron oxide) to powder on a stone metate and added the dried residue from boiling mustard plants for adhesive.

Clay prospected at Hopi has a uniquely variegated orange color after firing that makes the pueblo's pottery easily recognizable. Sometimes Hopi pottery is called "golden." The particular clay, although I have not chemically analyzed it, must contain small percentages of titanium or uranium, which burn yellow or orange, mixed with iron oxide, which fires buff to brick red colors depending on the amount incorporated into the clay. Fannie and most of the Hopi potters working today learned to polish the smooth clay to the high gloss that brings out the rich variation of tans to yellows to oranges to reds from the firing.

The day I was there Fannie was getting ready to do a firing. She was warming a group of small pots in the oven of her big woodstove. Outside she had constructed a wind shield made of old bedsprings and boards at the corner of a small building near the house. A layer of wood chips was prepared in a circle on the ground in the

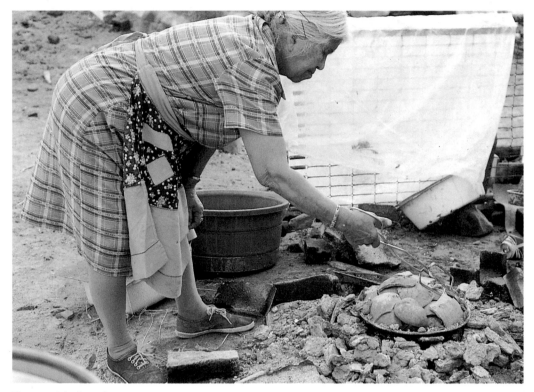

Photograph by Susan Peterson

lee of the shed. Fannie brought out the warm pots resting on old broken pot shards on a large metal tray. She placed the tray on top of the wood chips. Larger shards were laid over the pots for protection, and the whole bier was covered like an igloo with bits of squirrel and sheep dung for the fuel.

Fannie told me that the Hopi have lost most of their sheep over the years, so her family and others were firing with squirrel dung. "It just takes more of it, and it's hard to find," she said. Ignited by the wood, the little bits of dung smoldered about an hour. Fannie led us back into the house to talk, saying that the firing would take care of itself.

She spoke of her seven children, of which Elva, Tonita, Iris, and Thomas Polacca are well-known potters. She didn't know exactly how many grandchildren she had; "A lot," she said. All of her children have children and grandchildren who make pottery, and this is also true of the families of her deceased sisters. She said that everybody helped everybody, especially the ones who were not so well known who helped the more famous ones, and in this way she felt that they all carried on the family tradition. When Fannie was almost eighty years old, she decided to stop making big pots. She said it was too hard for her and that it took too long to make big pots: "Let the younger ones do that."

Fannie worked on three small ones a day, although not to completion. "But it takes many more days to do a large pot," she told me. She sold to people who found a way to her door, that was all, just on order—and only in summer, because by 1980 the winters had become too cold for her. With all the time needed for constructing, drying, scraping, smoothing, painting, and firing, she said that maybe she made thirty small pots in a year.

We went outside to see if the pots from the firing were ready. The dung had shrunk to ashy clods, and the pots were showing through. Fannie took a stick—the Indians call it a poking stick—to remove the pottery. Gingerly touching the hot pots one by one with her cotton apron she examined each. She remarked here and there with a smile or a grunt, or she pointed to the flourish of a brushstroke that she liked. She showed us the corn sign under her signature on a pot and explained, "We are the Corn Clan, that's how we are out here. Mother was Corn; we are Corn."

Fannie in her gingham dress standing alone on the vast desert mesa, with blue sky and white clouds at her back, did not really know how famous she was or what an impact her mother had had on the economy and prestige of this pueblo.

Fannie Nampeyo, the last of Nampeyo of Hano's children, died in 1987.

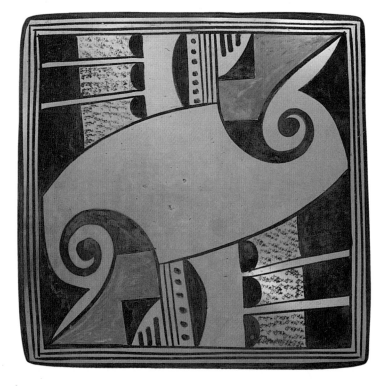 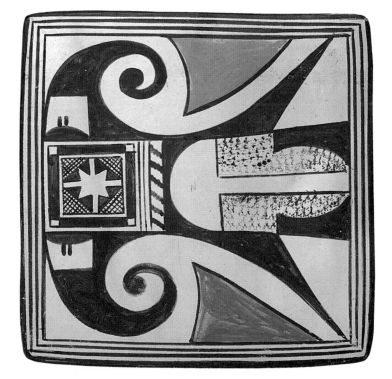

Fannie Nampeyo (opposite, above) Tiles, 1943. Polychrome; 6 × 6 in. each. Southwest Museum, Los Angeles, California. Photographs by Craig Smith

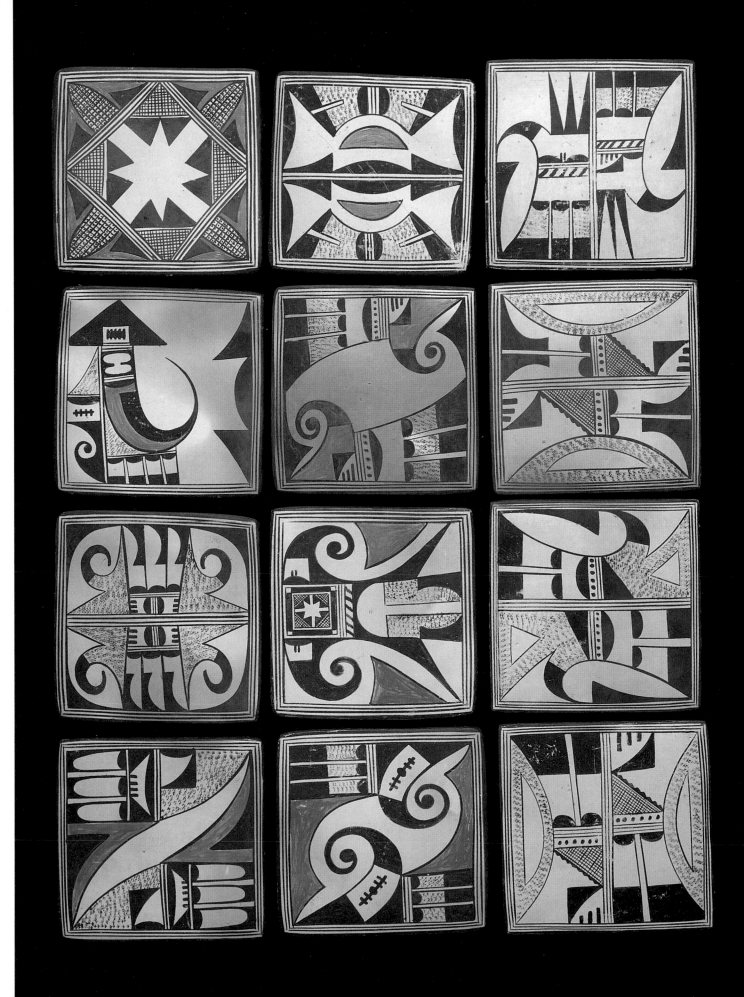

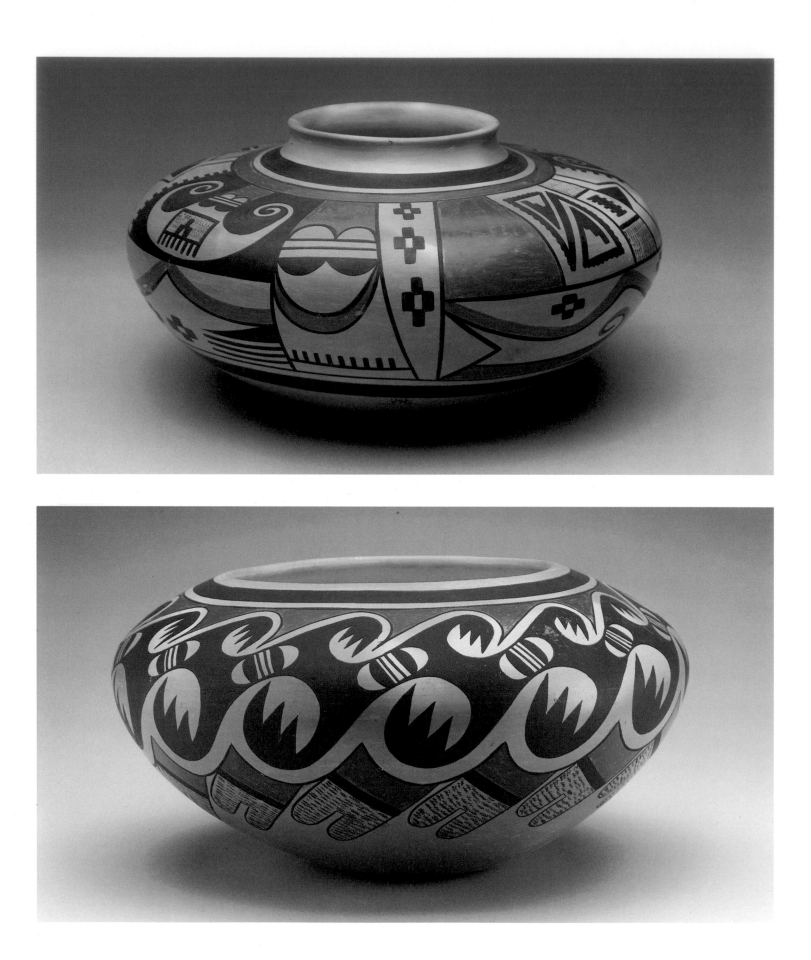

Fannie Nampeyo (opposite, top) Jar, c. 1930. Polychrome; 6⅞ × 12¹¹⁄₁₆ in. dia. On loan from the Museum of Northern Arizona. Photograph by Craig Smith

Fannie Nampeyo (opposite, bottom) Jar with migration design, 1971. Polychrome; 6 × 11⅝ in. dia. Collection of Lucille and Marshall Miller. Photograph by Tim Thayer

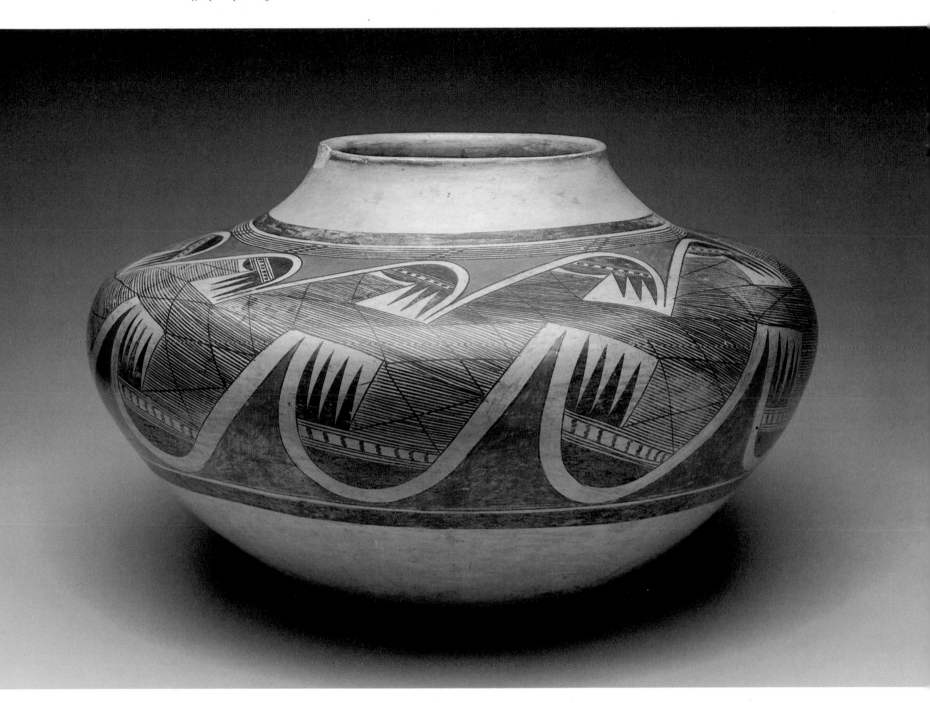

Fannie Nampeyo Jar with migration design, c. 1950. Polychrome; 13 × 20¾ in. dia. Collection of Nedra and Richard Matteucci. Photograph by Craig Smith

Dextra Nampeyo

Dextra Nampeyo, born in 1928, is Nampeyo of Hano's great-granddaughter, and today may be the best-known of the matriarch's descendants. Her work represents a qualitative leap in style and intricacy, and often evokes the changes in the American Indian world. Still active, Dextra patiently creates pots of remarkable delicacy and beauty.

Dextra is an innovator at the forefront of Hopi potters. She experiments with the natural materials used in the arduous traditional pottery process—a process she learned from her mother, Rachel Nampeyo—creating variations on the characteristic orange, tan, and brown hues of Hopi bonfired pots. Dextra gathers clays from different sources on the reservation and mixes to her desire. She will not know what she has until after she fires the mixtures, and many trials are needed to perfect the results.

Although adept at the Sikyatki revival designs of Nampeyo of Hano, Dextra is known for her novel decorations that bespeak her own feelings and her relationship to both the Indian and Anglo worlds. One of her now famous ideas was the "shard pot," a type that pictures a conglomeration of small pieces of broken pottery from previous generations such as Indians find every day in the sand of the pueblo.

Dextra works clay in the age-old process of coil building and refining with gourd tools, sanding, and applying another clay slip on the surface to polish. She decorates with a yucca frond brush and with mineral and plant pigments in the technique all the family shares. Exceptionally thin and well crafted, Dextra's work is particularly exemplary in the difficult wide, flat, disk-shaped vessel that she has perfected even more than her great-grandmother. Sheep manure is the only fuel Dextra uses for her outdoor bonfire.

In describing her way of creating pottery, Dextra has said: "One day my pottery calls for me, and then I know this is the day I must do it. At other times I do not have the right feeling for it. In those times I do my housework or take long walks. If a piece is damaged in any way, or if it just doesn't look right before it is fired, I break it up and put it back in water. Some pottery goes fast, some slow, but I always take my time with it, never try to hurry a piece. Sometimes when I am working on a pot, the designs come into my head and I know what I will put on the pot, but then people come and tell me what kind of pot they want. They want a 'fine-line' or something but I can't do that. If I do that, I am smothering the design that is in my head."

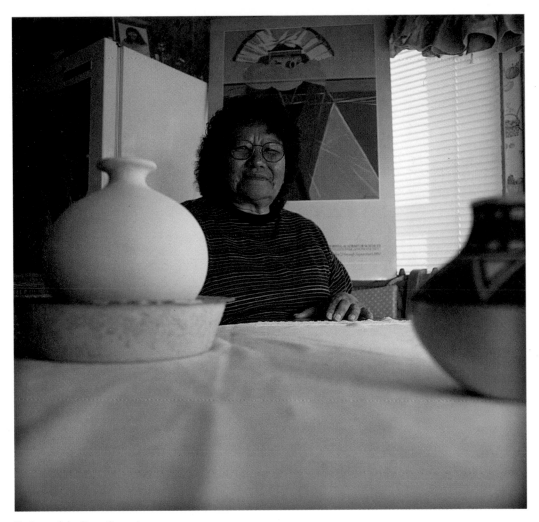

Photograph by Owen Seumptewa
Courtesy of the Heard Museum

Martha Struever, who has encouraged Dextra and who occasionally exhibits her work and other Nampeyo family members' pottery in various exhibition spaces, says that it is difficult to get pots from Dextra because she is working mostly on commissions from collectors. Dextra is assisted by her painter husband, Edwin, who helps with new concepts. Her potter daughter, Camille, and her celebrated painter son, Dan Namingha, have developed their own skills under her tutelage.

Dextra remembers her great-grandmother Nampeyo as the "nicest old lady, so nice to the children. Even after she was blind, she knew each of us by feeling. I guess because she was so nice to us is the reason we were always up on the Mesa to see her. She was very thoughtful and taught us to respect people." Dextra, who says, "We have been blessed as a family," is one of about forty artisans of Nampeyo of Hano's Corn Clan who feel the same way.

Dextra Nampeyo (opposite) Bowl with shard design, 1980.
Polychrome; 3½ × 13¼ in. dia. Collection of Martha
Hopkins Struever. Photograph by Craig Smith

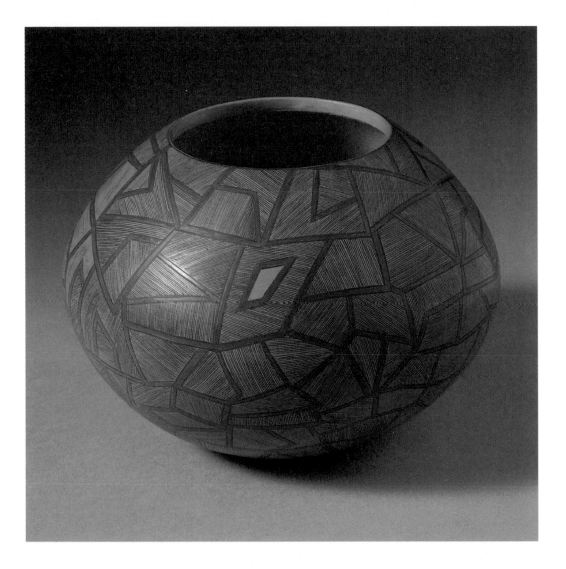

Dextra Nampeyo *Windows to the World*, 1981. Polychrome;
5 × 6¾ in. dia. Collection of Theodore and Louann
Van Zelst. Photograph by Rob Orr

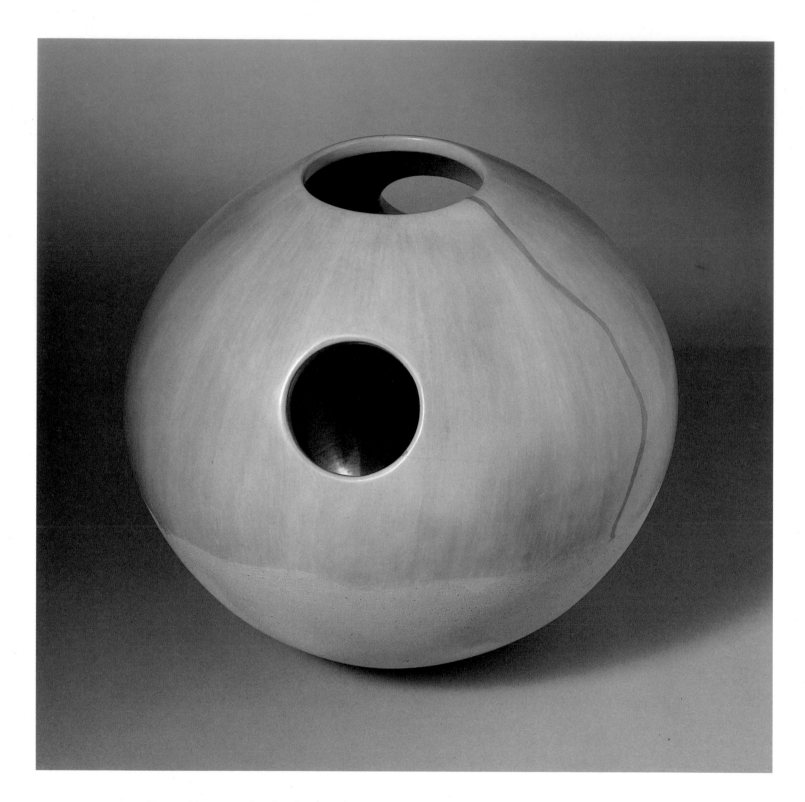

Dextra Nampeyo Bowl with sun and moon cutouts, 1985.
10 × 9 in. dia. Collection of Theodore and Louann Van Zelst.
Photograph by Rob Orr

Santana Martinez

Born at San Ildefonso around 1909, Santana Martinez began assisting Maria Martinez after marrying the matriarch's eldest son, Adam. Santana is known for her redware and black-on-black wares. Today, she continues to work with her children and grandchildren, in the true tradition of matriarchy.

Sister to Awa Tsireh, the best-known painter of the pueblo, and niece to Crescencio, also a renowned painter, Santana was brought up in a household of artists. Her grandmother, Dominguita, and her aunt, Tonita Roybal (whose red and black pot appears on a U.S. postage stamp), were Santana's models in pottery making. In 1926 Santana married Adam Martinez, the oldest son of famous potters Maria and Julian, and moved with her husband into the house of his parents.

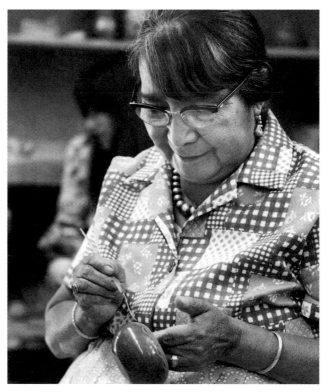

Santana Martinez paints a cloud design with a yucca brush.
Photograph by Virginia Garner

Santana, who had already learned pottery, was an immediate help to the Martinez couple. She learned Maria's way of working the clay and Julian's method of painting the refractory clay designs that became matte in the firing on the highly polished pots. Naturally shy and reserved, Santana's personality was a compatible contrast to Maria's gregarious magnetism. Santana called Maria "Mother" and respected her for her worldly experience. Santana and Adam spent many years in Maria's orbit.

"I went to day school in the pueblo. We just had kindergarten to sixth. One year I went to St. Catherine's in Santa Fe, but only for one year. I didn't like it so I came home. After sixth grade if you wanted more you went to Santa Fe Indian School and didn't come home except for Feast Day. They took us to Santa Fe in a wagon, a whole day trip. I went to eighth grade there," Santana told me. I have known Santana about thirty years, and I am always learning something new about her.

Of the old days, Santana says, "We would all make pottery for a while, thirty to thirty-five pieces, then put them aside, and set a date for polishing. Everybody

would come. And while we do that, Julian would be decorating. And while everything is being done, we'll be getting ready to fire and then we don't do anything for maybe two weeks. We mostly make pots in the summer when it's warm. Winter it snows, and summer is better for firing."

Santana and Adam, now elderly, still prospect their clay on the reservation, screen it on the site, and bring it home in flour sacks to mix with volcanic ash for temper. Santana is a talented potter, although she says that she never made the big pots Maria did because she didn't have time. Santana and Adam had eight children to raise, and Santana took care of domestic chores as well as assisting Julian with his painting of Maria's pots.

When Julian died in 1943, Santana took over the decorating of Maria's claywork for several years. The pots of those years were signed "Marie-Santana." When Maria's son, Popovi Da, returned to San Ildefonso after World War II, he began to paint for his mother. Santana and Adam then embarked on their own pottery adventure, and their pots were signed "Santana and Adam." Santana did all the potting, polishing, and decorating. Adam helped gather clay for the fabrication and collected wood, horse manure, and cow chips for the firing.

Santana makes her pottery now as she has done for the last seventy years. She begins each shape by laying a flattened pancake of red clay into a *puki*, the round-bottomed broken shard of a pot. She has collected many of these broken pot-bottoms of varying sizes so that it is easy to choose the proper one for the size she will build. She rolls one fat coil after another by pressing a big wad of clay between her two hands, moving the clay between her palms until it extrudes out into a long rope.

Coils are added to the base in the *puki*, one directly on top of another, luted together and smoothed up into a cylindrical shape. Then the wet clay is expanded from the inside with a rounded gourd tool. More coils are added to make the form larger. The shape is controlled by moving the clay out from the inside or pushing in from the outside until what is desired is achieved, and the work is smoothed as much as possible.

After forming what she wants, Santana sets the piece aside and begins another. Potting goes on for some days; then it's time to wait for the drying. The chalky outside surface is scraped with a crisscross motion all over with an old tin Calumet baking powder lid, to give a clean-line profile. Finally the pot is sanded perfectly smooth with sandpaper, perhaps by Adam. Then a different natural clay slip, containing more iron oxide, is applied with a rag and polished quickly with a riverwashed stone. This whole process may take weeks.

Santana still uses the designs that Julian developed from abstracting decorations he saw on ancestral pots in the museum; she has Julian's sketch books to refer to

when deciding on a design. She uses the yucca-frond brush that Adam has chewed for her and cut into the proper shape for the line she wants to make.

Toward the end of Maria's life, Santana did the firing for the family, when Maria could no longer manage the difficult process. Sometimes when Santana does the firing, she does not smother the bonfire with horse manure, keeping the red clay pots brick red in color. Other times she spreads the horse manure over the flaming mound, suffocating the fire and causing the pottery to become jet black. The firing consumes one to two hours, depending on the number and the size of the pots she stacks together and covers with cow chips for insulation. At just the right moment (and how can she tell?) the pots must be pulled out of the ashes with "poking sticks" or the shine will be dulled.

When I asked Santana how many pots she makes a year, she said she does not count. She added that if she did count, probably one hundred. These days, in her later years, that figure is diminished. But she still pots, takes care of grandchildren and great-grandchildren, and participates in pueblo functions. She describes the joy of making pottery, which she has never lost. She has exhibited in many galleries and taken numerous prizes at powwows and fairs. But one of Santana's most important achievements is providing a strong mainstay for the tradition and standards of the Martinez family pottery at San Ildefonso.

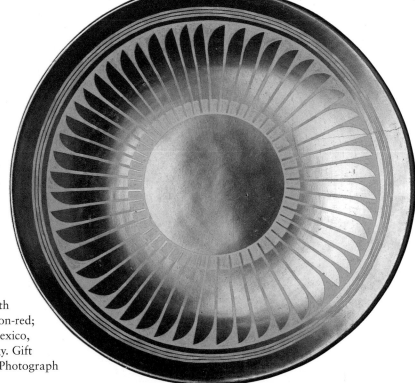

Santana and Maria Martinez Plate with feather fan design, 1943–56. Red-on-red; 14¾ in. dia. University of New Mexico, Maxwell Museum of Anthropology. Gift of Gilbert and Dorothy Maxwell. Photograph by Craig Smith

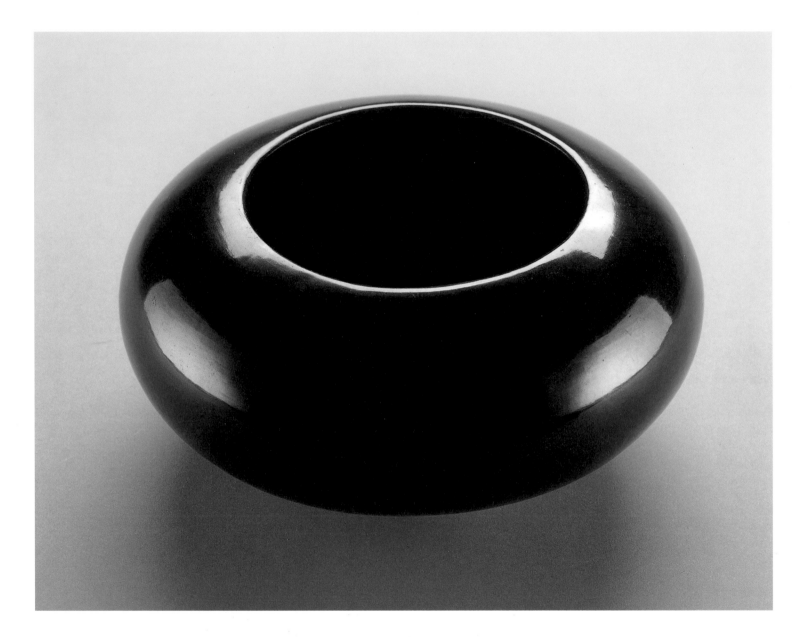

Santana and Adam Martinez Bowl, 1986. Blackware;
4¼ × 10 in. dia. Collection of Ruth and Robert Vogele.
Photograph by Greg Gent

Santana and Adam Martinez (opposite) Jar, c. 1984. Black-on-
black; 10 × 13½ in. dia. Collection of the National Museum
of Women in the Arts. Gift of Wallace and Wilhelmina
Holladay. Photograph by Lee Stalsworth

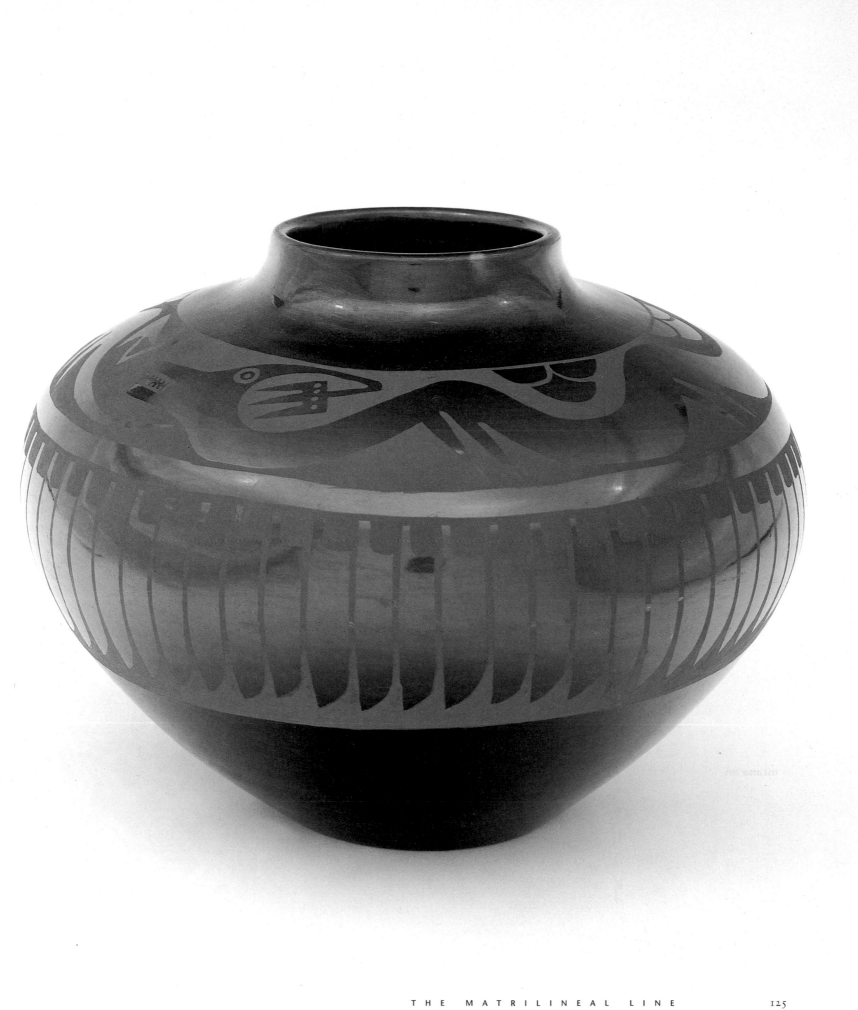

Barbara Gonzales

Barbara Gonzales was born at San Ildefonso in 1947, the first great-grandchild of Maria Martinez. Known for innovative shape, design, and decorative techniques, Barbara enhanced the technique of oxidizing blackware to reflect red highlights, and adds coral, turquoise, and heishi beads to her surfaces.

Barbara, fourth generation in the Maria Martinez dynasty, was destined to carry on the tradition of the matriarch. Barbara's energies are carefully and conscientiously directed toward this aim. The daughter of Juan Pino and Anita Martinez (Santana and Adam's oldest daughter), she lived with Maria from the age of five until she was about ten. She watched her great-grandmother make pots, and she went with her to Santa Fe for the Indian exhibitions. She sat with Maria on the plaza or in the Albuquerque train depot, selling pottery. She was often photographed with Maria. For Barbara, those years forged a strong emotional bond with the Indian traditions and the artistry of pot making, which she could not help gleaning from her matriarchal great-grandmother.

Barbara is a very well known artist in her own right today. She uses her Indian name, Tahn-Moo-Whe, on her pottery, and its English translation, Sunbeam, on the paintings, cards, and stationery she makes. The Indian name was given to her by Maria in the traditional manner, before she received her Christian name. Barbara was sent to a private Catholic boarding school in Santa Fe, and eventually she obtained her degree in education from the College of Santa Fe.

She married Robert Gonzales in 1969; they have four sons. Cavan, the oldest, came with us as a child when we all went to Washington, D.C., for the opening of the exhibition *Maria Martinez: Five Generations of Potters* at the Renwick Gallery in 1978. Cavan is now a graduate of the New York State College of Ceramics at Alfred University and has returned to the pueblo. He makes traditional pottery—but in his own style. His work is already being collected by museums. Aaron, his brother, has achieved recognition for his bear and bison sculptures. The two youngest brothers, Brandan and Derek, also make pottery. The family lives at San Ildefonso and has established a gallery there, of which Robert is in charge, for the exhibition and sale of their work.

Pottery has always been a part of Barbara's everyday life. She feels she has learned it naturally. During her childhood, with Maria setting the example, the family's activities centered on pottery making in all stages. Barbara feels that this

familial closeness and the concentration that all of them gave to the job created a definite structure and a strong discipline in their lives.

"When I first made pottery, I started with animals, each one a little different. Then I pinched little pots. Later I began to explore the clay surface, etch, and inlay on small bowls and spheres. I have always wanted to try different clays. I began to experiment with red clays for polishing and that led me to search for different types and colors and eventually to the clay collection that I have today.

"My father, whose Indian name is Ta-mu-yo-wa, was a well-known painter in our traditional style. As a child I watched him sketch and paint Indian dances." Before Barbara was actively doing pottery, she herself was a painter. Her paintings were exhibited in such illustrious places as the Philbrook Museum of Art in Tulsa and the Heard Museum in Phoenix, and one is in the permanent collection of the Smithsonian Institution in Washington, D. C. Barbara's paternal grandmother was also a potter. She feels fortunate to have pottery influences on both sides of her family. "I treasure them all!"

Photograph by Susan Peterson

Continuing her musing, Barbara says, "In the Indian way, the whole philosophy of something is understood silently. Each of us is trained to be intuitively aware of what the other person wants us to do, without speaking of it. It is planned to make you self-sufficient. We learn to be aware and pay attention to what our senses tell us."

Barbara thinks that this training applies also to designs on pottery. "Unless a genuine effort goes into your perception of a subject, an idea of how to put a design on a pot will not be there. We all have different ways of perceiving an object. Take an elm leaf. The way the veins stem in and out to the leaf edge is different every time. Some people might interpret that realistically and others will abstract it. We are surrounded by designs!"

Barbara is mindful that the qualities of discipline and patience are legacies of Maria's own diligence and her devotion to pottery. Traditional Indian clay techniques are demanding. Once a piece has been started, its construction must be finished. Once polishing is begun, it must be completed. These requirements apply to other facets of life.

"Clay is like dough, it remembers too!" she laughs. "It is special. It has character. If you don't knead it properly, it may not rise. Likewise, your masterpiece could explode into many pieces in the firing. That teaches discipline. We learn that a pot doesn't forget where it was ignored. It is pretty much the same with people.

"My pottery does vary from traditional to contemporary in style. I use my own designs plus those my great-grandfather Julian originated. I try to do all my work with perfection, which limits the number of pieces I make, and each pot is unique. Market value has increased but so has quality and competition. Indian pottery has become very popular, but we have been doing pottery for centuries. So whether the trend dies or continues, I will still be potting."

Here are the last two stanzas of a poem Barbara wrote for Maria some years ago:*

. . . *What large steps you did take.*
The courage unmeasurable.
My pace so slow . . . I can never catch up.

Great grandma, a title so long.

Kque-yo, *more meaningful—"Lady,"*
A name we all call you.
Kca-e-Kque-yo *to all others—"Lady of the hill."*

Barbara has exhibited and demonstrated her way of pottery making all over this country. She and Santana and Maria have been sought out by many well-known visitors at the pueblo. Her work has been growing a glowing reputation—she is on her way toward becoming a matriarch herself.

*Originally published in *The Living Tradition of Maria Martinez,* by Susan Peterson; reproduced by permission of the author.

Barbara Gonzales (opposite) Three-tiered vase, 1991. Polychrome; 13½ × 11¼ in. dia. Collection of Lynn and Larry Welk. Photograph by Craig Smith

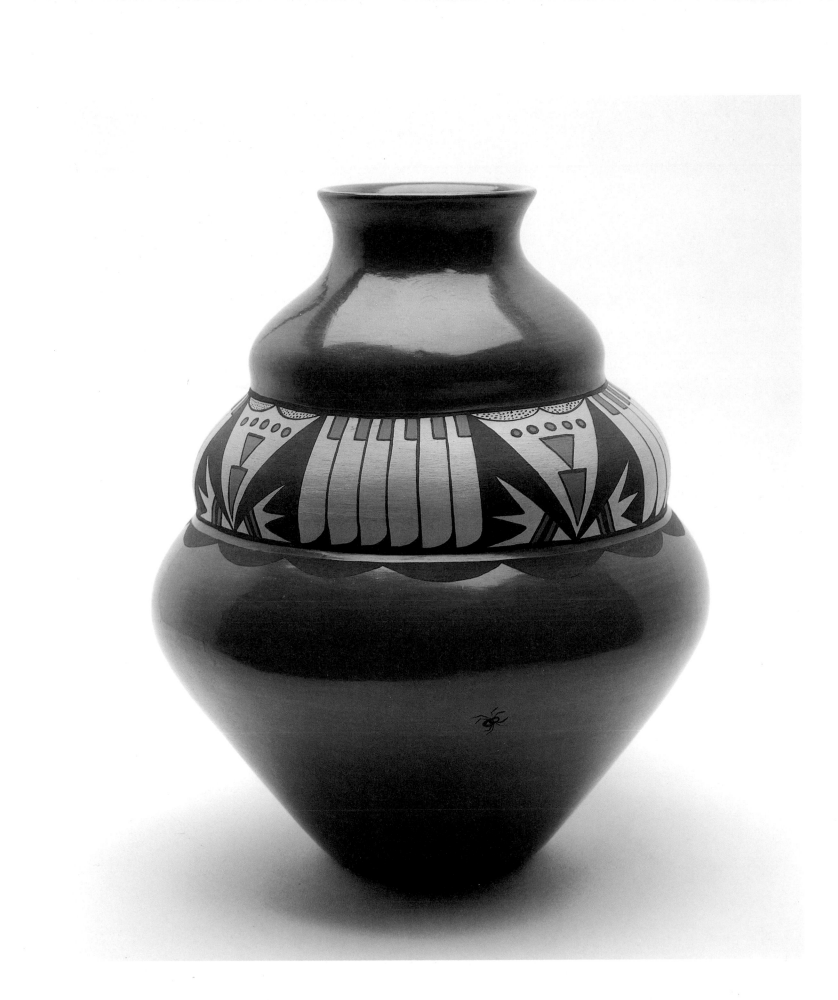

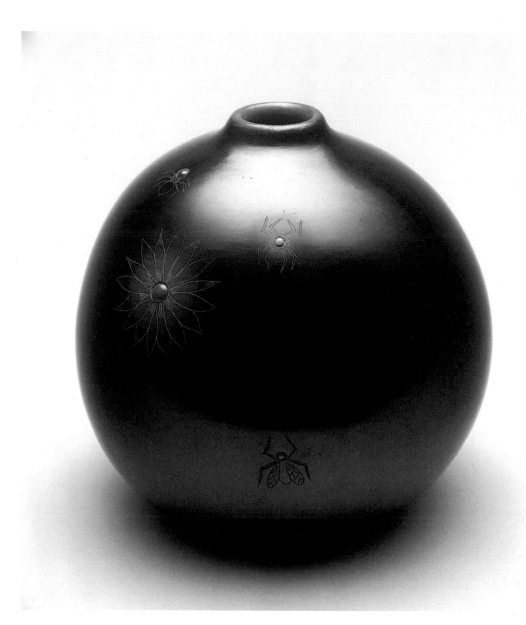

Barbara Gonzales Jar with incised nature designs and
semiprecious inlay, 1982. Blackware with coral and
turquoise; 6½ × 6½ in. dia. Collection of Lucille
and Marshall Miller. Photograph by Tim Thayer

Barbara Gonzales (opposite) Swish bowl with incised spiderweb
design and semiprecious inlay, 1991. Blackware with coral
and turquoise; 7½ × 14 in. dia. Collection of Barbara and
Frank Salazar. Photograph by Craig Smith

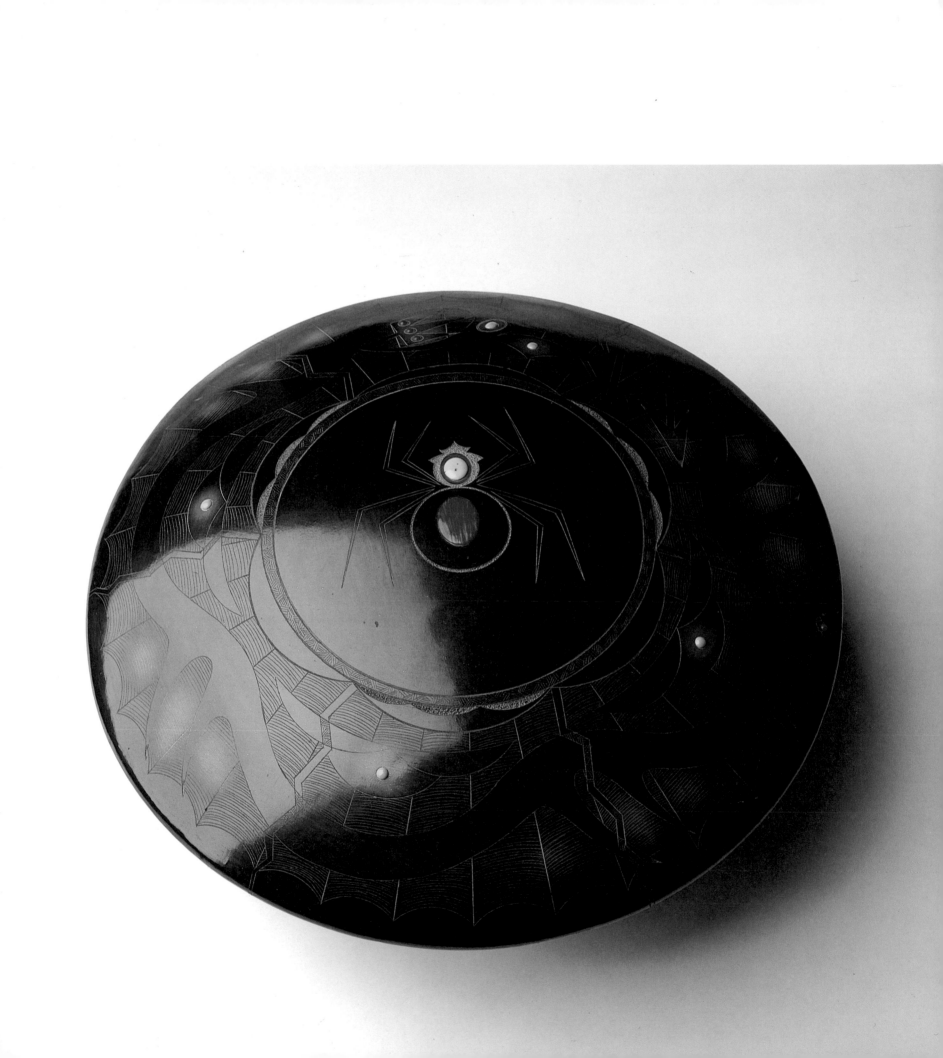

The Lewis Women
Emma Lewis Mitchell
Dolores Lewis Garcia
Carmel Lewis Haskaya

Living at Acoma Pueblo are the three most noted of Lucy Martin Lewis's daughters: Emma Lewis Mitchell (b. 1931), Dolores Lewis Garcia (b. 1938), and Carmel Lewis Haskaya (b. 1947). These three potters maintain the high standards of their mother in the face of Acoma's widespread abandonment of traditional techniques.

Emma and Dolores are the two of Lucy Martin Lewis's children who cared for her after her husband died years ago. The girls, as they call themselves although they are middle-aged, also traveled with Lucy to her workshops after she gained some notoriety from my Indian program summer classes at Idyllwild School of Music and the Arts (ISOMATA) in Idyllwild, California. More fame and invitations came with the 1984 publication of my book, *Lucy M. Lewis, American Indian Potter.* Later, Carmel, the youngest of Lucy's children, helped her two older sisters care for their mother. In this way Emma, Dolores, and Carmel were close to the core of Lucy's traditional Acoma Pueblo pottery technique and innovative style.

Today, pueblo officers are making a concerted effort to promote Acoma pottery that is not handmade, using colorful tourist brochures. Lucy Lewis's potter children, all nine of them, are trying to hold on to the level of skill of traditional pottery and the inventive designs their mother popularized for fifty years. Most of the pottery made for sale by the women of Acoma Pueblo today—and nearly all of the pots I saw in a current publicity pottery flyer from the Acoma tribal center—is not hand-made but purchased from hobby shops as "greenware" (ready-made unfired ware) slip-cast from multiple molds, painted with commercial underglaze stains, and fired in commercial kilns. Some potters use the traditional Acoma pigments ground from metallic oxide rocks instead of manufactured paints, but they brush them on cast greenware bought at the store. Regardless, these Acoma potters and the Indian art galleries who sell their work often fail to explain to the public that this pottery is not done in traditional fashion with Indian materials.

This subject is much on the minds of the Lucy Lewis family members who think it is morally wrong to use cast greenware and commercial paints for Indian pottery. Occasionally, pottery judges fail to recognize the fake ware and sometimes award it prizes. If questioned, the jurors say that the potter's painting on the pot

Emma Lewis Mitchell chews a yucca to make
a brush. Photograph by Susan Peterson

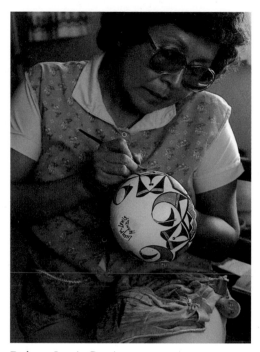

Dolores Lewis Garcia
Photograph by Susan Peterson

got the prize. Then why, traditionalists wonder, was it in the ceramic category?

Nowhere else does this variation in standards seem to be as prevalent as at Acoma. Some of the Storyteller makers from several pueblos are using commercial pigments, but at least the potters model the figures themselves. Some of the gorgeous red ollas made in various pueblos are kiln-fired, but they are also shaped, slipped, and polished by the hand of the artist. The Acoma Tribal Council condones electric kilns because the pottery is so valuable, especially when it is made by a well-known artist, and the potential monetary loss from breakage in bonfiring is so risky. Electricity is a cleaner atmosphere and some collectors prefer the resulting whiter color of the Acoma clay instead of the gray clouds that can occur in the outdoor firing.

The use of commercial greenware and pigments by Acoma potters is too entrenched to go away. But it seems to me important for people truly interested in the work and all that surrounds it—not just the look of the piece but the process, customs, and history behind it—to learn to differentiate authentic traditional from fake traditional Indian-made pottery, and sell or buy the work accordingly.

I asked the Lewises if the commercial castware affects their Pueblo Indian religious life. "Of course," they responded. "Look at the drought! We think it's because of this commercial slipware the ladies are using that we have no crops. These pots don't work in the ceremonies. They aren't handmade. This is our greatest concern."

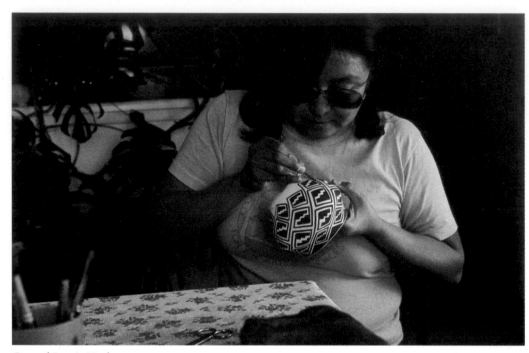

Carmel Lewis Haskaya
Photograph by Susan Peterson

All Lucy's children were sent away to school but learned pottery making from their mother during visits home. Later, as adults, they became more serious potters, continuing to learn from their gifted mother. Emma, Dolores, and Carmel, arguably the best potters among Lucy's seven daughters, feel that they have not been recognized by their pueblo. Although they have received recognition from the outside world, they have the desire to be appreciated by their own people.

Pottery making is sandwiched in somehow among the many duties and responsibilities of life in this isolated and very traditional pueblo. Many days are required to prepare food and costumes for the frequent religious observances, but pottery also has a place. Emma and Dolores worked clay for years with their mother, but Carmel, whose job was to take care of the cows, has been learning from her sisters with her own young daughter, Katerina.

The three potters dig clay in the secret spot somewhere on the Acoma reservation as their ancestors did. They make pottery in the age-old method, using a *huditzi*, the bottom of a broken pot (called a *puki* by the Tewa), to form the base. They roll coils and pinch up the contour, shaping with gourd tools, scraping with tin lids, and water-smoothing. They apply a whiter liquid clay slip to the pot's surface, and polish it with a riverwashed heirloom stone. The pigments for painting are natural rocks containing metallic oxides such as iron, hematite, manganese, rutile, and uranium, which must be ground fine on a stone metate; brushes are chewed yucca fronds cut

for the size of the stroke. Firing is accomplished outdoors with cow chips for fuel and plenty of air early in the morning on a windless, rainless day.

Emma is a graduate of Haskell Institute in Kansas. She began making pottery seriously after she had six children, although she had made pots from childhood. Her first pottery prizes came in the Flagstaff, Arizona, Fourth of July Indian Pow-Wow in 1966. She has worked prodigiously since. Emma is willing to experiment; she has been working on her own interpretations of bird and animal fetishes in clay sculptures for some years. Her beautiful Mimbres-influenced drawings of animals in black on white are a joy.

Dolores was born in 1938, seven years after Emma. Dolores went to public school in Albuquerque before she could speak English, which she remembers as one of her most difficult learning experiences. Dolores says that at Indian schools the teachers punished children who spoke their native languages, so Lucy and her husband, Toribio, kept their last three children out of Indian schools. After Toribio died, Lucy lived with Dolores's family, which included four children, all of whom watched Lucy make and paint pottery. Dolores began with small pots for ceremonials and is now the family expert on making clay canteens.

Since Lucy's death in 1992, Emma and Dolores have continued traditional pottery as their mother taught them. Emma and Dolores went with Lucy to workshops around the country and now give demonstrations on their own. They conduct classes in the process of Indian pottery making and lecture about their work, shyly.

"We get wonderful compliments on our potteries," says Dolores. "Emma and I do appreciate our pottery making, and we do enjoy meeting people outside our own life, giving lectures and pottery workshops so the public will be aware of how time-consuming handmade Indian pottery is."

The two women exhibited their work recently at an international exhibition of traditional arts and crafts in Taipei, Taiwan. Emma and Dolores are also proud of having been honored in 1990 by Indiana University's Institute for Advanced Study as fellows, "in recognition of the superb contributions to the ceramic arts and to enhanced respect for traditional cultures."

In Acoma families, the youngest children are given the duty of caring for the cows. Tending the cattle is a symbolic means of survival for these children who, because they are frequently decades younger than their siblings, often outlive them. Carmel has spent much of her time fulfilling this duty as well as raising her daughter. She has been unable to travel with her sisters to fairs and markets and only recently has had the opportunity to focus on pottery making. Carmel's talent is considerable, and much is expected of her in the coming years. Through Carmel and her daughter, Katerina, Lucy's legacy will continue.

Emma Lewis Mitchell Jar with lizard design, 1996. Black-on-white; 7¼ × 8 in. dia. Collection of the artist. Photograph by Craig Smith

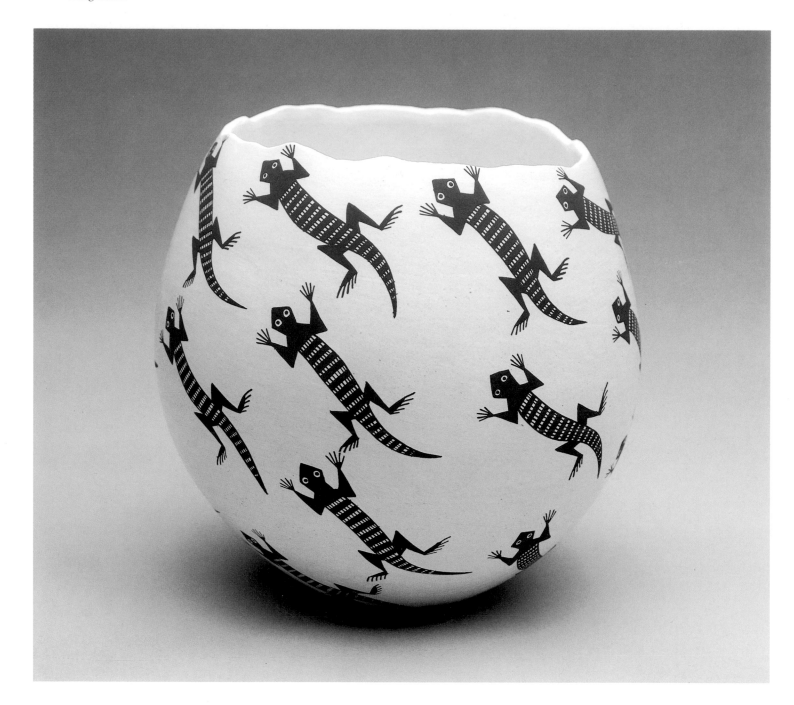

Emma Lewis Mitchell (opposite) Jar with heart-line deer design, 1992. Polychrome; 6 × 9 in. dia. Collection of Marjorie and Charles Benton. Photograph by Rob Orr

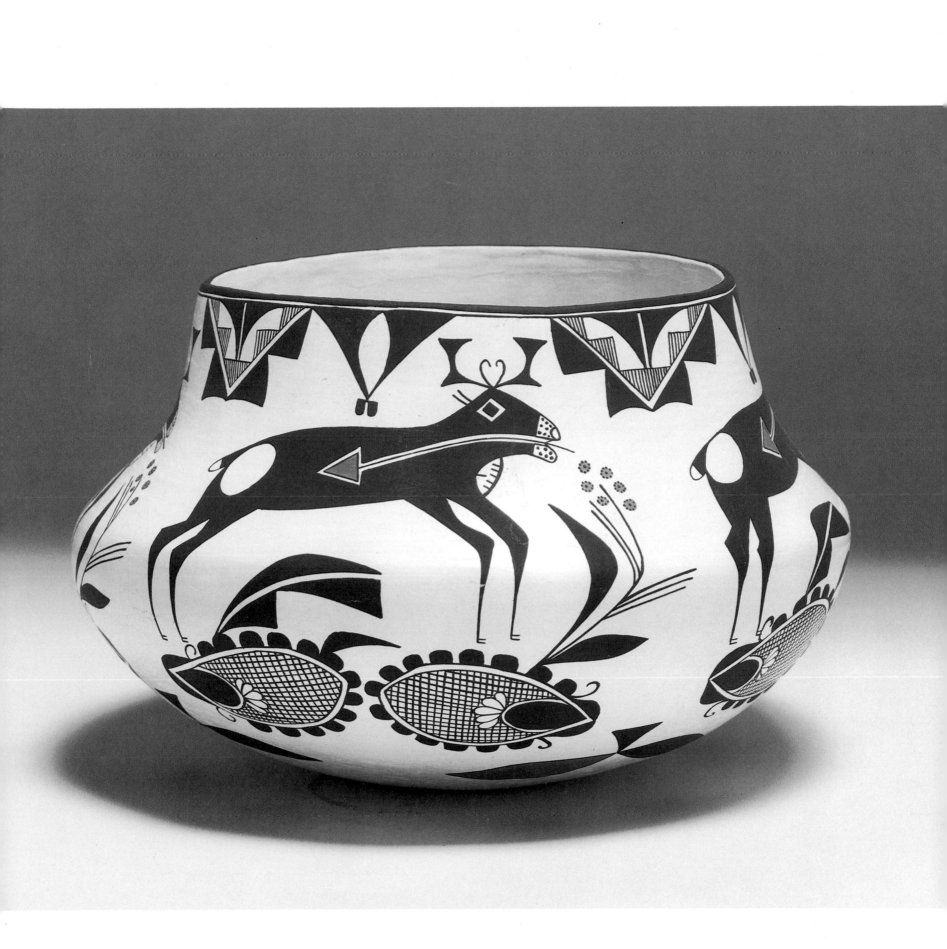

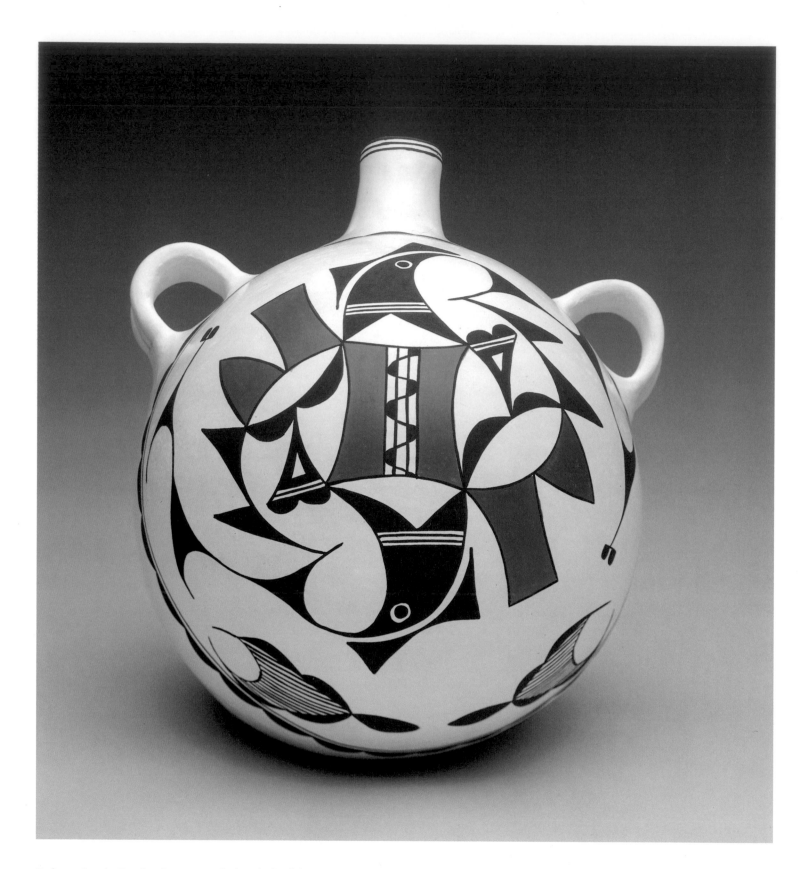

Dolores Lewis Garcia Canteen with thunderbird design, 1996.
Polychrome; 9½ × 8 in. dia. Collection of the artist.
Photograph by Craig Smith

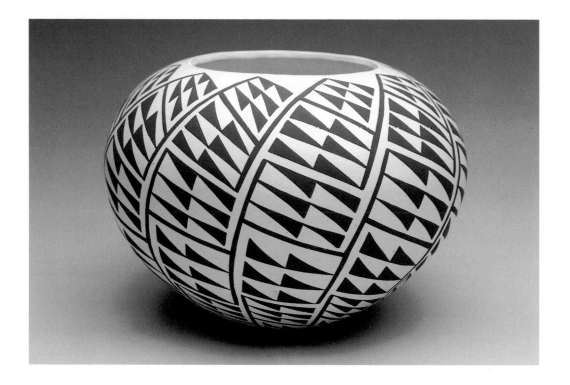

Dolores Lewis Garcia Bowl with lightning design, 1995.
Black-on-white; 7½ × 10½ in. dia. Collection of the artist.
Photograph by Craig Smith

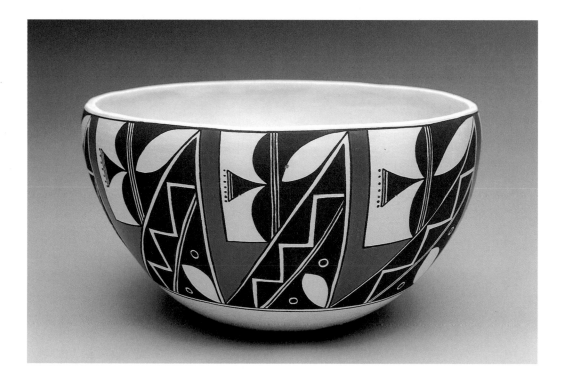

Dolores Lewis Garcia Dough bowl, 1996. Polychrome; 12 × 7 in.
dia. Collection of the artist. Photograph by Craig Smith

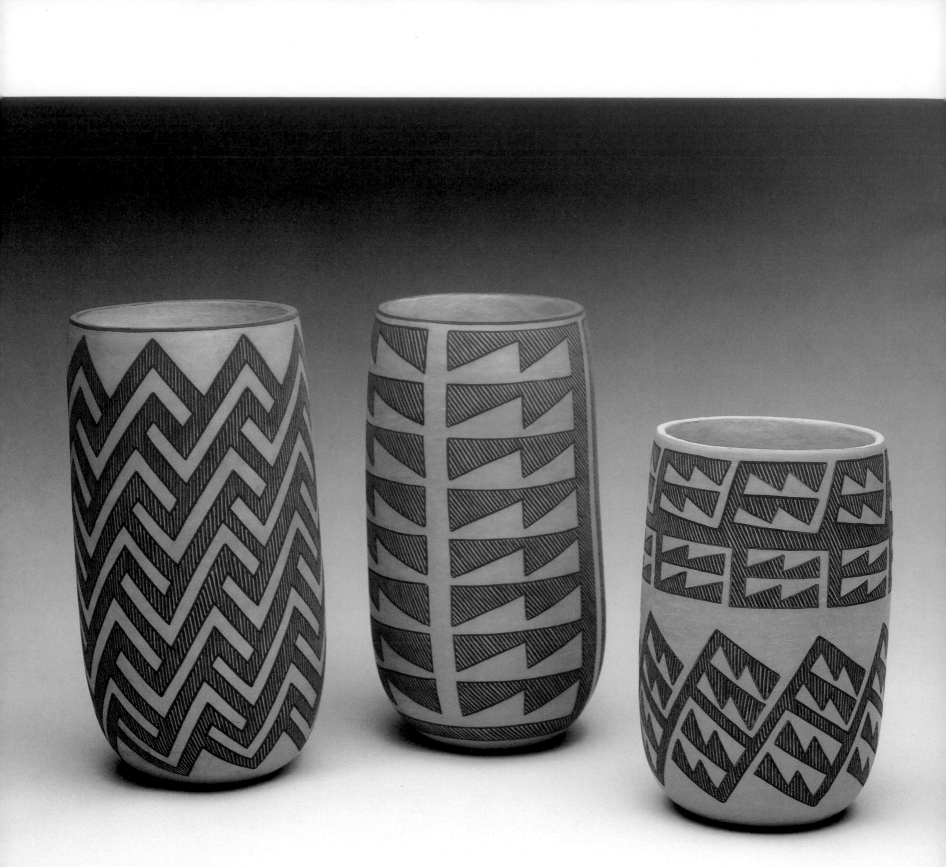

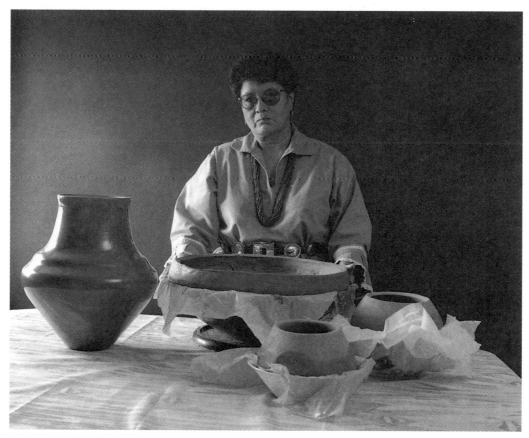

Photograph by Taba Tucker

to be used as a liquid slip over the pot for polishing, for each color we want in the firing, either the red or the black. I prefer the smothered black-fired pots; it is a longtime tradition; and I think artistically we like it better." Then she added, "People seem to like black, more than the red pots," which is the same statement that Maria Martinez made to me many years ago.

Lu Ann started polishing as a young child; she says she loved to do it. She polished fast and hard, which is what it takes to achieve the mirrorlike shine for which she is famous. Lu Ann had just fired another work, a huge, magnificent, black carved jar that swelled into a broad round width from a narrow foot and then closed to a short neck, perhaps fourteen inches in height and three feet in diameter. This piece was an astonishing size for the extreme shape, and I marveled at the perfection of form, polish, and decoration.

The *avanyu,* a water-serpent rain god design deeply incised on this particular pot, took Lu Ann three days to carve with the used screwdrivers she has had for twenty-six years; the widths of the blades give the size and character of the drawing, which later is sanded to perfection. Then Lu Ann applies the Santo Domingo slip

coating all over the outside of the pot with a cloth and begins to polish, one small section at a time. She polishes all around until she gets the high shine she desires; she uses a very small quantity of lard intermittently. "I try a new shape once in a while, when I have time. This was one of my largest, this big black one is only the third I have made with this shape this large, and I'm still learning. I've been making huge pieces like this for just the last four or five years."

Lu Ann, a prodigious worker and a wonderful clay artist, can make only a few pots of this size a year, and only one or maybe two of her largest storage jars. A large vessel, several feet tall or more, will take a month to dry after it has taken weeks to fabricate the form. Her work is in great demand, and she is selling mostly to collectors who are willing to wait for their orders to be filled. Lu Ann is one of the best known of Margaret Tafoya's ten children, eight of whom make pottery.

For the black firing, Lu Ann uses no cow chips over the top of the pot. Instead, she dumps finely ground horse manure directly on the wood slabs that surround the metal cage to smother the fire at the end.

"Nowadays some younger ones at the pueblos use commercial clay, paints, and kilns," she says dejectedly. "The commercial firing is higher in temperature, and the pots sound different; they have a flat tone. We were always taught traditional open firing and never to do commercial kiln firing. I have never fired in a kiln. Traditional clay does blow up, even with volcanic ash in it, from air bubbles or if it isn't really dry. Handles on a pot, or especially twisted handles where air can get in, those blow up in the fire. The pots have to be preheated slowly before firing. Most young ones won't take this time."

Lu Ann says she is worried that someday the traditional way of clayworking will be gone at Santa Clara, because of the short cuts. She knows that everyone who fires traditionally loses pots—she never gets used to it—and generally there are no blowups in a ceramic kiln because it takes hours to fire slowly to a high temperature. There is much more risk in an open fire with instant flames. Lu Ann feels that Indian life goes hand in hand with traditional Indian pottery and that Indian artists need to hang on to both the handed-down way of claywork and the unusual pueblo system of communal living.

Lu Ann Tafoya (opposite) Bowl with carved design, 1996. Blackware; 10 × 18 in. dia. Collection of Ruth and Robert Vogele. Photograph by Greg Gent

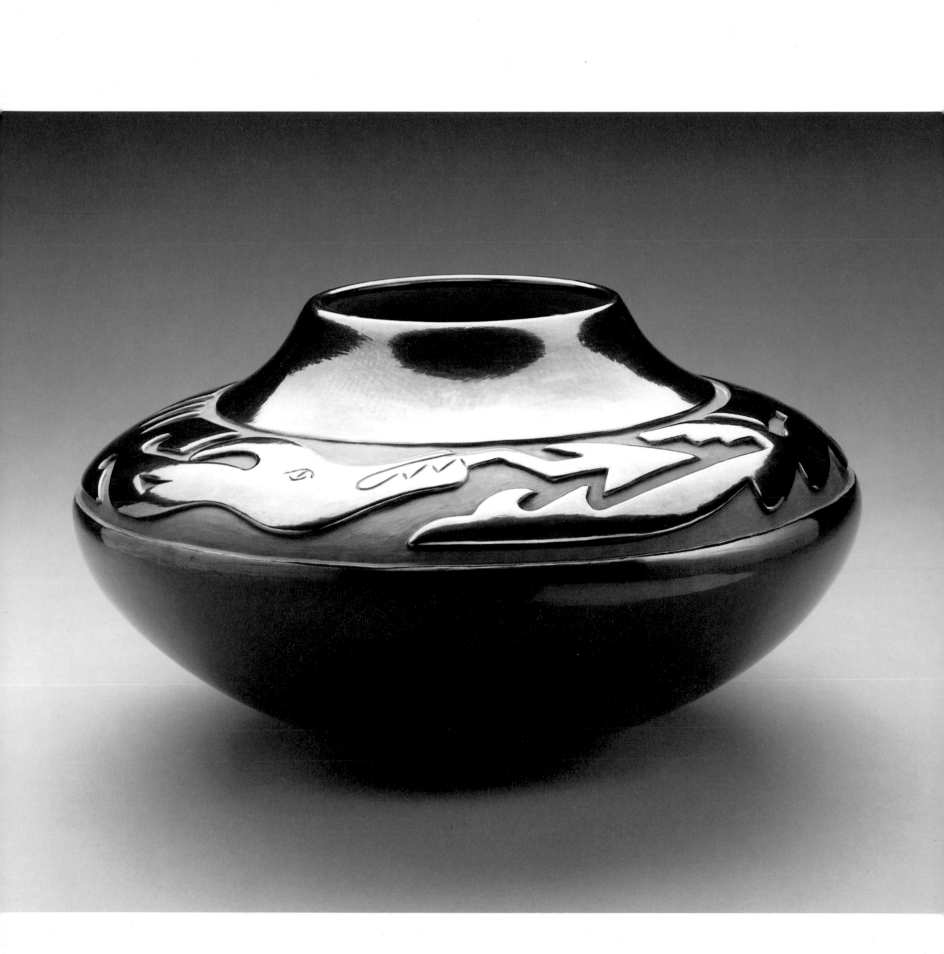

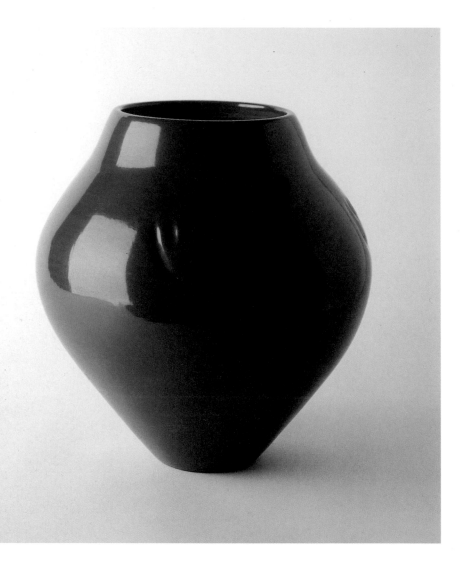

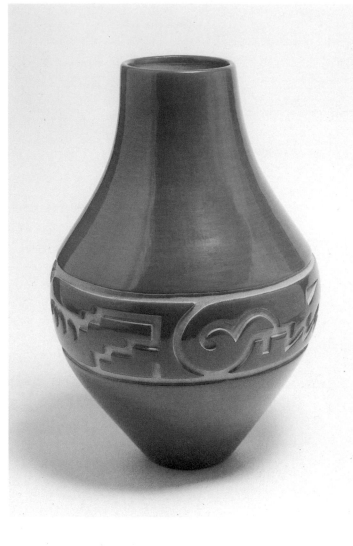

Lu Ann Tafoya Jar with carved design, 1990. Redware; 19 × 13 in. dia. Collection of Charles and Marjorie Benton. Photograph by Rob Orr

Lu Ann Tafoya Jar with bear-paw imprint, 1996. Redware; 22¼ × 20 in. dia. Collection of the artist. Photograph by Craig Smith

Lu Ann Tafoya (opposite) Jar with *avanyu* imprint, 1989. Redware; 8½ × 10 in. dia. Collection of Jim Jennings. Photograph by Lee Stalsworth

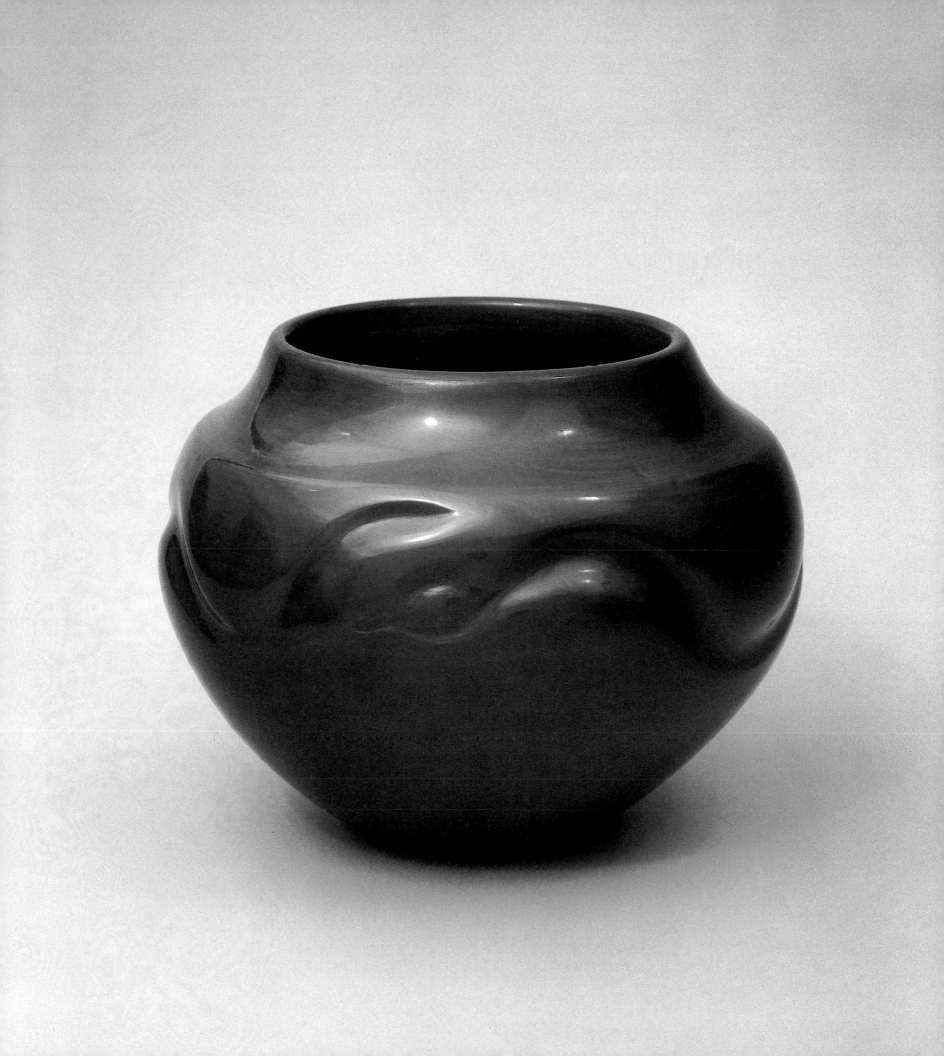

Grace Medicine Flower

Born in 1938 at Santa Clara Pueblo, Grace Medicine Flower is Margaret Tafoya's niece. She is best known for her miniature bottles and ball-shaped sculptures, and for the finely incised narrative designs she carves in redware and blackware. Her talent has won her many awards.

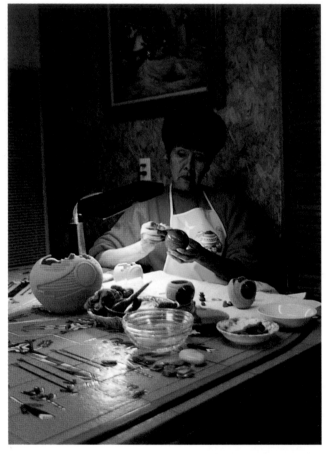

Born into one of the most prestigious Indian pottery families, Grace is the daughter of Camilio Tafoya—the son of Sara Fina and Geronimo, and the brother of Margaret Tafoya. Grace and her brother, Joseph Lonewolf, became the celebrated practitioners of their father's technique of incised carving on red and black polished pots. Their late mother, Agapita, was also a potter.

Although she also carves on larger pots, Grace is best known for her exquisite miniatures, round or egg-shaped hollow clay balls with no opening or bottles with tiny stoppers, on which she incises in fine relief cameos or allover designs of an Indian story, a flock of birds flying, bunches of flowers, or groups of animals. "I just feel happy that people like my work," Grace said to me recently. "People may copy what I do now, but that keeps me busy. It keeps me growing and changing and finding new ways. If you are gifted with your hands, why use anything else? God gave me talent, and I am grateful for that."

Grace has experimented with prospecting different clays in order to have a variety of colors for her pottery. So far, she says, all she has found that will hold their color in the heat are clays that fire iron red, rust-colored, buff, blue, and green, and of course the black that comes from the smothered firing. She is still looking for yellow; since she insists that her materials all be natural, she tried boiling banana skins and adding that to buff clay, but it didn't work.

"The clay used in my pottery is found in clay pits on the Santa Clara lands.

Many of these pits have been in use for centuries. Before the clay is taken from the earth, special prayers are offered to [a spirit I call] the 'Clay Lady.' When I take the clay home, it is dried in the sun several days, then crushed and soaked in water a few days, then screened for impurities, and I mix it with my feet and my hands. I add some white sand-ash for temper. Before I work, I thank God for giving me the hands to create the pottery; I talk to the Clay Lady and promise to do my best to make the clay beautiful."

After the burnishing and the firing, Grace carves her intaglio designs freehand from her mental visions. She draws fine etchings into the vessel's surface with a nail, a pocket knife, or a small utility knife. Designing a whole pot in this manner often takes weeks. "My mind can go completely blank if I spend too much time on a particular pot," she explains. "It's like trying to make something happen before its time.

"Every pot I create is special to me because it comes from my inner being with the help of God and the Clay Lady. The designs on my pots have symbolic meanings such as the *avanyu* (rain god), signifying life; the butterfly, meaning the beginning of life; and birds and wildlife, representing clothing, food, and beauty for my ancestors and myself. I have used the hummingbird design for over fifteen years. I watch these lovely creatures while I work."

Many prizes have come to this artist, but the one she was most proud of was Best in Show from the Gallup Inter-Tribal Indian Ceremonial some years ago. Now she does not compete in shows. She is always working because her intricately carved pieces are repeatedly commissioned by galleries and collectors. "I've been to the White House, and I have met so many nice people and so many nice things have happened to me. I'll let the young ones win the awards.

"I feel that our art today is in keeping with the traditional way of making and firing. I also feel that the shapes and designs have to change as time changes. My art is considered by some to be contemporary, but the making and the firing are traditional. I think that pottery as an art medium is growing, and as young and up-and-coming potters come on the scene from our culture, they will have new ideas and there will be more changes, but our pottery making will be around for a long time."

As for her interesting belief in the idea of change, Grace knows that she is still able to grow and change in her already award-winning work. She is trying larger pots now.

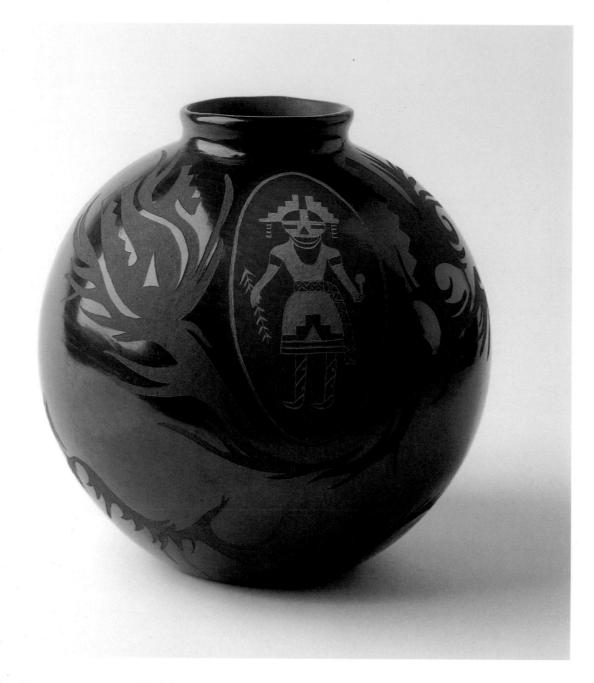

Grace Medicine Flower Jar with incised red design, 1972. Red
and blackware; 9 × 8 in. dia. Collection of Dennis and Janis
Lyon. Photograph by Craig Smith

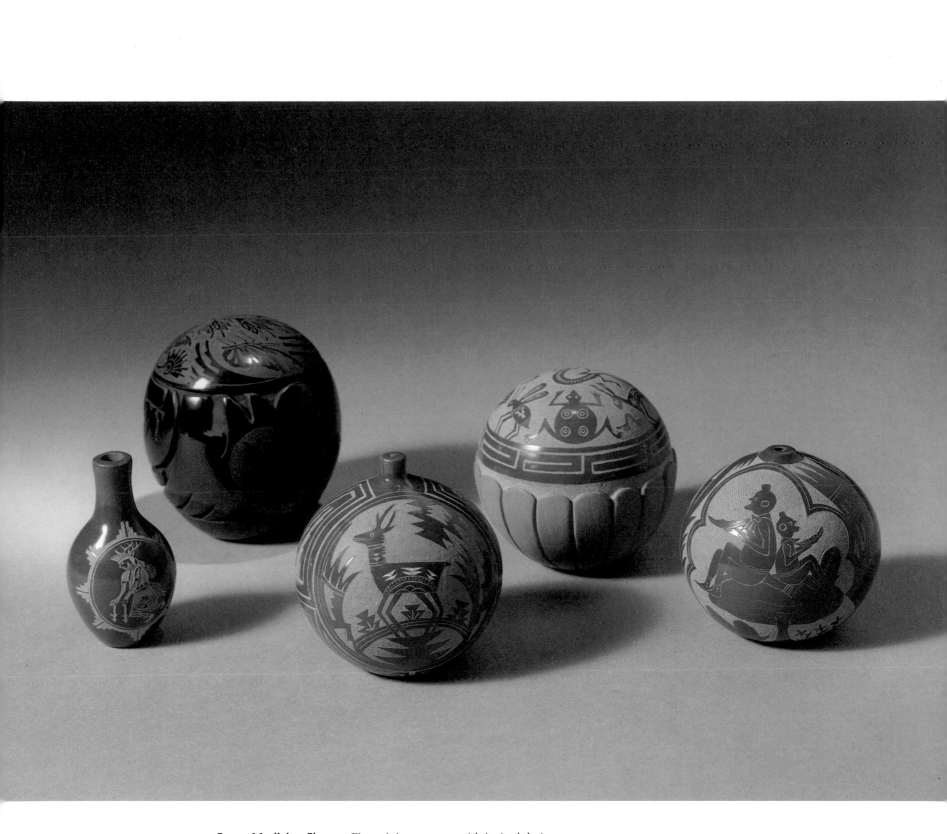

Grace Medicine Flower Five miniature vases with incised designs,
1974–1987. Redware and blackware; $2\frac{1}{2} \times 1\frac{1}{2}$ in. dia.,
$2\frac{1}{2} \times 2\frac{3}{4}$ in. dia., $2\frac{3}{4} \times 2\frac{1}{2}$ in. dia., $2\frac{1}{2} \times 2\frac{1}{2}$ in. dia., and
$2\frac{1}{2} \times 2\frac{1}{2}$ in dia. Collection of Theodore and Louann
Van Zelst. Photograph by Rob Orr

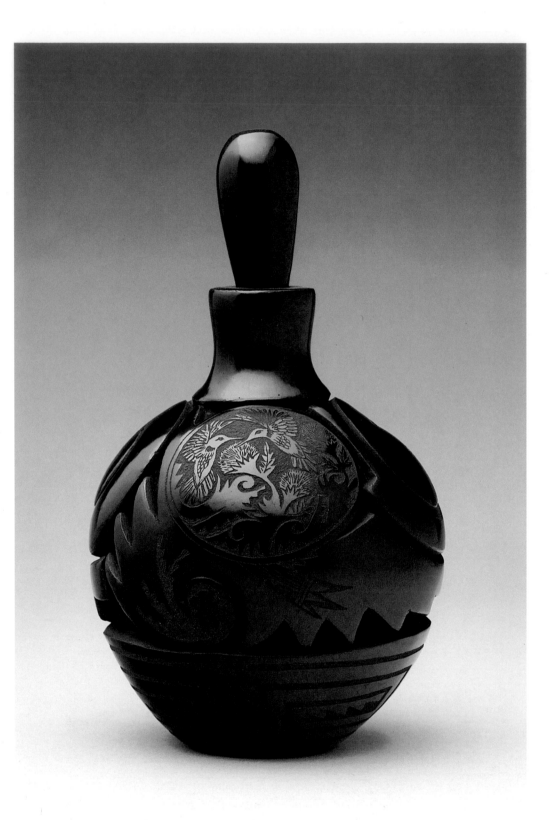

Grace Medicine Flower Lidded jar with incised design, 1989.
Blackware; 5 ¾ × 3 in. dia. Collection of Lucille and
Marshall Miller. Photograph by Tim Thayer

Nancy Youngblood Lugo

Nancy Youngblood Lugo, grandniece to Margaret Tafoya, was born in 1955 in Fort Lewis, Washington. Her painstaking attention to detail has brought American Indian pottery to its highest level, earning her widespread recognition. Today, her work fetches some of the highest prices ever seen in this field.

Nancy, the daughter of Margaret Tafoya's daughter Mela, is a driven perfectionist. Her military father, Walton Youngblood, moved his family to a variety of places until Nancy was twelve; then she returned to the pueblo to live and became interested in her grandmother's pottery making. There were many girls in the extended Tafoya group who made pottery or who did some of the related chores, and Nancy already understood what she wanted to do. As she says, she was drawing on the walls at the age of two.

Nancy attributes the extraordinary continuation of good and beautiful Indian pottery today to the railroad, the Indian ceremonials, the competition of seventy-five years at the Indian Market, the interest of the museum people, the promotion

Photograph by Tamea J. Mikesell
Courtesy of the Heard Museum

from world's fairs, and the influence of Maria Martinez—"who showed people how it was done."

The young artist went for a very short time to the San Francisco Art Institute because her father thought she should go to school. It was not a satisfactory arrangement. Al Packard, an influential dealer who had a shop on the Plaza in Santa Fe, encouraged Nancy to do her own pottery when she went to him to ask for a job. Soon she entered a few polished black miniatures in the Gallup Inter-Tribal Indian Ceremonial and won prizes. She gave pottery demonstrations and began to feel that she had a following, a clientele that liked her work.

During a short stay at the University of New Mexico art department, Nancy married a medical student. She lived with him in Kansas City for five years, supporting him while he finished his surgery residency program. Having free time while her husband worked long hours gave Nancy a continuous opportunity to concentrate on pottery. She claims that this intensely focused period, when she did almost nothing else but work on pottery, enabled her to hone her work to perfection. She allowed herself to get better and better at all the techniques associated with the Indian pottery process. She flew the polished raw pots, strapped in their own seats, back to the pueblo for firing, and took the finished work to Gallery 10 in Santa Fe. Then-owner Lee Cohen gave Nancy her first major exhibition. Lee's encouragement and confidence in Nancy's work led to a successful working relationship that lasted nineteen years.

Divorced in 1990, Nancy was remarried in 1993 to Jorge Lugo. Jorge left his profession as a telecommunications engineer to join Nancy in Santa Fe and participate in the pottery business and help raise their three little boys. Chris, Nancy's son from her first marriage, just turned seven. Nancy and Jorge have two children together, three-year-old Sergio and eighteen-month-old Joseph.

Jorge prospects and prepares the proper clay for the work that is planned. Getting the right clay and having it in the right condition is one of the most important aspects of the Indian pottery procedure. Jorge sifts and screens the clay and volcanic sand many times until it reaches a very fine consistency, then mixes it in excess water for more homogeneity, then partially dries it in canvas and newspaper to a plastic, workable state. Different clays are used for the oxidized red firing and for the reduced-oxygen black firing. Nancy says that for some reason, she can get a better polish on the clay that is used for the black firing.

The prices that Nancy's work now commands are some of the highest of any Indian pottery. It is in such demand that it is often sold before it is made, and on Indian Market day in Santa Fe, her fans line up hours in advance for the chance to buy the few pieces she brings. Minutes later, the lot is sold and Nancy is gone. She is

becoming a legend in her own time. In addition to selling her pots at Indian Market, Nancy markets her own work and is no longer represented by any gallery. Nancy and Jorge invite existing as well as new customers to view her work by appointment.

Nancy has won a total of 256 awards for her ingenious creations. Included in those awards is the coveted Best of Show award at the Santa Fe Indian Market in 1989. She is best known for her ingenious "melon" forms with deeply carved, perfectly even vertical or swirling ribs on round, oval, squat, or tall shapes. Nancy has made as many as sixty-four sections on a melon bowl, taking two to three hours to polish a few ribs at a time. Polishing is arduous, done with handed-down riverwashed polishing stones, one section at a time, until the rapid polishing strokes yield a mirrorlike shine. The piece must be touched with extreme care because it is eggshell-fragile at this prefiring stage and could easily be broken with pressure. Nancy leaves a single rib unpolished until the end so she can tell where the polishing began and compare the shine all around. She says that this very difficult burnishing technique is like practicing a musical instrument; "You have to keep at it or you lose it. Polishing the swirl is the hardest of all."

Several years ago, with characteristic attention to perfection, Nancy analyzed the traditional Indian method of outdoor bonfiring that requires good weather conditions, meaning no wind or rain. With an architect, she designed and built her own enclosed firing house at the pueblo. The building configuration promotes draft and makes concern about the weather unnecessary.

Each of Nancy's pots has so much potential monetary value that Nancy fires one piece at a time. Overfiring or underfiring the pot will result in a dull finish. There is no way except trial-and-error informed by many years of experience to even begin to control this kind of intuitive firing. Nancy has been at it twenty-two years—more if one counts the hundreds of years of Tafoya family experience.

The firing begins with the placement of the first pot singly on a grate with cedar kindling underneath for the warming; two or three batches of burning cedar are used until the pot becomes quite hot. Then two-inch-thick slabs of the highest grade white pine are placed upright around the work, and a metal sheet is placed over the top. The wood must be of a consistent size and thickness so that it will burn evenly all around the piece. As the wood ignites, the fire becomes hotter and hotter. The ashes that form must be burned away for a red firing, or soot will discolor the work. If a black pot is desired, there is a very crucial time during the firing process when dry horse manure is dumped over the burning wood. The fire is smothered, and carbon, expending from the wood and manure, exchanges ions with the iron in the clay, causing the pot to turn from red to black.

I asked this magnificent potter what she wished to achieve next, young as

she is and with the considerable fame that is hers. She quickly replied that her dream piece would be a 128-ribbed melon. "And I want to do something different, more swirls, carved lids. I like the squat shape, flying saucer shape, Japanese lantern shape. People copy me; I have to stay ahead. I feel like I really achieved a lot. I worked for many years, twelve to fifteen hours a day, to learn these skills. My mother said to take time to smell the roses and asked if I was willing to pay the price of such long hours of hard work.

"I am. I did. I have, and I still am. I think it is really because of my grandmother; she was such a strength for all of us. I use cornmeal before I get my clay and my sand to pray before each firing. If I bought the clay and if I used a kiln, that would hold no drama for me. The way I do it, the pot is a part of me and preserves the Tafoya family traditional method."

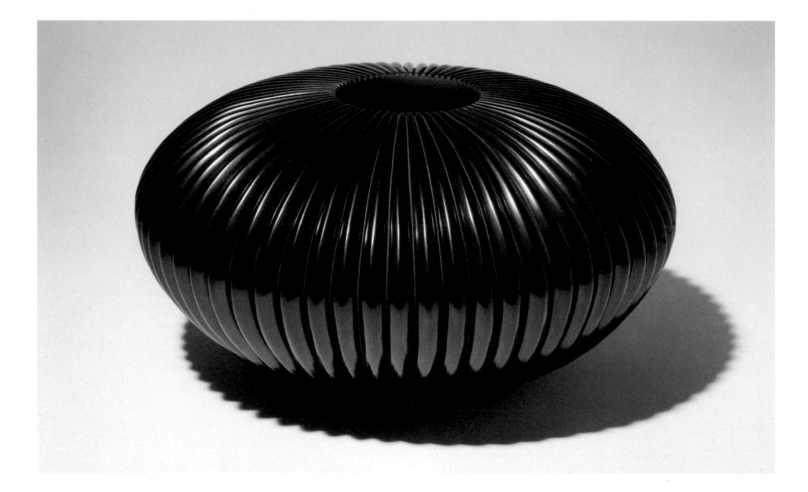

Nancy Youngblood Lugo (above) Melon bowl, 1995. Blackware; 6¾ × 13 in. dia. Collection of Sid and Char Clark. Photograph by Craig Smith

Nancy Youngblood Lugo (opposite) Swirl bowl, 1996. Blackware; 5½ × 7½ in. dia. Collection of the artist. Photograph by Craig Smith

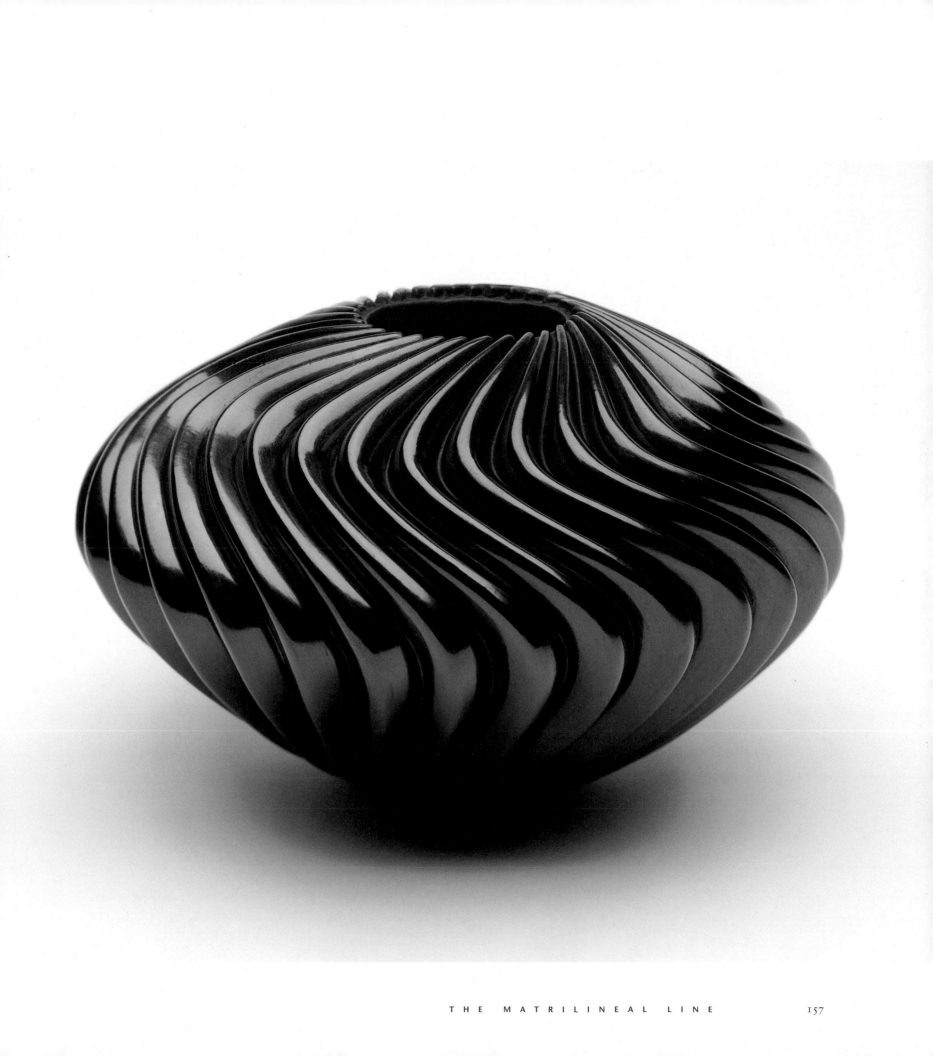

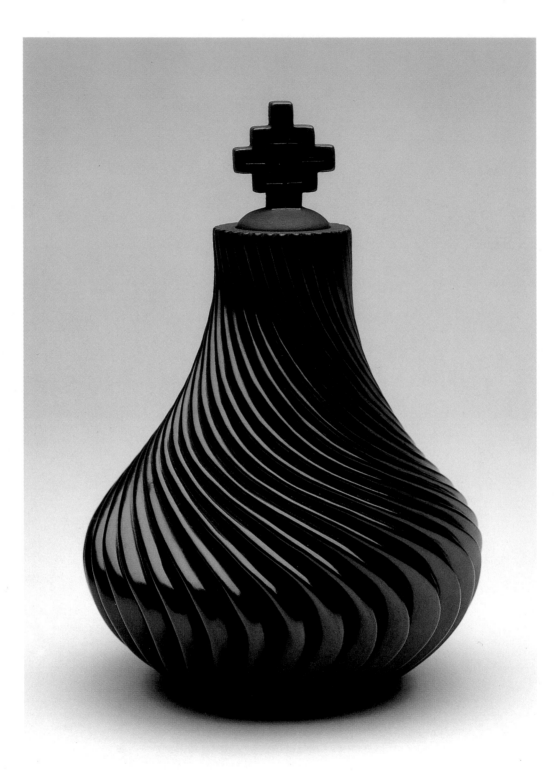

Nancy Youngblood Lugo Lidded swirl-style jar, 1991. Blackware; 7⅝ × 5¼ in. dia. Collection of Sid and Char Clark. Photograph by Craig Smith

Elizabeth "Buffy" Cordero-Suina

Buffy Cordero-Suina, a Cochiti Indian born in 1969, is the granddaughter of Helen Cordero. Like her grandmother, Buffy sculpts Storyteller figures rather than fashioning pots. She is the only living descendent of this matriarch to continue potting.

Buffy's father, George, was the son of Helen Cordero, the famous Cochiti Pueblo artist and creator of Storyteller figures. The youngest of the matriarch's descendants discussed here, she lives at Cochiti with her husband and their two small boys. She remembers that she used to live behind her grandmother when she was a child. The young girl sat day after day at Helen's worktable, asking, "What are you making today?" Buffy laughingly recalls one day when she was about eleven years old; "My grandmother just threw me a piece of clay without saying anything. So I made a little animal that wasn't too bad!"

Photograph by Susan Peterson

Buffy claims not to be very good at making bowls or other pottery forms. She states that her grandmother wasn't either, and suggests that this may be the reason they prefer making figures. Buffy mixes one-third pumice (volcanic ash), which comes from the reservation, and a little sand with the gray clay from the sacred spot that her grandmother preferred over the more abundant red clay. A white slip is applied on the finished clay surface and softly polished before the painting detail is brushed on with natural mineral paints.

"I'm a competent potter," states the young artist. "I do what grandmother said. I don't work on feast days or on Sundays. I don't fire when it's wet or windy. I don't fire if anyone is watching, except my family. Helen wouldn't fire if anyone watched. Fire is special and critical so I learned from her. I'll continue to make Storytellers because I like what Helen did. I don't want to use weird color paint. If I do anything new it will come from pueblo life, the scene here, the dance, the ceremonies—not tourists, not ladies, not mermaids like the old folks made years ago."

"My mother, Kathy, is Spanish and she doesn't make pottery. But my father did, and I helped him. My father, George, died in 1990; Helen died in July 1994; and grandfather, two months later. I'm young, I have time. I don't make as much as a lot of other potters here do, but I keep Helen's place at the Santa Fe Indian Market. I always go because Helen told me to keep the booth; no one else is left in my family to keep the tradition going."

Buffy says that she also goes to the Annual Guild Indian Fair and Market at the Heard Museum in Phoenix every spring. She explains that she doesn't have time, with her children and her husband, Jerry, to care for, to go to other shows; she admits that she does not like being asked incessant questions about what is a Storyteller or what is pottery. She says she and her family are very busy participating in the Indian "doings" at Cochiti and are on hand for every dance, so she only has time for a few shows each year.

Buffy's Storyteller figure usually has a dog somewhere around, in addition to the children. "It's my own innovation. My children like dogs. I think my trademark is a little boy lying down, or standing with his hands on his hip like my own little boy who is lazy!" Buffy says she also makes a separate figure with the children spread around on the floor, "like a Children's Hour at the library. Helen did that too.

"What I like about Helen's and my figures is that the proportions are right. A lot of potters have Martian-like figures or cutesy figures; I try not to. Grandmother said don't make the kids too skinny. Her Storytellers changed from the beginning, from doing the first Storytellers I think, she got better and better proportions—children to the storyteller, drums, legs got better."

Buffy knows that by just working with the clay you get better; you know if it looks right. "It comes out of my head," she says. "Helen never took pottery out of my hands to fix it. She just encouraged me, saying, 'Yes, you're doing good.' We joked together. I watched her, she talked about how to make the figures stick together. You know she didn't have a neck on her figures. I have a neck so I had problems. Then I added a coil to help me attach the head and arms. I like the neck lift.

"Helen said to fire alone. She thought people being around might have bad feelings that would get in the clay. She also said to be happy, work when you feel happy, so now I always think of grandmother when I work. She knew that happy thoughts are important for claywork," says Buffy, smiling through her own tears.

Elizabeth "Buffy" Cordero-Suina (opposite) Storyteller, 1996.
Polychrome; 11½ × 9 × 7 in. Collection of the artist.
Photograph by Craig Smith

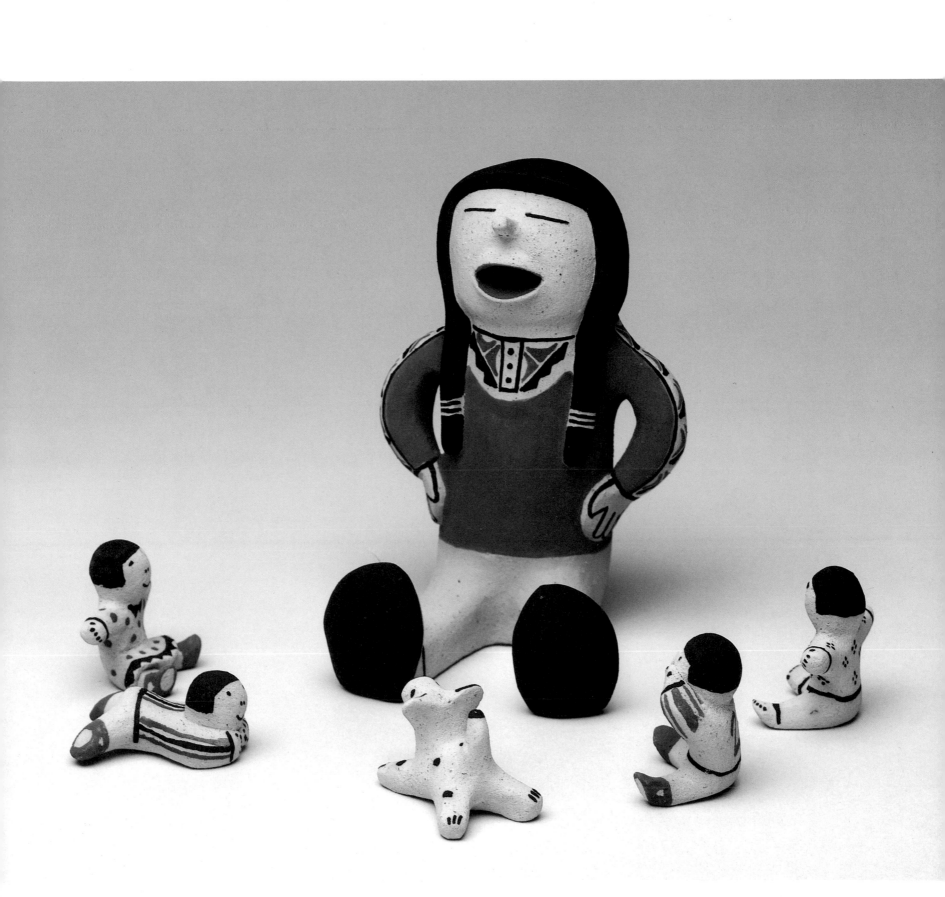

Diane Calabaza-Jenkins

Born at San Ildefonso Pueblo in 1955, Diane Calabaza-Jenkins is one of the many children of Blue Corn. Maintaining the traditional foundations of her mother's technique, Diane explores styles that are both ancient and modern. Like her mother, she makes strong use of colored clay in her work.

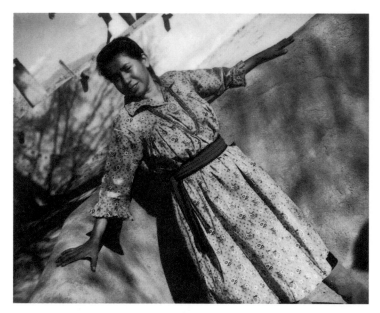

All of Blue Corn's children helped their mother with the chores of Indian pottery making—gathering and processing the clay, mixing in the volcanic ash, gathering wood and cow chips, and helping with the firing. Diane has accompanied her mother on pottery-demonstrating workshops over the past twenty years, learning everything that could be learned by watching.

Today, although she also teaches preschool in Santa Fe, this artist continues her mother's innovation of using unusual clay colors in polychrome technique on her pottery. Blue Corn was famous for the green, yellow, red, orange, and tan clays she used for decoration and prospected from secret spots on the reservation. Diane has studied various clayworking techniques and wishes to continue developing her knowledge of the art of pre-Columbian, Columbian, and contemporary Indian styles of pottery.

Diane says that her ancestors fired pottery in a pit using lava rock, sandstone, and "cedar" (juniper) wood. She says that it was the Europeans who inspired native people to incorporate metal, brick, and animal dung into their open-firing process. Because Diane's work is polychrome, it is fired in an oxidizing atmosphere in an outdoor bonfire.

Diane gives her own workshops now, and she uses her Indian name, Seashell Flower, to sign her pottery. She has exhibited her pottery with her mother's work all over the country.

Diane Calabaza-Jenkins (clockwise from left) Bowl with feather design and rain falling in distance, 1996. Red-on-white, $5\frac{1}{4} \times 4$ in. dia. Bowl with cloud design, 1996. Red-on-white, $6 \times 6\frac{3}{4}$ in. dia. Bowl with straight feather and cloud designs, 1996. Red-on-white, $4\frac{3}{4} \times 4\frac{5}{8}$ in. dia. Bowl with cloud design, 1996. Red-on-white, $3\frac{1}{4} \times 5$ in. dia. Collection of the artist. Pictured in the background is a metate used to grind clay. Photograph by Kreig Calabaza

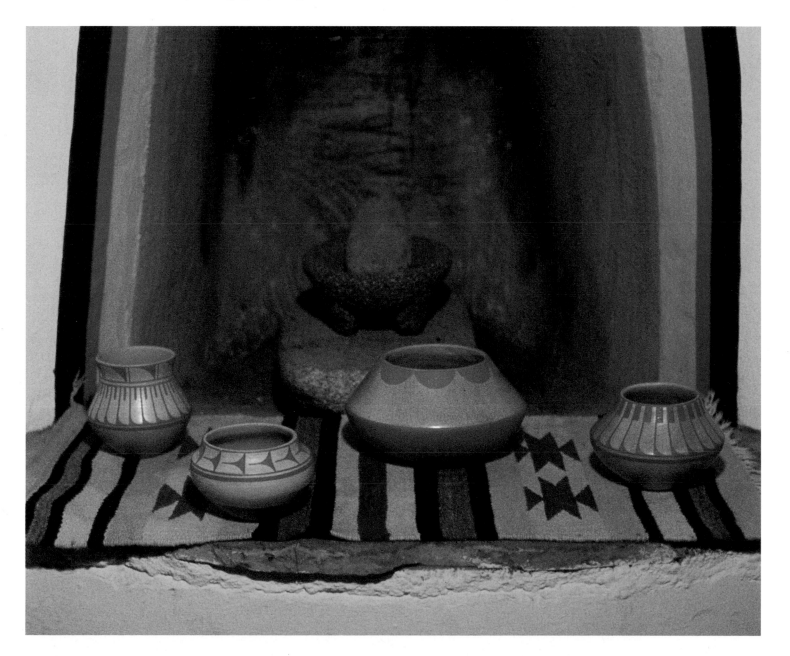

The Avant-Garde

In recent decades, the matriarchs and their descendants have inspired a number of American Indian women of rare and innovative ability. These craftswomen have forged artistic paths in many new directions, creating an avant-garde of American Indian pottery. Driven by unknown forces toward unusual aesthetic accomplishments, they create works that defy traditional definitions.

Some "new generation" women, born with unusual vigor and drive, have chosen to live in two worlds, balancing both Indian and Anglo cultures. Many have gone to college and have learned about the history of world art. Others have left the tribal homes of their youth to reside in cities. The ceramic art practiced by some of these women is executed in non-traditional materials and techniques, drawn from the Anglo ready-made marketplace. Most of these Indian women struggle with dealers and agents in the same way Anglo artists do.

All of the artists featured here, however, have chosen to maintain traditional Indian lifestyles, and acknowledge the specific traditional influences that shape their work. They pay tribute to the vision of their elders, and then proceed in their own ways—stretching and experimenting, sometimes breaking barriers to stray far from original ideals.

While many of these trailblazers have been isolated in the midst of their tribal indigenous culture, they have shown remarkable integrity—striving independently to "make art" in order to relate to a confining culture in a positive way. These visionary women have achieved personal freedom while reconciling their obligations to the community, both giving and receiving inspiration.

Dorothy Torivio (detail, opposite) Vase, 1995. Polychrome; 10½ × 9¼ in. dia. Courtesy Andrea Fisher Fine Pottery, Santa Fe, New Mexico. Photograph by Craig Smith

Alice Cling

Navajo artist Alice Cling was born around 1946 in a hogan at Cow Springs, in the Tonalea section of Arizona. Her pots, embellished with the traditional thin coat of pitch, are deceptively simple. Their lasting beauty comes from her unusual use of clay and from the striking colors caused by outdoor firing.

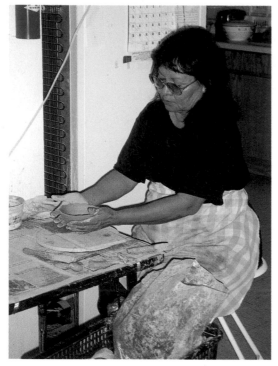

Photograph by Sally Martinez

Alice learned how to make pottery from her mother, Rose Williams, an innovative Navajo potter who had been trained by her aunt, Grace Barlow, who had raised Rose at Shonto. Grace, Rose, and Alice have been the inspiration for many Navajo potters who have recently tried to make pottery for the "market." Navajo clay-work for hundreds of years was made for domestic or ceremonial use only. No railroad stations or museums existed in this vast, sparsely populated desert landscape to spark a demand for tourist goods or for scholarly endeavors that would bring the art of potters to the fore.

After graduating from an Indian school, Alice married Jerry Cling. They have four children who make pottery now, too. The family digs the brown-firing clay from a special place near Black Mesa, screens it to eliminate impurities, and mixes it with sand for temper and with water to make it workable. Alice's particularly unusual aesthetic contribution to the Navajo pottery renaissance is the magnificent coloration she achieves on the softly burnished and lightly pitch-coated surfaces of her forms.

Alice says that these elegant, gracefully austere forms did not come to her easily. Her first pots twenty years ago were "so ugly" that she vowed to keep shaping and polishing her clay "until it was beautiful." She applies an iron-bearing slip to the finished dry clay form and polishes the surface with a riverwashed stone or a Popsicle stick. She says that some women use corncobs to burnish. The chemistry of the clay body and the clay slip, the atmosphere in the fire, and the ash that falls onto the pots from the juniper wood combine to produce the red-orange-purple-brown-black blushes that enhance the unusual veneer of Alice's pots. Through trial and error, she has developed her own techniques.

Alice applies a light coating of warm pitch to the warm pots after firing, and burnishes that down to a distinctive low sheen. Usually her pots are totally undecorated except for the natural pigmentation from the clay and the fire. Many traditional Navajo storage jars have a *biyo*, a beaded necklace around the shoulder of a vessel made from a textured coil of the same clay. Alice does not like to use decorations because her grandmother disapproved of using the traditional designs on nonutilitarian wares. Instead, Alice allows the beautiful pigmentation to serve as the decoration, thus forging an original path for the works she creates.

Several of Alice's jars were chosen by Joan Mondale for use in the vice president's house in Washington, D.C., during their tenure, along with the art of other contemporary American craftpersons. Alice has taken numerous awards at Flagstaff and Santa Fe Indian fairs and powwows. Alice's work is unmistakably Navajo but has flair that sets it apart from any other Indian pottery being produced today.

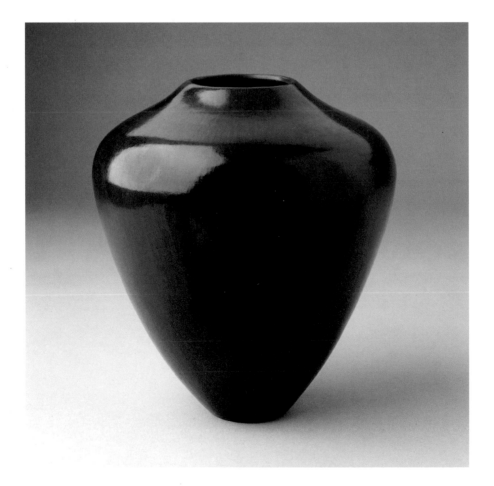

Alice Cling Jar, 1995–96. Redware; 9 × 8 in. dia. Collection of Judith and Stephen Schreibman. Photograph by Craig Smith

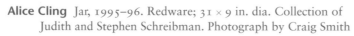

Alice Cling Jar, 1995–96. Redware; 31 × 9 in. dia. Collection of
Judith and Stephen Schreibman. Photograph by Craig Smith

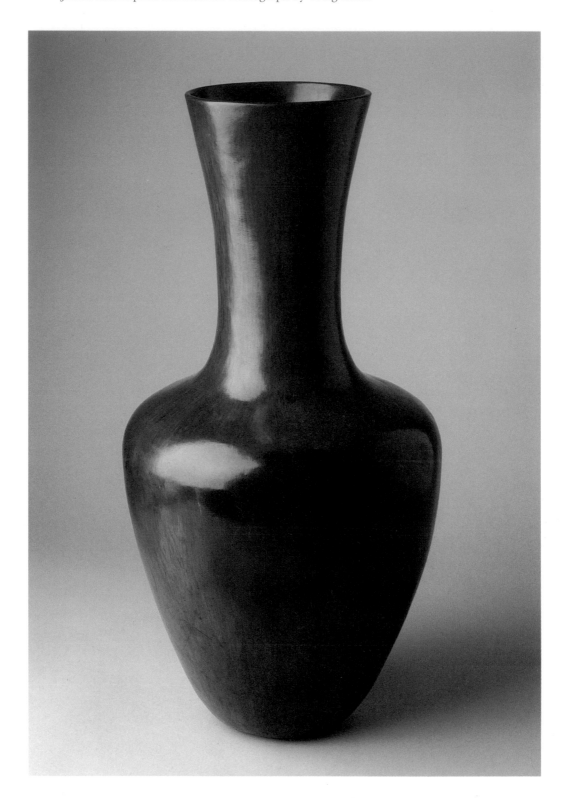

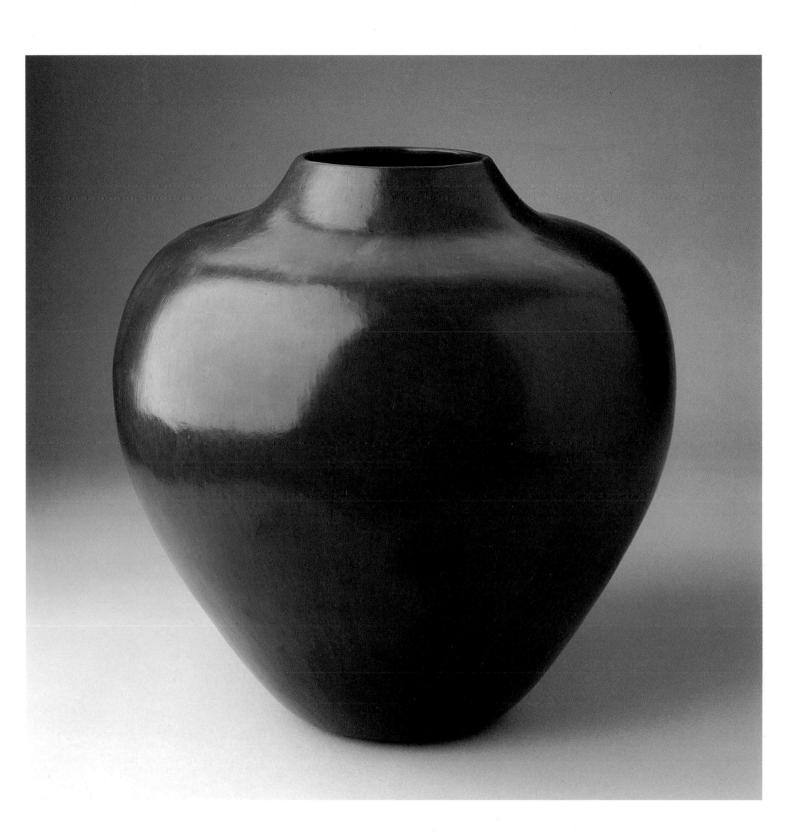

Alice Cling Jar, 1995–96. Redware; 12 × 12 in. dia. Collection of
Judith and Stephen Schreibman. Photograph by Craig Smith

Anita Fields

Anita Fields, born in 1951, belongs to the Osage and Plains Indian community in the Midwest. She was probably the first Indian potter to create conceptual installation pieces, and she often incorporates abstracted images of traditional clothing and artifacts. Her use of domestic motifs is intended to honor all women, particularly those of Indian descent.

Photograph by Tom Fields

Raised in Hominy, Oklahoma, Anita is one of a few American Indian potters who do not live in the Southwest. Although the entire country we now call the United States of America was once populated with potters of all Indian groups, the mainstream of continuous clay tradition exists today in the twenty southwestern pueblos in New Mexico and Arizona and in the Navajo nation.

Anita was influenced by traditional Osage ribbon work, clothing, and blankets. She also studied the objects and ceremonial dress of other tribes. The personal and emotional elements in these textile designs led Anita to use them symbolically in clay, translating the personality of these vestments into her work. About one of her recent series, Native American Dresses, which are coil- and slab-built installations, Anita says: "The dresses convey my attitudes toward the strength of women and how native peoples show remarkable resourcefulness and adaptability toward their environment. The clothing Indian women created shows great pride, dignity, and hope in a culture facing insurmountable odds."

Making art was Anita's earliest desire. She has been doing it in one form or another from childhood. "It was an intuitive thing; I knew I was doing something right." She attended Santa Fe Indian School, married, had children, and made functional pottery. Seven years ago, after completing a college degree, she made a commitment to change direction, becoming a full-time clay artist. "Response to clay is so immediate," she explains. "I believe it's the tactile quality, the involvement with the material and with the process that intrigues me—I take it from the earth and make something out of my head."

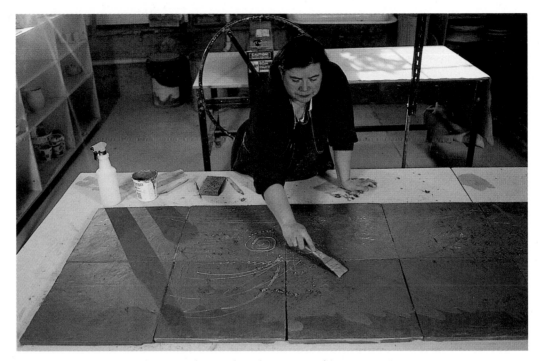

Anita Fields works on *Elements of Being* for *The Legacy of Generations* exhibition. Photograph by Tom Fields

By working the clay in the indigenous fashion of making handbuilt earthenware, Anita feels that the material is transformed into this powerful medium because it was created by the natural forces of the earth and time. She says she fuses her thoughts and ideas with the clay's vitality.

Anita finishes her work with softly-colored terra sigillatas, as did the ancient Greeks. This very fine clay slip coating is applied on the surface before the pieces are dry. The sigillata can then be stone-polished to produce a sheen or left unburnished to look and feel like raw earth. Anita's work is usually fired in an electric kiln and finished by a postsmoking process with sawdust, straw, or leaves. Many times she adorns nonsmoked sculptures with tiny rakued additions, such as the elk teeth on sculptures of native costumes.

Anita lives in Stillwater, Oklahoma, with her Osage husband and three children. They participate in the nearby Osage community ceremonials and other events, such as social gatherings and the feasts where the ritual is "putting out the food" to share. "We live in a time that is difficult for our culture. My grandmother gave me my Indian heritage, and I give it to my family because I know it will give them strength.

"My dream pieces go along with understanding who I am. My most prized possessions were my grandmother's clothes, which she gave me for me to know who she was. My works that have figures in them I want to feel are generic, not anyone

in particular, but spiritual. I want to show the spirituality of us as women, how we fit into a family, how we remain strong yet filled with love, and how we overcome all difficulties."

Anita believes that it is the spirit within, the strong human spirit, that transcends cultural boundaries, and she is intrigued with trying to impart that idea through her claywork. Her multiple-piece installations as well as her iconlike sculptures are artistically significant. Her work sets her apart from other American Indian artists because she is so involved in living and parodying her own culture.

"It takes a long time in this life to know yourself. Clay is my narrative, reflective of my journey."

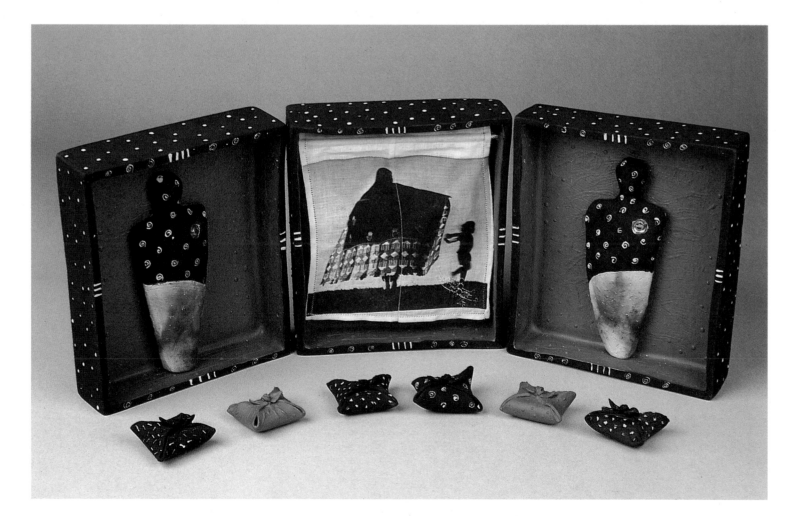

Anita Fields *Elements of Her Being,* 1994. Polychrome with terra sigillata, gold leaf, and sawdust; 6 × 5 × 3 ft. Collection of the artist. Photograph by Tom Fields

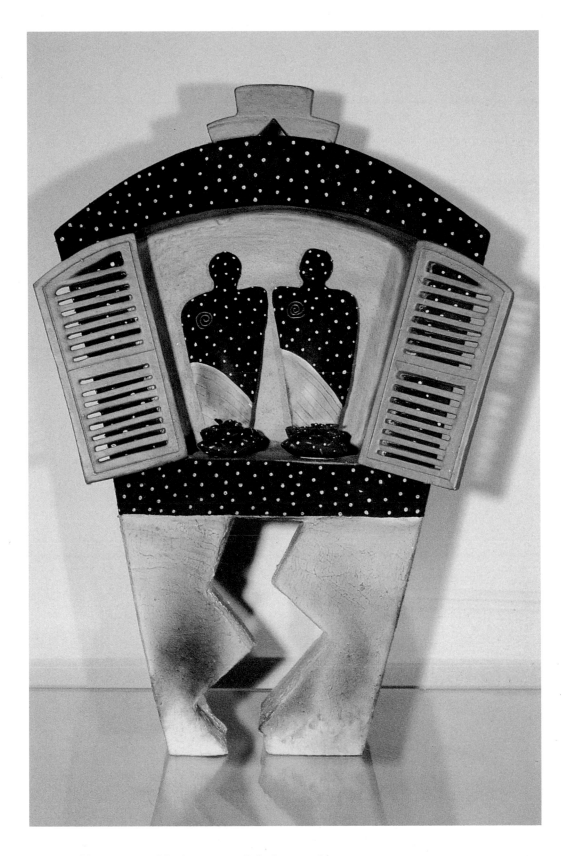

Anita Fields *Woman of the Stars*, 1994. Polychrome with terra
sigillata, gold leaf, and sawdust; 27½ × 16¼ × 6 in.
Private collection

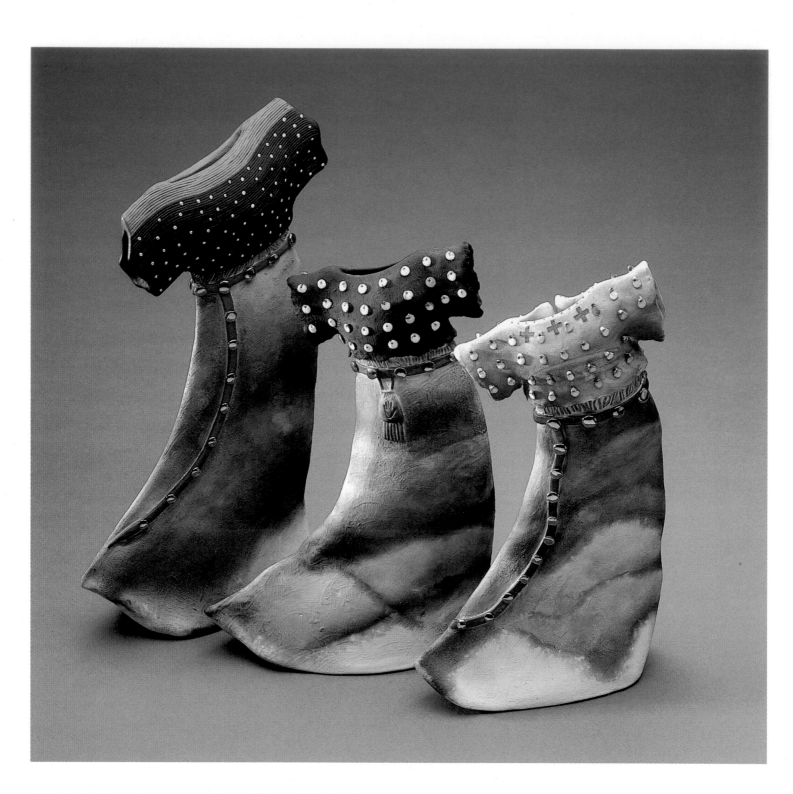

Anita Fields Three dresses, 1995. Terra sigillata, gold leaf, and saw-
dust; $19\frac{1}{2} \times 8 \times 3$ in., $18 \times 10 \times 4$ in., and $17\frac{1}{2} \times 11\frac{1}{2} \times 4$ in.
Collection of Sherre Davidson and Private Collection.
Photograph by Sanford Mulden

Jody Folwell

Jody Folwell, born at Santa Clara Pueblo in 1942, is one of the best-known of the avant-garde potters. She consistently finds new ways to draw attention to controversial political and social issues through her remarkably plainspoken pots. Her works are meant not as utilitarian pottery, but exclusively as works of art.

Photograph by Chad Penhallow

One of nine children in the accomplished Naranjo family, Jody is one of the most renowned American Indian clay-workers. She is known for the many innovations she has instigated in the art of the pot. Her mother, Rose, is an accomplished potter.

Lee Cohen, the now deceased owner of Gallery 10 in Santa Fe, told me not long ago that he thought Jody Folwell was the first Indian artist to make good, innovative, off-round, uneven-lipped, asymmetrical polished pots. He referred to Jody as the "first impressionist potter" and said her ideas were very different from those of anyone else working in clay. He thought this even then, over twenty years ago, when Jody was just beginning to make these types of pots. "She was flying in the face of resistance," Lee said, "and she will always be on the edge fighting the odds."

Lee met Jody at the Santa Fe Indian Market before he had a gallery. He bought a group of Jody's asymmetrical pots from her and told her he felt she was making a breakthrough in her work. An architect by trade, Lee had a good eye for form and design; he eventually opened an Indian art gallery in Scottsdale, Arizona, and was an early champion of Jody's unusual pots. "Lee was touched by God," says Jody. "I believe he was one of the clay spirits."

Jody has become known as a nationally prominent artist and was from the beginning promoted by Lee as such, not necessarily as an American Indian, but rather as a contemporary American artist.

Having probably always had a deep sense of social injustice, Jody believes in making statements, both in her speech and with clay. She senses that times are changing constantly, and she tries to keep up with the changes enough to make statements that will affect people. In a culture where harmony is a most valued element, Jody has taken on a challenging role.

We sit quietly looking at the special jar with a dog design Jody has made for the exhibition. This piece calls to my mind Jody's belief in the importance of bringing personal values into her work, in this case her compassion for animals. To Jody, accomplishment is important; it is vital that you work until you drop and that you be connected outside your own self. Living between two worlds, as she does, has given this remarkable artist unique insight.

Jody's satirical pots are so well designed and executed that the casual viewer may not be aware of the significance of the decoration. Jody often uses words, letters, or parts of words as symbols on the surface of the clay or integrated with the form. Each pot of this kind has an important story, a real reason for being, and it is probable that most collectors who buy such pieces have some understanding of her meaning.

Each of Jody's clayworks is vastly different from the others; there is no repetition for the sake of repetition here. Some of the pieces are beautiful for the finely polished surface and the gracefully incised designs embellished with colorations from the bonfire. Others are caustic, with satirical elements illustrating the statement she wishes to impart. Still others are contrasts in matte and shine or in colors, or sit precariously in light of their width. Each piece has a life of its own. Jody will tell you that's where all of the power exists.

"I do not think of my work as pottery," she admits. "I think of each piece as an artwork that has something to say on its own, a statement about life. I think of myself as being a contemporary potter and a traditionalist at the same time. Combining the two is very emotional and exciting to me."

Jody Folwell (opposite) *Iran Contra–Ollie, Hero or Idiot,* 1986–87. Redware; 16 × 10 in. dia. Courtesy Eleanor Tulman Hancock Inc., North American Indian Art. Photograph by Allan Finkelman, © 1996

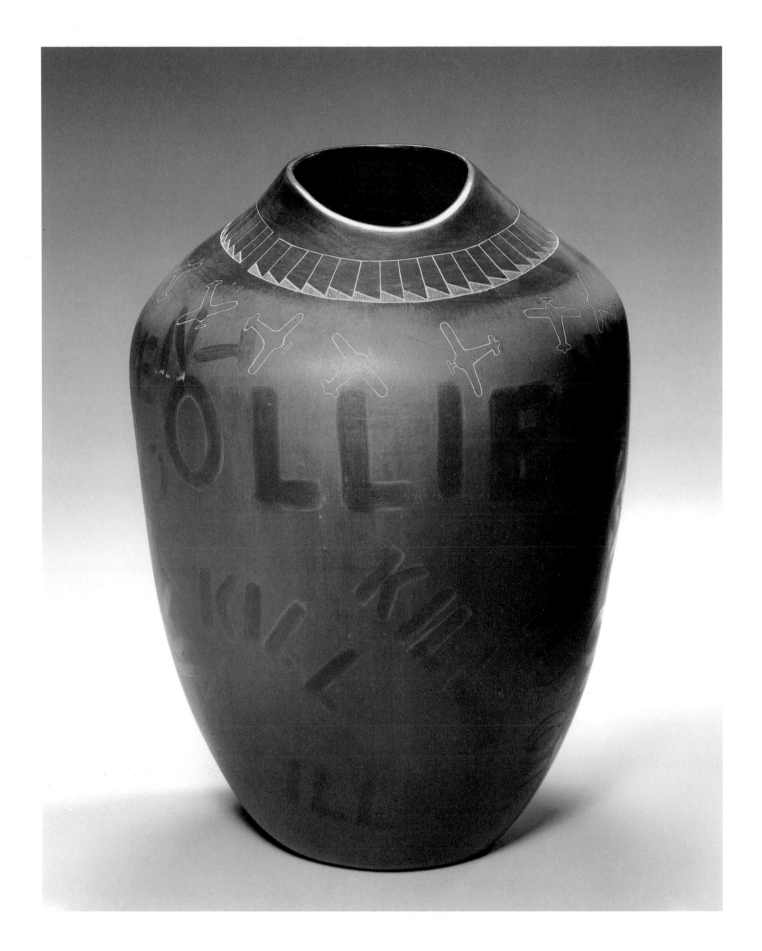

Jody Folwell Jar with incised eagle design, c. 1987. Micaceous clay; 8 × 9 in. dia. Collection of Marjorie and Charles Benton. Photograph by Rob Orr

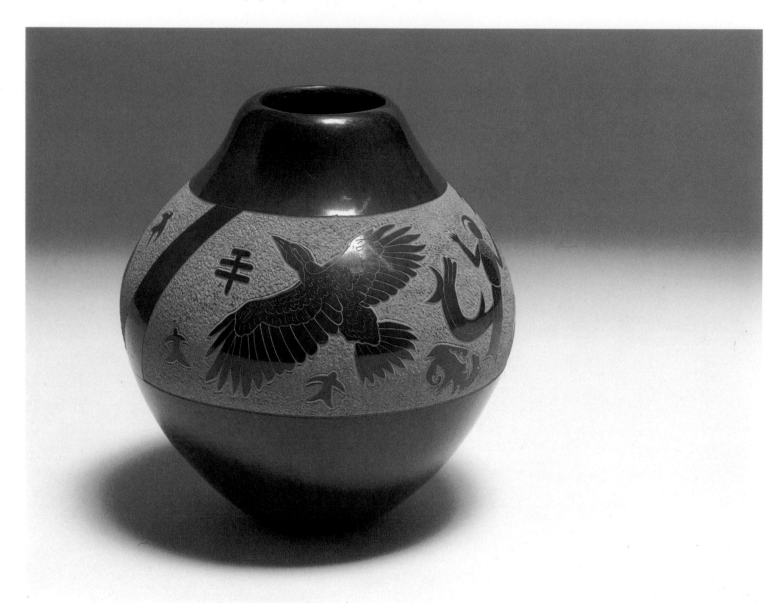

Jody Folwell (opposite) Lidded jar with dog motif, 1996. Redware; 24 × 13 in. dia. Collection of the artist. Photograph by Craig Smith

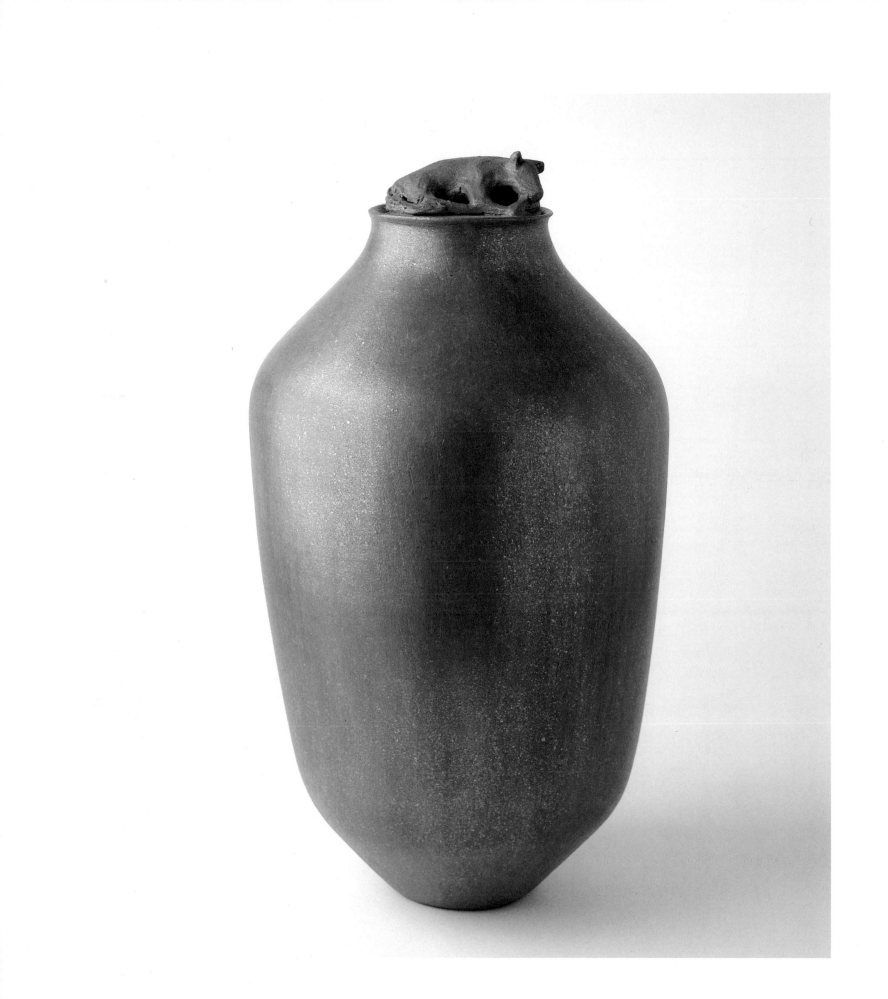

Jean Bad Moccasin

Born in Europe in 1947, far from the lands once traveled by her Lakota-Sioux ancestors, Jean Bad Moccasin has struggled to reconcile the many different aspects of her ancestry. Today, she revives her Sioux heritage through innovative, colorfully painted designs, featuring recognizable Indian and Anglo motifs.

Descendants of one of the largest groups of migratory Indians of the northwestern United States, Jean's family wandered further than most; she was born in a refugee camp in Hanover, Germany, in 1947, to a Lakota-Ukrainian mother and a Ukrainian father. Her maternal grandfather, Bad Moccasin, was a member of the Hunkpapa branch of the Lakota nation who traveled with Sitting Bull to Europe as part of Buffalo Bill's Wild West Show. Her grandfather remained in Europe and married Jean's maternal grandmother.

Jean's family migrated to the United States in 1951, settling in North Dakota and later moving to Chicago. Jean says that she found it difficult to empathize with so-called Anglo culture and remained a loner. It was not until some years later that her mother revealed to her her own American Indian heritage. After a disastrous marriage and several personal tragedies, she remarried again, has two daughters, and now lives with her family in Spring Grove, Illinois. When Jean finally realized her Indian heritage, she became obsessed with learning about it and now assiduously attends powwow dances and various ceremonials in her home area.

Jean studied books about southwestern pueblo pottery and "felt a compulsion to paint Indian designs." Using a commercial clay, she started out by hand-building her own simple round forms with "kiva-step" openings and low, flat, oval shapes with no openings. A hobby shop's electric kiln and commercial, matte-surfaced underglaze colors with no glaze coating amplified her early efforts. To perfect the hand-formed surface, she used the traditional Indian technique of stone burnishing, but then added a superfine solution of watery clay called terra sigillata (as did the ancient Greeks) and repolished the surface for a better background for drawing.

With a grand sense of design, Jean's colorful painting parodying traditional Indian symbols or recognizable Anglo institutions—Indians refer to all non-Indian cultures as Anglo—has become the trademark that attracts her collectors. She is working *from* the tradition (but not *in* the tradition) of American Indian pottery.

Jean has been adopted by a Dakota spiritual teacher. As his daughter she has enjoyed the pleasure of his wisdom. Jean is finishing a bachelor's degree at

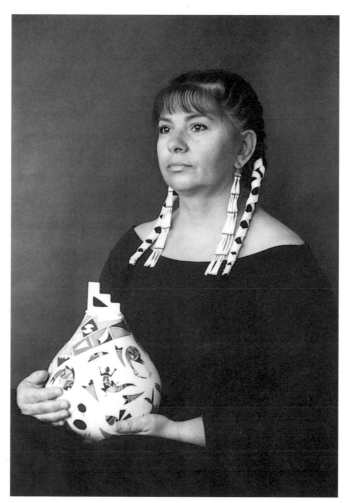

Photograph by Stanley Szewczyk

Columbia College in Illinois with a major in clinical psychology, so that she can help with the many serious problems of the Indians in her community on and off the reservation.

The tribal history that was denied her in her childhood is being realized on the Pine Ridge Reservation in South Dakota, where she and her children spend summers so that they can all be included in the language and customs of their people. She expects to move nearer to the tribal community with her children in the near future. Jean's art may become more serious, influenced by this move, but my guess is that her sprightly drawings will retain their whimsical and personal touch.

"In life there must be a balance. Balance expresses the duality of all creations, that of the body and that of the spirit. One is a mirror image of the other. When there is a balance there is harmony. When there is harmony true beauty exists," declares this young artist, balancing herself on the fringe of two cultures.

Jean Bad Moccasin Front and back of the *Two Nations* vase, 1996. Polychrome; 16½ × 11¼ in. dia. Collection of the artist. Photographs by Stanley Szewczyk

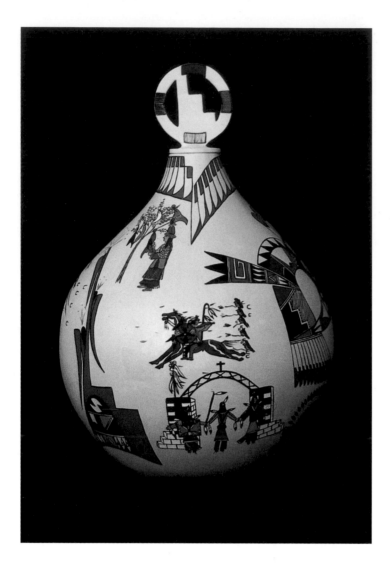

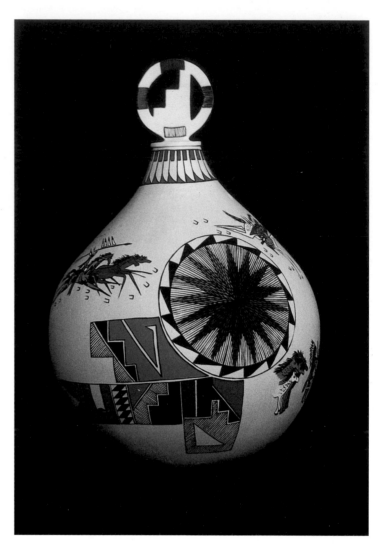

Jean Bad Moccasin (opposite) Kiva-step vase, 1993. Polychrome; 10½ × 11¼ in. dia. Collection of Mr. and Mrs. William Freeman. Photograph by Craig Smith

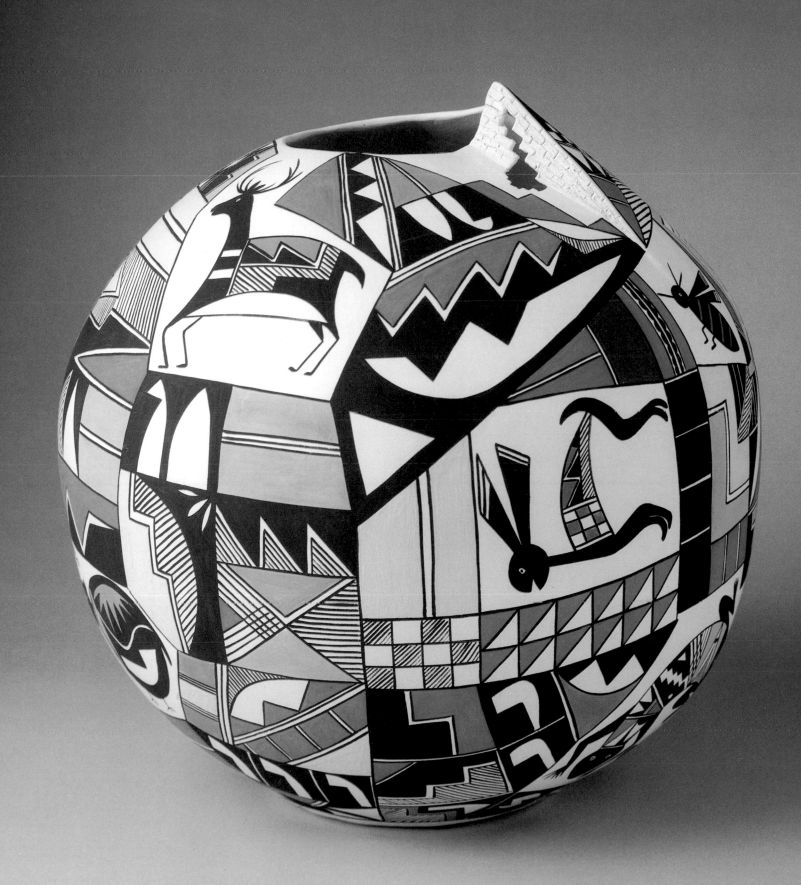

Nora Naranjo-Morse

Nora Naranjo-Morse, born in 1953, is a potter and a poet with an unusual world view, though she lives a traditional life at Santa Clara Pueblo. Her pointedly satirical figures and huge conceptual installations make her one of the most exciting Indian artists of her generation.

"For hundreds of years Pueblo people have treasured their powerful relationship with clay," writes Nora in the preface to her book of poetry, *Mud Woman*. "Veins of colored earth run along the hillsides of New Mexico, covering remote trails with golden flecks of mica. Channels of brown and scarlet mud wash across the valleys, dipping and climbing with the sprawling landscape. Intricately woven patterns of clay fan out under the topsoil, carrying the life of pottery to the Pueblo people."

Nora, youngest daughter of Rose Naranjo, a well-known Santa Clara–Laguna potter, has eight siblings, all of whom have made pottery at one time or another in their lives. Nora remembers that years ago they gathered clay together and while their mother was making a pot, she gave pieces of clay to her children to work too.

One of Nora's important recollections is of watching her mother one night when Rose was sitting on a small stool making a huge pot out of micaceous clay that was "testing her boundaries." Nora was so impressed with Rose's wondrous look of peace and accomplishment that she never forgot it. Rose's serene countenance that night inspired Nora to work with clay.

After Taos High School and the College of Santa Fe, taking ten years to get her bachelor's degree, Nora traveled and wrote poetry. Then she married, had two children—girl and boy twins, who she says have changed her life—and built her own house. Today she is confident that she can do almost anything she wants. The major events in her life have made her more zealous and directed in her own way.

Nora's large figures, which are now in museums and private collections, are generally concerned with satirical notions playing on Anglo and Indian lore; several figures of Pearlene—a Pueblo character she created—have in particular made Nora famous. As the artist says, her work is so different that there is often no place for her in the Indian markets of the Southwest. But she professes not to be concerned. "I'm an open vessel. I never know what life's experiences will give me, what opportunity will inspire my creativity. That is why it is essential to my creative process that I remain open to absorb information, feel emotions, and ultimately react, whether I'm forming a sculpture, filming, or choosing words.

Photograph by Tamea J. Mikesell
Courtesy of the Heard Museum

"I'm in the Indian world too. I want to believe that any of us can do what we want. I didn't a lot of my life because I was afraid of what people in the village would say. I learned that no matter what culture, there are limits.

"Coming from a strong cultural base allows me to appreciate the creative process. Pueblo thought celebrates and utilizes creativity as an intrinsic component to our world view. I hear the drum beat during a ceremony, and I am moved from that place which shelters my soul and encourages my imagination. It's in this wondrous gift that I feel the courage to expand my creative boundaries."

In 1983 Nora went to Germany to teach, taking her three-year-old daughter and a big bag of clay. She had a rapport with the German women, who reminded her of her aunts at Santa Clara. Nora attended the Women's Conference in Beijing in 1995 and took her fifteen-year-old son to that. She has been exposing her children to the world all along, and now they are attending the American Indian Preparatory School in Rowe, New Mexico.

Although the act of making pottery is practiced traditionally as a communal art in all Indian villages, today collectors vie for unique pieces and the demand has shifted to individual expressions by name artists. Indicative of the changing values, so-called contemporary Indian claywork can command as much money as a good painting does in New York City galleries. Nora often creates atypical conceptual

installations composed of a number of ceramic objects. If living an Indian life was not a high priority for Nora, her provocative work would easily secure her a place in the New York City art scene.

"There is no word for art in the Tewa language," recalls Nora in her book. "There is though the concept for an artful life, filled with inspiration and fueled by labor and thoughtful approach. The process of recording my life through clay and poetry results in an exciting volley of creative expression for me."

Impressed as I was by what I had seen of Nora's work in several museums, and having gone to meet her in her studio at the pueblo, I asked Nora to do a special piece for *The Legacy of Generations* exhibition—anything she wanted, but something that she might not have made otherwise. The tallest of the group of four figures that she made for the exhibition—she said it "stretched" her—was 11½ feet tall unfired. It was so large that it had to be fired in a large gas kiln rather than in a ground pit-fire. Once all was said and done, the work measured 8½ feet, having shrunk three feet because of artistic adjustments and firing.

The other multi-piece installation she created for us to choose from covered one large room. Nora and her niece, Roxanne Swentzell, are among the most innovative Indian women working in clay today.

"I know that I have something powerful in me, whatever happens I have that. I *am* changing. I'm writing; I'm doing monoprints, videos. The clay is changing— I'm doing larger pieces. My experiences pile up and get incorporated. I feel more certain now. When the time is right new things happen. I never know. I'm excited. I never know what will happen!" Nora repeats this exclamation over and over, literally bouncing up and down with the pleasure of these thoughts and with passion for the future.

Here is a poem about Nora's strong connection to clayworking, from her book *Mud Woman: Poems from the Clay* (University of Arizona Press, 1992).

WHEN THE CLAY CALLS
This clay starts calling to me only days after I've sworn it off
　　wishing to leave tired hands to rest,
　　wanting to release myself from the browns and reds
that bend easily into gentle curves,
　　instantly becoming a child's face,
　　a woman's skirt, or her husband's smile.

Resting from lines I review,
　　have reviewed,
　　　　and will review again.

Dusting off the sanded earth
 as coarse surfaces level into fluid forms
 I had not yet discovered,
 so smooth and yet richly textured with life of its own.

I am in awe of this clay that fills me with passion
 and wonder.
 This earth
 I have become a part of,
 that also I have grown out of.

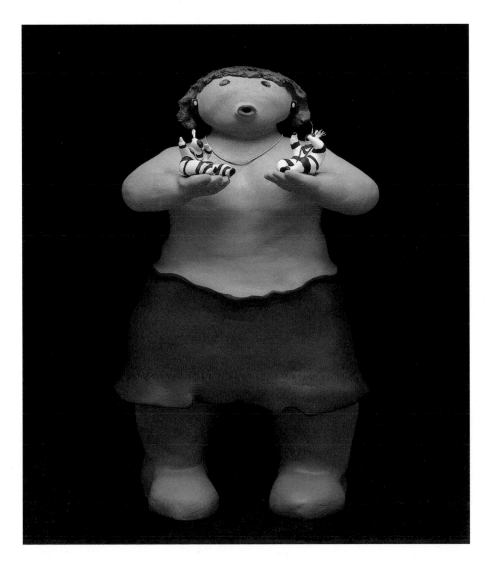

Nora Naranjo-Morse *Pearlene*, 1987. 38 × 16 in. dia. The Heard Museum, Phoenix, Arizona. Photograph by Craig Smith

Nora Naranjo-Morse Four figures, 1996. From 4½ ft. × 11 in. dia. to 8½ × 1½ ft. dia. Collection of Sara and David Lieberman. Photograph by Craig Smith

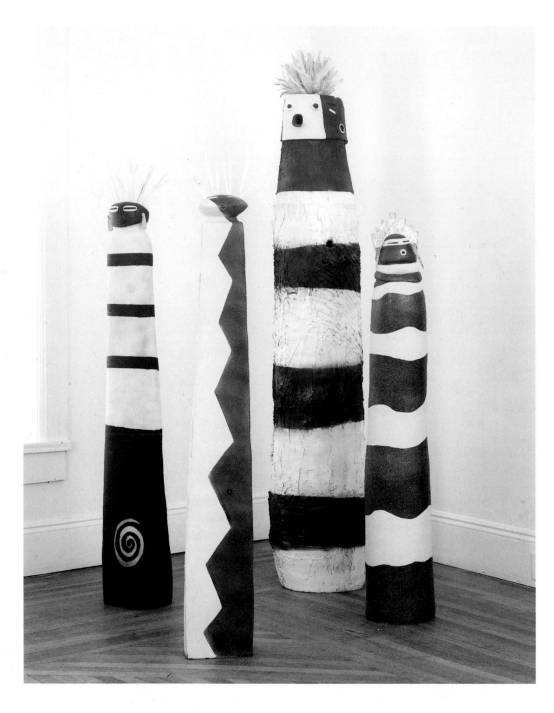

Nora Naranjo-Morse (opposite) Mud woman with pot, 1991. 28 × 18 in. dia. Collection of Carol and Charles Gurke. Photograph by Mary Fredenburgh

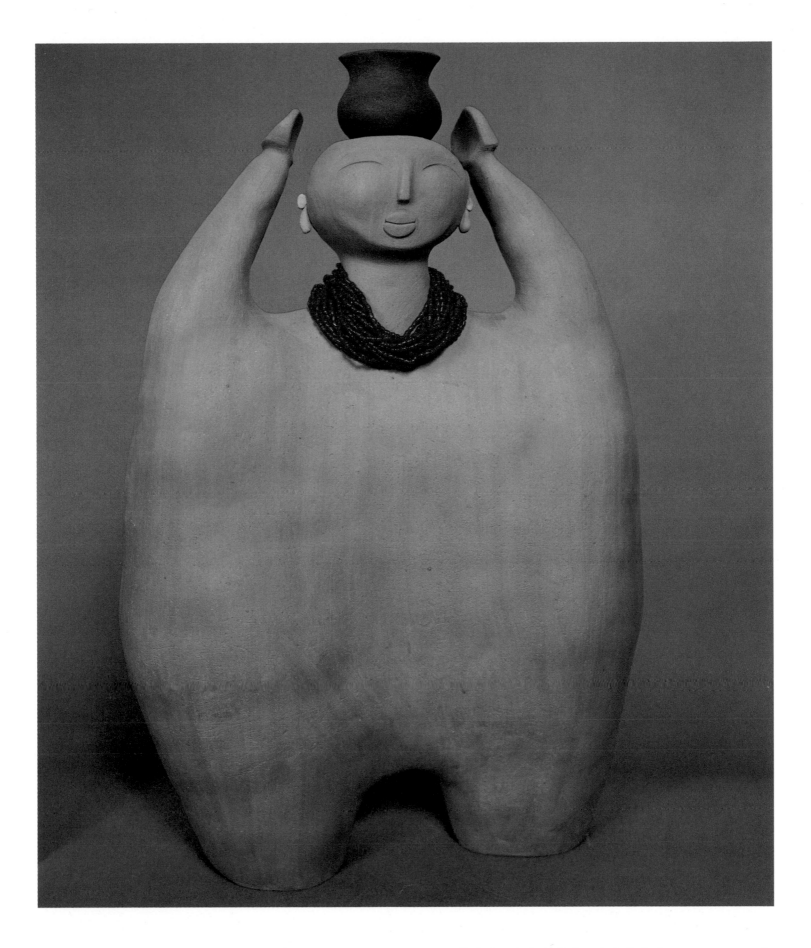

Jacquie Stevens

Jacquie Stevens, a Winnebago Indian, was born in Omaha, Nebraska, in 1949. She creates asymmetrical pots with a monumental presence and a minimalist feel. Her large, skillfully constructed vessels—augmented with touches of wicker, fiber, and stone—set her apart.

Photograph by Walter BigBee ©1995

Jacquie was raised by her grandparents on the Winnebago Nebraska Reservation, seventy-five miles north of Omaha. She had clay in her backyard along the Missouri River and was continually making things, particularly unusual clay objects. "But," she says, "if I had known then what I know now, I wouldn't have spent so many years as I did making traditional Winnebago appliqué work on costumes, blanket shawls, and pillows."

She was sent to boarding school in Flandreau, South Dakota, at age thirteen, and then to Haskell Institute, because her family believed in formal education. Later she attended the University of Colorado at Boulder to explore anthropology as a major subject.

After being introduced to aboriginal art from around the world, which Jacquie realized related to her own tribal background, she yearned to investigate further. In 1975 she arrived in Santa Fe to enroll in the Institute of American Indian Art with a particular interest in the museum program. There Otellie Loloma, the well-known Hopi potter and teacher, became Jacquie's mentor.

"It must have been fate that made me take a class taught by Otellie. It was like I returned home; clay became my expression. Otellie taught me that each pot has its own life, personality, character, and form—and that is what set me free. Pottery is like people, every one is different and not perfect. I thought about this and decided it was an important idea. So I developed a new way, an unconventional way, of looking at form."

Jacquie was perhaps the first Indian potter to coil large, off-round vessel shapes. Hers are splendidly simple, with flawlessly scraped and sanded clay surfaces in their natural state—unglazed and unburnished. Because she likes subtle color changes, she uses many varieties of clays in combination with each other or mixed together. She is prone to adding other textures, such as leather, woven reeds, wicker, wood, or stones somewhere on the pristine fired clay form. She pays fastidious attention to the contrasts between the clean undefiled form versus the quiet disturbance of an added material. This artist is one of the most innovative American Indian potters working today.

Jacquie works with clay from the Pecos area and other clays that she finds and tests. She pit-fires her pottery with cow dung and "cedar" chips lining the bottom of the earthen cavity, and carefully sets in the pots, surrounding everything with wood. (The term "cedar" is one that Maria Martinez used when I first saw her firing thirty years ago. I learned the hard way that Indians say cedar when they really mean juniper or mesquite, both of which are harder woods than cedar.)

Jacquie usually covers the fire with dung, which smolders and makes what she calls "fire clouds" on the ware. Sheets of metal cover the bier, and if there is a wind the smoky marks will vary more than when the air is quiet. "When I peek in I can see what's going on," says the artist. Sometimes she uses a cone-shaped metal lid with three-inch holes in it for another color effect. Jacquie is always experimenting with the clay or the form or the fire.

"My work has been a process of constant transformation. I dare myself to try to create some new clay form, and that is what keeps me on my toes. Right now I am very excited about my monumental glass bead forms in clay. Glazing them in brilliant and bold primary colors is a very exciting process for me." Jacquie is so ebullient about this new work that her conversation goes into orbit; she shares with me her mental visions of one idea after another, planning the concepts that will come from this challenge of adding glaze to the vocabulary she already knows.

Jacquie's idea about her new work is characteristic of her approach to innovation. Her grandmother kept beads that she used to decorate vests, and she showed the small pretty objects to her grandchild. Now the adult grandchild exclaims: "Beads, I never dreamed they would give me ideas! Such a whole link of generations from my grandmother. It's a growing thing. It's like our language, that's a link, a connection. For me this is a time of freedom!"

Jacquie says she loves Santa Fe, that it is a perfect place to work. She loves the changes in the land, the wind, the light, the earth, the colors when it rains, the sky, the color of the ground, and how gathering the clay makes her feel. She knows she has energy here.

In 1837, Winnebagos came from Wisconsin to the Nebraska reservation. Later, in the 1880s, some returned to Wisconsin. There, basket making was more prevalent than in Nebraska, because the women could find better material for weaving in the Wisconsin woodlands. But Jacquie remembers that her grandmother made wonderful baskets in Nebraska. The influence of these baskets shows in the textural contrasts in Jacquie's earlier work. "The Winnebagos kept the language both places," she muses, "and that helped keep their ways. It is a strength for me.

"I am a very private person. I figure that all I have to say and share with the world is conveyed through the language of my pots."

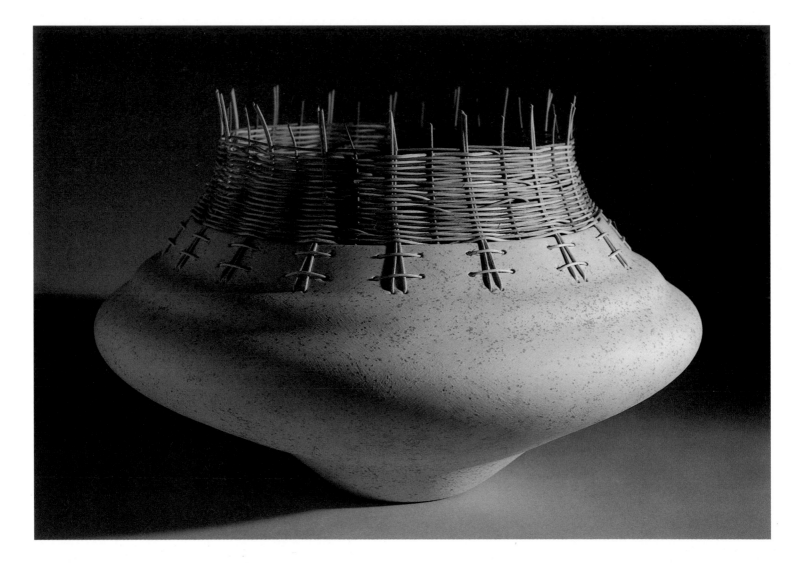

Jacquie Stevens (above) Woodweave bowl, 1995. Whiteware; 14½ × 22 in. dia. Collection of Mr. and Mrs. Phillip Casey. Photograph by Craig Smith

Jacquie Stevens (opposite) Sculpted jar, c. 1990. Redware; 16 × 11 in. dia. Courtesy Gallery 10, Inc., Scottsdale, Arizona, and Santa Fe, New Mexico. Photograph by Craig Smith

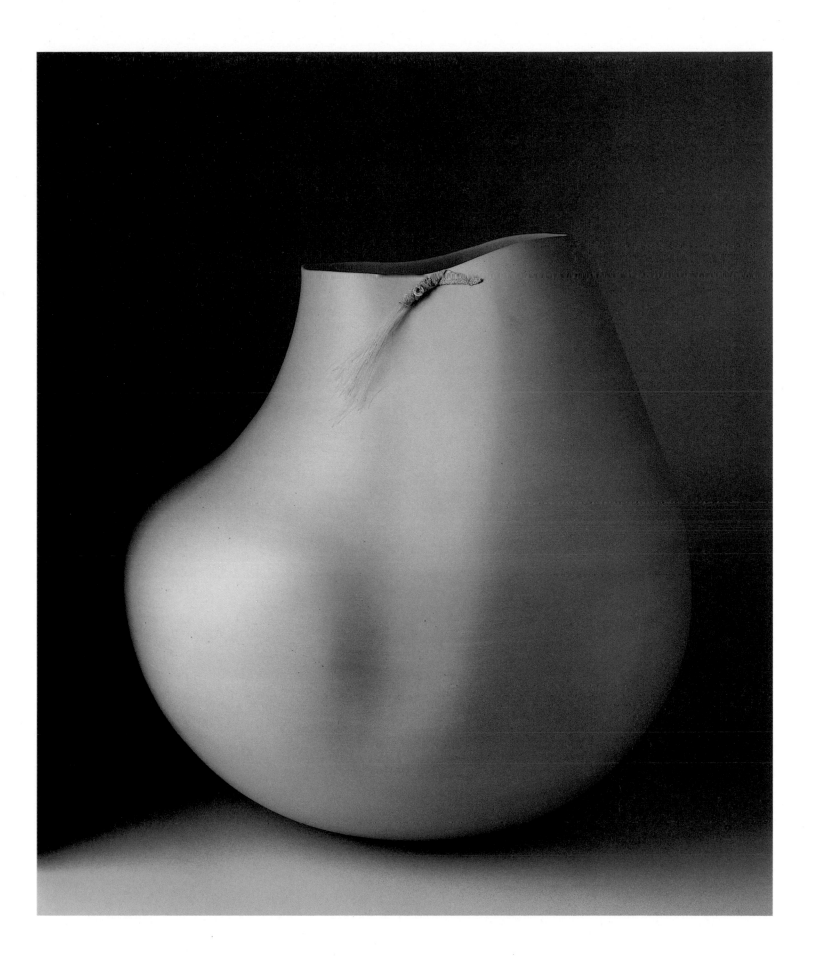

Jacquie Stevens Vase, 1983. Whiteware with leather, wood, and stone, 18 × 18 in. dia. U.S. Department of the Interior, Indian Arts and Crafts Board. © Jacquie Stevens

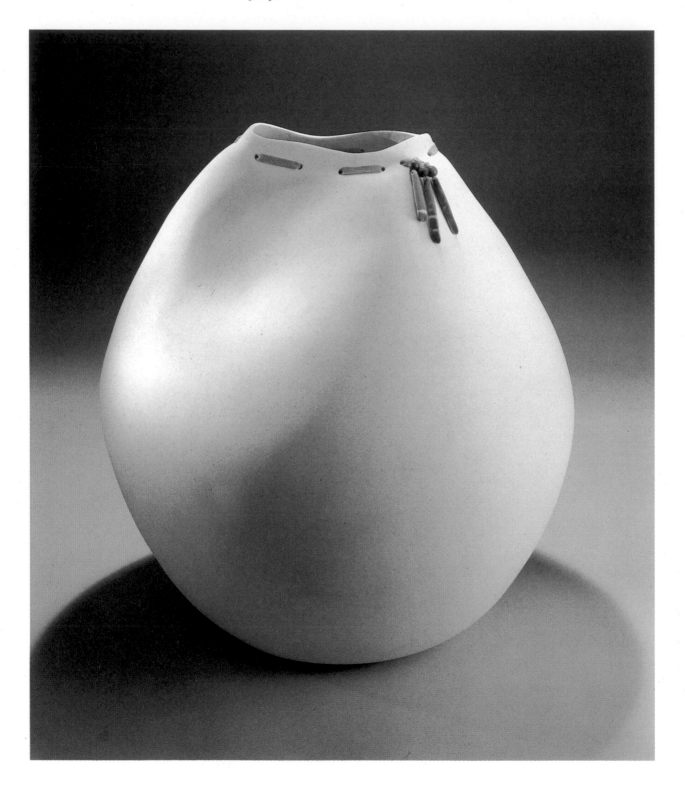

Roxanne Swentzell

Santa Clara potter Roxanne Swentzell, born in 1962, amazes audiences today with her extraordinarily large, complicated figures and provocative images. Recognized as one of the most inventive Indian potters, she is also one of the youngest. The same ideals that shape her pottery keep her active in a self-sustaining environmental project at her pueblo.

Roxanne is the daughter of Rina Naranjo Swentzell and the niece of Nora Naranjo-Morse. Rina, a well-known activist, has a doctoral degree in American studies and a master's degree in architecture. This interesting woman was taking her architecture courses when her daughter, Roxanne, was a little girl. Rina Swentzell has been a force in Anglo-Indian controversies ever since, and this activism has made an indelible impression on her family.

Roxanne's mother was a potter before she began her university studies, and Roxanne remembers making figures with her from the time she was very little. "My mom potted so the clay was right there where I saw it all the time. I had a speech impediment so I had to communicate in other ways, and I started making figures that would depict what I meant. I hated going to school so I made a clay figure of a little girl crying to explain how I felt. I made hundreds of these figures. They were tiny, but they got more elaborate as I was pinching them solid in the clay. In junior high school I began to hollow-build the clay figures because they got larger.

"I would say I am still communicating with figures. I want to symbolize women, and my culture, and humanity. I am trying to say things to the world, and the response has been amazing! My pieces are crossing cultural and all kinds of boundaries. People from all over the world see things in my pieces. It has been very, very exciting to me, the ultimate communication."

In high school Roxanne continued to have difficulties. Her parents decided to send her to the Institute of American Indian Art in Santa Fe, a special

Photograph by Tamea J. Mikesell
Courtesy of the Heard Museum

school for Indians from all over the country who show talent in art. During that time, when the school was on Cerrillos Road, the gifted Roxanne was given her first real show in the school's museum. Roxanne says that she did not price anything but that all the people wanted to buy her work. Next, the school wanted to send her work to an exhibition in Niagara Falls, New York, "but my mother said that I didn't need that in my life right now."

Rina wouldn't let her daughter sell her figures at all, to avoid Roxanne's becoming "money minded." As Roxanne describes it, her parents still wanted her to attend school and to stay very clear about why she was doing her art. Her parents did not want her to become involved in the commercial aspect of pottery making. They allowed her to attend the Portland School of Art in Oregon for one year, but she got very homesick. She came home and married.

"I married twice, but I am not now. My second marriage is important because we started a nonprofit organization to do sustainable living, the ten years that I stayed with my husband, and now I carry it on. At the same time, I have tried to make sculpture that would help people get basic values, would help them get in touch with themselves, basically.

"A whole philosophy comes out of my life in the pueblo and my people. We have a close sense of ourselves. We are close to our environment, and we have a different way of living from most Americans. As Indians we try to hold our own culture together in a modern world. With money that comes to our Flowering Tree Permaculture Institute, my group and I are researching native plants and seeds and ways of living.

"We keep alive old traditional crafts and plants. There is lots of history to study about my people from the Indian ruins around us. We teach what we have learned to groups of people that are interested; big groups of American Indian people come here from all over the country. Native Americans are trying to come back to learn what they lost. Of course this is not exclusive to natives, anybody can have these ideas. My tendency is to think of my own people.

"We started a newsletter around this pueblo, and we give it to interested people. A lot of our young people now are really getting curious. Ten years ago, no one wanted to think about sustainable living except maybe the old folks who knew how it was to live in this natural manner. Now we have a group on the pueblo, young, who want to learn how to grow plants the old way. So the pueblo gave these young people three fields to work, and I help them with this project. This group goes around the pueblo seeking to learn from the old folks, to see if they have any seeds to give, and to gather knowledge about the root plants. The information is still there, but we need to get it before it is gone."

When Roxanne talks of her clay figures, she says they are reminders of what Indians are about. Remembering is important, she says. Her feeling is that traditional "ways of being," as she calls them, impart something spiritual that makes Indians special, gives them a special way of thinking and moving in the world, and makes them a unique people. Roxanne is not the first Indian to have this belief, and many Anglos have it as well.

Roxanne feels that doing the research about growing food today as it was done yesterday is a way to remember. She hopes that when the younger people work in the fields they will get a sense of their relationship with their environment and in that way a sense of themselves. She hopes that more of the younger people will not drink and waste themselves but will have purpose in life. Roxanne dances and partakes in ceremonies: "This is how we hang on to our values," she says. "These songs are about what we used to do."

Roxanne's motives for making her clay figures are more important to her than the act of prospecting clay in the traditional way. Her clay is store-bought red earthenware from a ceramic supplier in Minnesota. The large scale and the complexity of her figures necessitate great technical skill and require a homogeneously composed claybody that will stand tremendous weight and manipulation during the fabrication. Digging a common surface clay on the reservation will not do for Roxanne's work.

"Santa Clara Pueblo clay is not strong," she says. "It won't hold together with these complicated structures. My mother prospects her own clay from the pueblo, or from anywhere, but I can't." Roxanne's large, emotionally-charged figures are coil-built, beginning usually with the place where the figure sits, if it sits, building down to the toes and up to the head from the "butt," as she calls it. If the figure is standing, it can be coiled upwards from the feet and legs into the body and on to the face and head. "It's like building a fancy pot," says Roxanne, who makes light of this very difficult and arduous building process.

She burnishes the leather-hard clay surface with a knife, smoothing the coils and polishing a sheen as she works. Usually there is no decoration; sometimes for emphasis she may use red iron oxide for a dark brown accent, applied either on the raw clay or after a first firing.

"I know that I describe myself as a sculptor of human emotions. I think that the emotions get us in touch with our own centers, with ourselves. I hope others will see what I see and what I feel and what I put into my work.

"Now I use an electric kiln, but I want to go back to traditional outside firing. My pieces are too large to do in a bonfire. But my daughter, Rosie, works in clay too, and she is good, so maybe together we will woodfire soon, like the Japanese."

The long, slow firing with wood in an outdoor single-chamber kiln, and the patina that wood ash gives to clay during the firing, would be compatible with the size and emotional quality of Roxanne's work.

Roxanne home-schools her children and the children of several neighbors. "It's hard to find good schools. I remember how even I had so much trouble, so I want to do this for them. I can work on my clay while I home-school. Kids have their own interests if you leave them alone, they will learn if they are allowed to explore without push. I am glad to teach them."

This talented young artist's sculpture is in such demand that she has a waiting list of customers. In the last decade, her claywork has been purchased by many major museums in this country. At the Indian Market in Santa Fe, Roxanne brings good-sized figures and masks to the large audience. Her reputation is growing with widening recognition among museums and galleries. Roxanne's unusual sensitivity and dedicated commitment to her people and the generic ideals of Indian life resound in her work. This is more than most craftspersons ever achieve.

Roxanne Swentzell (opposite) *Tse-ping*, 1991. Bowl, 4 × 12½ in. dia.; figures, 31 × 14 × 13½ in., 18 × 13½ × 16 in., 19 × 13½ × 16 in., and 15½ × 13 × 19½ in. The Heard Museum, Phoenix, Arizona. Photograph by Craig Smith

Roxanne Swentzell (opposite) *The Things I Have To Do To Maintain Myself*, 1994. 15½ × 13 × 15 in. Denver Art Museum Collection. Photograph by Bill O'Connor

Roxanne Swentzell *Broken Hearts, Broken Bowls, Now What?*, 1996. 12 × 13 × 22 in. Collection of Georgia Loloma. Photograph by Craig Smith

Dorothy Torivio

Dorothy Torivio was born at Acoma Pueblo in the 1940s. She is recognized for her innovative work in exaggerated seed-pot forms in large and miniature sizes. She covers her vessels with black and white or polychrome patterns of staggering intricacy, painted freehand with computer-like precision.

Photograph by Chad Penhallow

Dorothy has extrapolated the innovative forms and decorations that were initiated by Lucy Martin Lewis and Marie Chino, famous potters in the previous Acoma generation. Her mother taught her to make pottery and still helps with the firing. An unusually deft painter who uses a traditional yucca brush, Dorothy maintains that the ideas for her decorations come from God. Her daughter helps gather the clay, grinds the mineral rock pigments, and chews the plant fronds for her mother's brushes.

This artist lives a secluded life on the Acoma reservation, but her meticulous work and startlingly difficult designs are in great demand. Style and perfection are hallmarks of her painting, which, according to Phil Cohen of Gallery 10, Dorothy did not exhibit until her technique was flawless.

It is impossible to analyze the mathematical precision of these designs, which she works out in her mind and puts directly on the pot. She looks at a pot, visually divides it in half, then in quarters, then eighths, sixteenths, and more, and keeps dividing until there is no room on the surface. After the mental gymnastics, she begins to paint the pot. Curiously enough, she paints in the negative, the opposite of the way our minds read it.

Dorothy does not think of herself as a genius; she thinks what she does is only natural. This is best illustrated by a story Phil once told me. One day Dorothy was having an exhibition of her pottery in his gallery, at which she was being honored. A man approached her saying that he was a mathematics professor, and he had been trying for a long time to figure out on his computer how she did the designs until he finally arrived at the solution. Whereupon Dorothy laughed, pointed her finger to her brow, and said, "My brain is my computer."

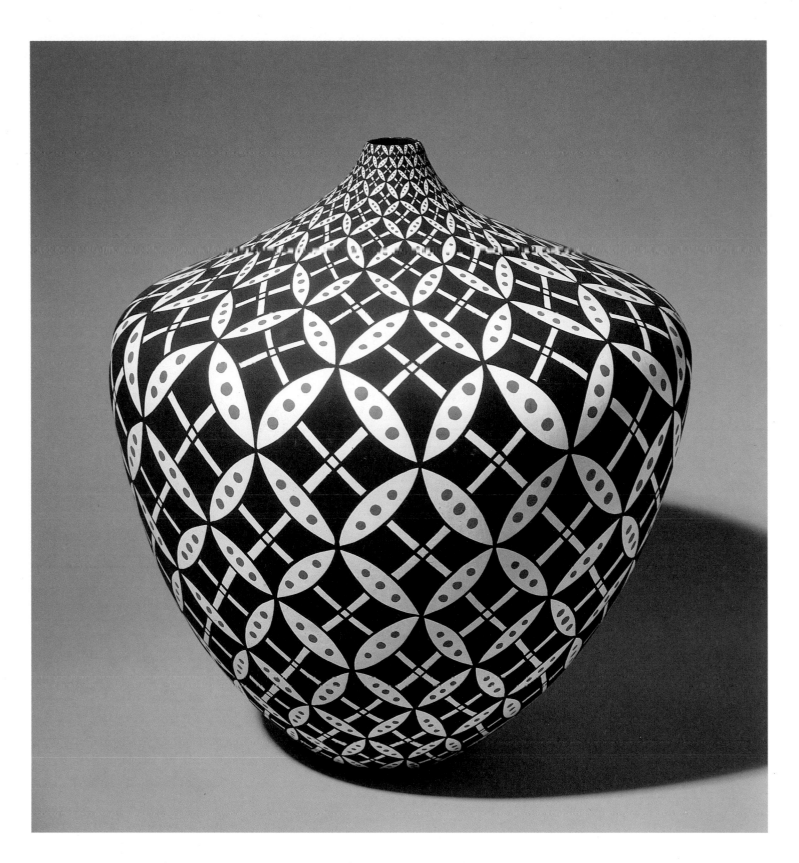

Dorothy Torivio Vase, 1995. Polychrome; 10½ × 9¼ in. dia.
Courtesy of Andrea Fisher Fine Pottery, Santa Fe,
New Mexico. Photograph by Craig Smith

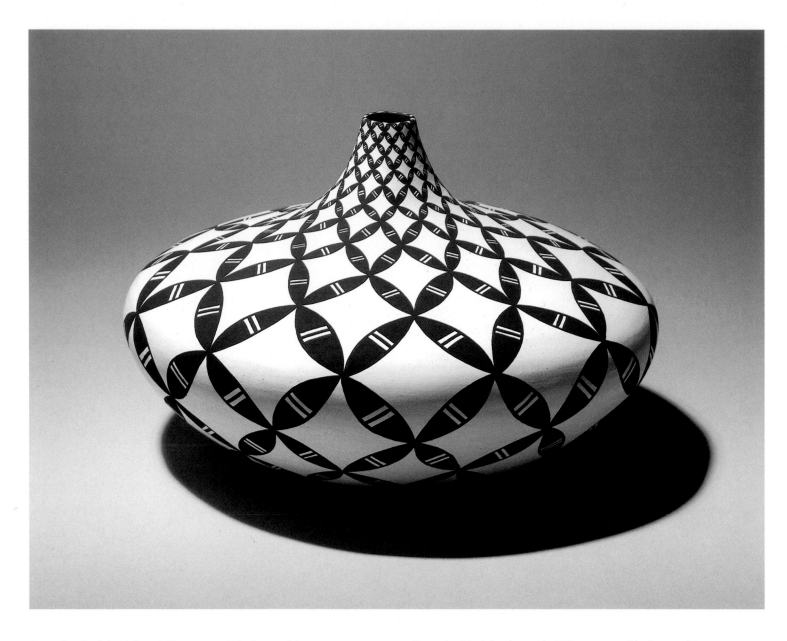

Dorothy Torivio (above) Vase, 1995. Black-on-white;
5¼ × 7½ in. dia. Courtesy of Andrea Fisher Fine Pottery,
Santa Fe, New Mexico. Photograph by Craig Smith

Dorothy Torivio (opposite) Vase, 1990. Black-on-white;
10½ × 11½ in. dia. Collection of Jim Jennings.
Photograph by Lee Stalsworth

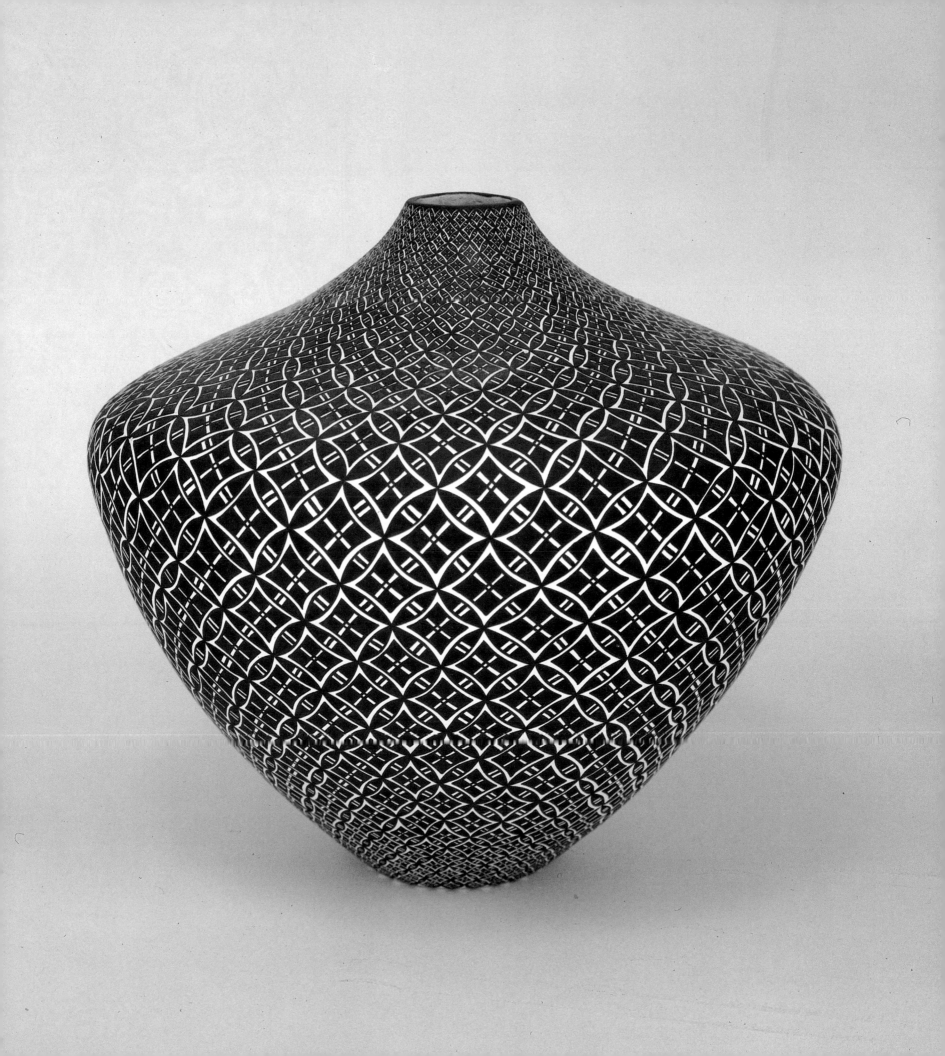

Dora Tse Pé

Dora Tse Pé, a Keresan Indian born at Zia Pueblo in 1939, has developed her art at San Ildefonso. Sometimes called "contemporary," she balances traditional methods with innovative juxtapositioning of clays, colors, and textures.

Dora learned pottery as a child from her mother, Candelaria Gachupin, gathering clay, sand, and the basalt that they added for temper (instead of volcanic ash). Basalt had to be stored in the ground to keep it from oxidizing. Dora would bring it home and bury it until it was time to make pots, when the basalt would be pounded and ground into a powder.

When Dora married and moved to San Ildefonso Pueblo, she already knew how to make pottery, but she watched Rose Gonzales, her new mother-in-law, make red and black pottery. "We didn't high polish at Zia," says Dora, who has helped Rose gather clay and fuel for fire for ten years.

Dora says that she was inspired by Maria Martinez's son Popovi Da, by his son Tony Da, and by her mother-in-law, Rose, who came to San Ildefonso from San Juan Pueblo. Rose was making polished black pottery as she did at San Juan. Dora says Rose claimed she taught Santa Clara potters to carve and started women carving at San Ildefonso and that she is responsible for the great tradition of carving polished red or black pots.

Dora has received a lot of recognition for her work. The first prize she ever won was a blue ribbon at the 1969 New Mexico State Fair in Albuquerque for a simple, plain black pot that she had polished and fired with Rose Gonzales. Rose often took Dora on workshop tours, and Dora took her own pots along, too. Dora says that every year at the Indian Market in Santa Fe, she gets some kind of ribbon, and that in 1988 and 1991 she won the prestigious Best in Traditional Pottery award.

Now Dora travels all over the country for shows and demonstrations and entertains workshop groups at her home on the pueblo. "I love to carve. I do some new things, but I will never get away from carving altogether," declares Dora, who has filled her home with traditional pots made by her mother at the Zia Pueblo.

Dora's innovation in claywork—she sees her work as an extension of traditional pottery making—is to combine various colored clays in the same piece, for instance, polished red clay combined with dull-surfaced, gold-flecked micaceous clay, or red polished clay combined with dull black and micaceous clays, or other combinations she works out. Micaceous clay, used years ago for functional pots by many different Indian cultures, is now being revived for its exciting orange and gold colors; Dora has accepted the challenge of finding the clay and working with it.

She also adds turquoise and coral to accent her deep carving technique or to mark a change of clay color on a pot. Dora complains that her galleries and collectors call her work "contemporary Indian." Dora dislikes the term because she considers herself traditional; she is unaware of the path she is forging.

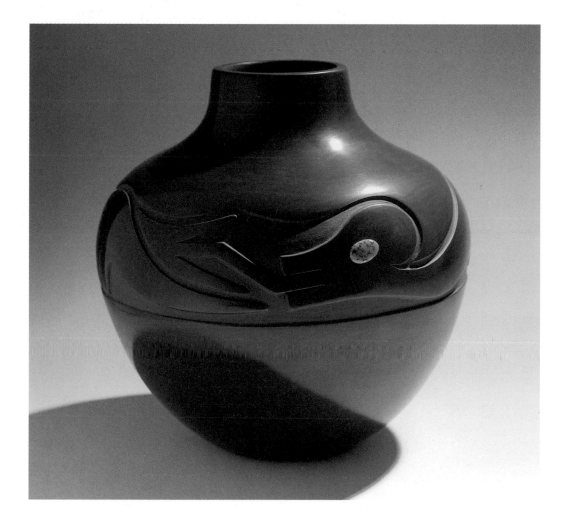

Dora Tse Pé Jar with carved *avanyu* design and turquoise inlay, 1990. Redware; 10⅜ × 10 in. dia. Collection of Sid and Char Clark. Photograph by Craig Smith

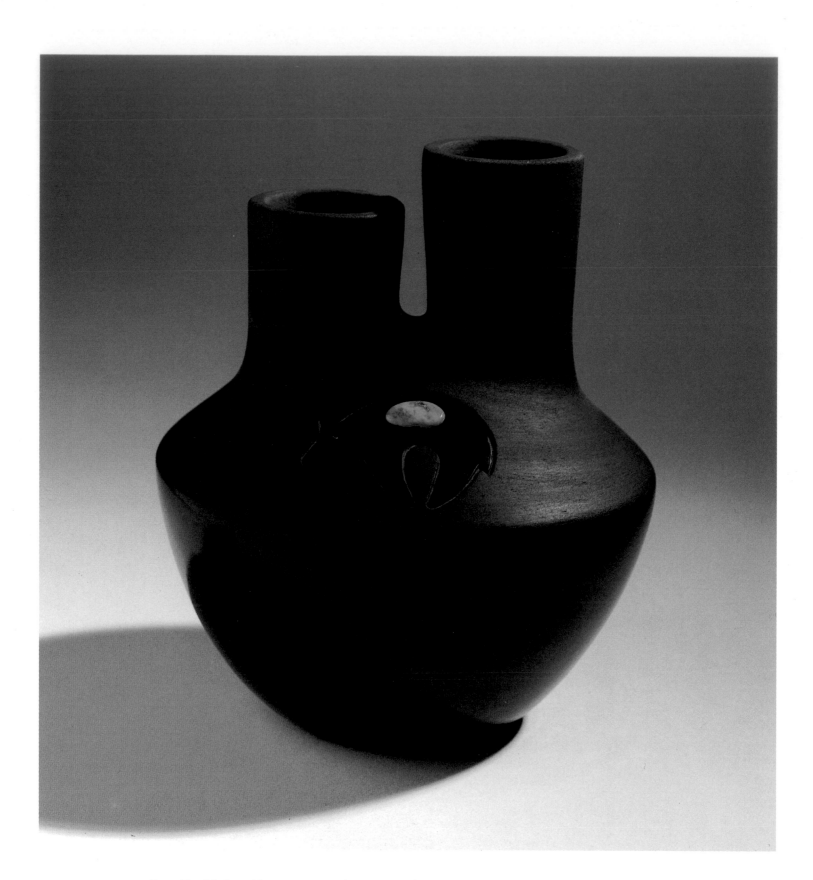

Dora Tse Pé Jar with two spouts and turquoise inlay, 1980.
Blackware; 6½ × 5½ in. dia. The Heard Museum, Phoenix,
Arizona. Photograph by Craig Smith

Lorraine Williams

Navajo Indian Lorraine Williams, born in Arizona during the late 1950s, was not raised with the tradition of pottery making; she did not begin working with clay until her adulthood. Today, her immense tribal pots and colorful Indian icons have made Navajo pots more commercially viable than ever before.

Photograph by Susan H. Totty

Lorraine was raised in Sweetwater, Arizona (near Kayenta and Teec Nos Pas), on a red mesa near Four Corners. Her Navajo maiden name was Yazzie, which Lorraine says is one of the names the Anglos gave out years ago. Her grandfather was one of the few rangers at Mesa Verde. Her father was a medicine man, and her mother was an herbalist. Three of Lorraine's seventeen brothers and sisters also work in clay.

Lorraine says she was aware of "potteries" at Indian ceremonies when she was growing up but that she didn't know the pots were made at home; she thought they were bought. She did not know anyone at that time who made pottery except "an old lady near Shiprock" who made ceremonial clay drums. "My father would go over there to get pots for ceremony, but I just assumed the old lady got them somewhere, I didn't know she made them. Now I try not to assume. I could be wrong, and we try never to ask questions. Just put in your mind what you see, and some day you will use it.

Lorraine married George Williams in 1977, and today they live in Cortez, Colorado. George is the son of Rose Williams, one of the best-known Navajo potters, who had been making pottery for years to trade for food. Lorraine was adept at making beads and sand paintings, and she was a weaver. "But when I married George I saw pottery with new eyes." Her new eyes led to Lorraine's beginning with clay about 1980. Ultimately, Lorraine would make the largest pots produced at Navajo today.

"I didn't know how to draw. You don't want to compete with your in-laws. Rose didn't draw, so I decided to draw on the clay and to make cutouts. By mistake I made a hole in a pot, and I went ahead and cut it out."

Lorraine confides that she has had epilepsy all her life. "Everyone around me thought I had a taboo. No one believed that I really had epilepsy. It went away for about five years and I thought it had gone but it came back. I found that working with clay kept it away."

Lorraine and George have four children; George has two other children; and together they also care for six foster children. One of their sons has epilepsy too. Lorraine told me the story of how one day she was hitchhiking to the hospital with her epileptic son when they came upon a black bear. "I thought he would attack us but I started to sing and he didn't. I'm traditional but bears are not in our tradition, we are afraid of them. We bring in someone in bear costume to someone who is ill to scare the spirit out. We use bear for that, otherwise bear is taboo. I don't know why he saved us that day."

Navajo weavers boil plant material—Lorraine calls them weeds—to make dyes for their yarn. Lorraine was used to doing that for her rugs, so she appropriated these colors in the beginning for decorating her clay. Her father, a very traditional man, did not like her using the plant colors, the same ones that were used for body paint in ceremonials, so he asked her not to do that.

For this reason Lorraine resorted to buying commercially made pigments for her designs on the clay, especially the gray-blue; but the red is a natural red sand that makes a grainy texture she likes. She fires each pot outside, separately and upside down, for about three hours with a lot of wood for a very hot burn. "We need lots of fire; it has to get very hot," Lorraine advises. "If wind comes you lose the pot. We fire more in summer than in winter."

Navajo pots are historically coated with hot pitch after the firing to give a shiny, more impervious finish. For applying the piñon pitch, Lorraine brings the pot back from the firing site and puts it on her stove burner to heat up slowly. She says this can't be done outside because the weather change may thermally shock the hot pot and crack it. The bucket of pitch must be hot as well as the pot. "When the pot is black from the burner, I dip a stick with a rag or a paper tied on it into the hot pitch and swipe it in and out of my hot pot."

Pottery was not made for sale on this reservation until the 1980s when galleries sought the work. Lorraine says that Navajo pottery had been done previously just for functional and ceremonial use and to trade, not to sell. When they saw that the pots could bring money into that area, the families and relatives began to work together on pottery. Lorraine says that still the majority of pots are made for ceremony and "that's why no one knows much about Navajo pottery."

Navajo pottery has had its own category in the annual Gallup, New Mexico, Inter-Tribal Indian Ceremonial only the last five or so years. Lorraine is proud of

the fact that she took the Best in Category prize for excellence in 1993. She also won other major awards at Flagstaff, Shiprock, Santa Fe, and Gallup.

I had despaired of finding a Navajo potter to feature in *The Legacy of Generations* exhibition, until one day I saw two huge, plain brown pots with a slight coiled texture at the shoulder in a gallery shop window in Santa Fe. These were remarkable pieces for their simplicity and style. I inquired about the maker, who was not known to the gallery; but the trader provider was. It took many more inquires to track down Lorraine. When I did, I also found her sister-in-law, Alice Cling, the daughter of Rose Williams. Together, these three women have electrified the future of pottery for the Navajo nation.

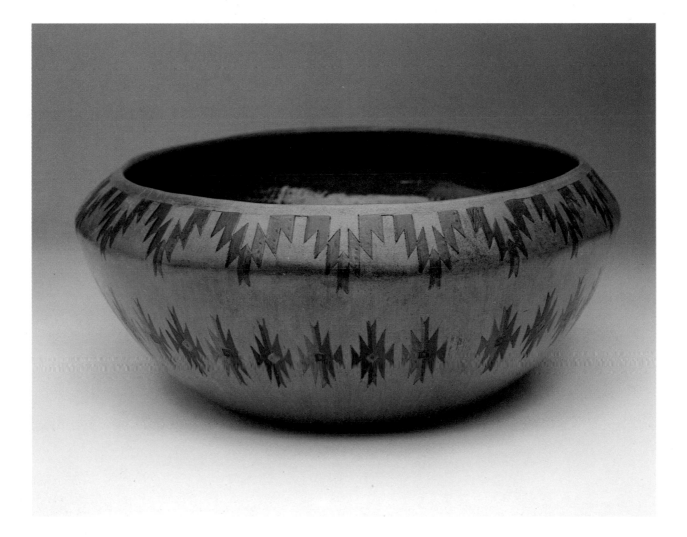

Lorraine Williams Dough bowl, 1996. Polychrome; 8 × 15 in. dia.
Collection of Judith and Stephen Schreibman. Photograph by
Craig Smith

Lorraine Williams Jar with *yei* design, 1995. Polychrome with
pine pitch; 34 × 22 in. dia. Collection of Judith and Stephen
Schreibman. Photograph by Craig Smith

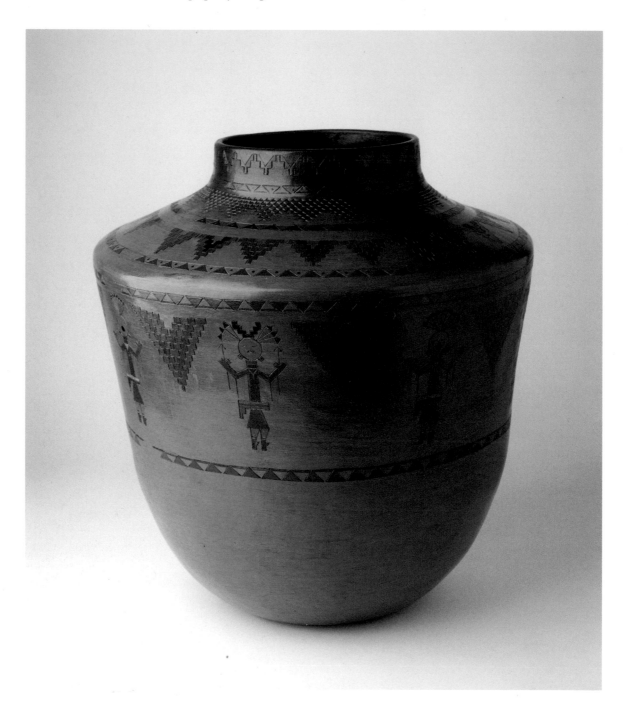

Lorraine Williams (opposite) Jar with *yei* design, 1995.
Polychrome; 20 × 15 in. dia. Collection of Tom Hargrove.
Photograph by Craig Smith

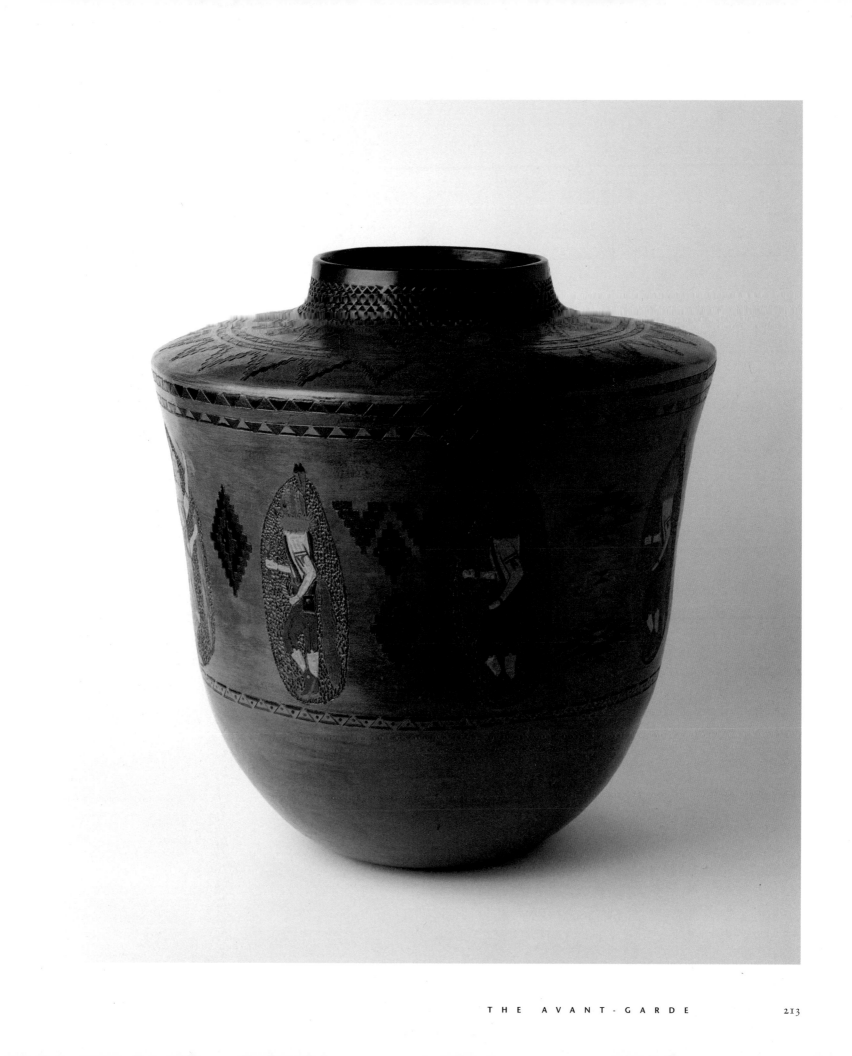

Exhibition Checklist

Numbers at left indicate pages on which the works can be found.

Jean Bad Moccasin

183 Kiva-step vase, 1993, Collection of Mr. and Mrs. William Freeman

182 *Two Nations* vase, 1996, Collection of the artist

Blue Corn

103 Jar, c. 1970, Collection of Marjorie and Charles Benton

102 Plate with turtle design, 1970–77, The Heard Museum, Phoenix

105 Plate with geometric design, late 1970s, Collection of Jim Jennings

106 Jar with feather design, 1978, Collection of Ruth and Robert Vogele

104 Plate with *avanyu* design, early 1980s, Collection of Jim Jennings

107 Bowl, 1985, Collection of Marshall and Lucille Miller

Diana Calabaza-Jenkins

163 Bowl, 1997, Collection of the artist

Alice Cling

167 Jar, 1995–96, Collection of Judith and Stephen Schreibman

168 Jar, 1995–96, Collection of Judith and Stephen Schreibman

169 Jar, 1995–96, Collection of Judith and Stephen Schreibman

Elizabeth "Buffy" Cordero-Suina

161 Storyteller, 1996, Collection of the artist

Helen Cordero

98 Hopi maiden, n.d., School of American Research, Santa Fe, New Mexico

95 Drummer, 1969, Girard Foundation Collection, Museum of International Folk Art, a unit of the Museum of New Mexico

99 Creche, 1972, Collection of Dennis and Janis Lyon

96 Storyteller, 1972, Collection of Dennis and Janis Lyon

97 Turtle with children, 1979, On loan from the Museum of International Folk Art, a unit of the Museum of New Mexico, Santa Fe. Purchased with the aid of funds from the National Endowment for the Arts and the International Folk Art Foundation

Anita Fields

173 Woman of the Stars, 1994, Private Collection

174 Three dresses, 1995, Collection of Sherre Davidson and Private Collection

171 Elements of Being, 1996, Collection of the artist

Jody Folwell

177 *Iran Contra–Ollie, Hero or Idiot,* 1986–87, Courtesy Eleanor Tulman Hancock Inc. North American Indian Art

178 Jar with incised eagle design, c. 1987, Collection of Marjorie and Charles Benton

179 Lidded jar with dog motif, 1996, Collection of the artist

Dolores Lewis Garcia

139 Bowl with lightning design, 1995, Collection of the artist

138 Canteen with thunderbird design, 1996, Collection of the artist

139 Dough bowl, 1996, Collection of the artist

Barbara Gonzales

130 Jar with incised nature designs and semiprecious inlay, 1982, Collection of Lucille and Marshall Miller

131 Swish bowl with incised spiderweb design and semiprecious inlay, 1991, Collection of Barbara and Frank Salazar

129 Three-tiered vase, 1991, Collection of Lynn and Larry Welk

Carmel Lewis Haskaya

140 Jars, 1965, Collection of the artist

141 Jars, 1996, Collection of the artist

Lucy Martin Lewis

83 Vase with corrugated design, n.d., Collection of J. Peter and Nancy Clark

79 Bowl, c. 1910–20, School of American Research, Santa Fe, New Mexico

78 Jar with lightning design, 1962, U.S. Department of the Interior, Indian Arts and Crafts Board

81 Jar with parrot design, 1968, Collection of Lucille and Marshall Miller

82 Jar with fine-line design, 1983, Collection of the National Museum of Women in the Arts, Gift of Wallace and Wilhelmina Holladay

80 Jar with heart-line deer design, 1986, Collection of Dr. and Mrs. Linus Pauling, Jr.

Nancy Youngblood Lugo

158 Lidded swirl jar, 1991, Collection of Sid and Char Clark

156 Melon bowl, 1995, Collection of Sid and Char Clark

157 Swirl bowl, 1996, Collection of the artist

Maria Martinez

69 Four black-on-black place settings, c. 1930–40, California Academy of Sciences, Elkus Collection

70 "Terraced" jar, c. 1930–40, California Academy of Sciences, Elkus Collection

73 Bowl, 1947, Oklahoma Museum of Natural History, University of Oklahoma

Maria and Julian Martinez

66 Jar with *avanyu* design, c. 1918–19, Millicent Rogers Museum of Northern New Mexico

36 Vase, 1924, Collection of David Rockefeller

An Afterword from Mobil

It is a rare privilege for Mobil to be a part of this unprecedented exhibition, *The Legacy of Generations: Pottery by American Indian Women,* organized by the National Museum of Women in the Arts, and a great pleasure to have this occasion to comment on what truly represents "The Legacy of Generations."

Mobil has been a long-time supporter of the arts wherever we do business, seeing it as an opportunity to return something to those communities that have welcomed us into their midst. Our people, after all, are part of those communities and, by participating in local arts and culture, we enrich their lives as well as those of their neighbors. And when we can also make others outside the local community aware of a particular artistic legacy, the world itself benefits from that enrichment.

This particular exhibition seems especially appropriate for us for several reasons. First, as a worldwide company with its roots in America, we are fortunate to join with the National Museum of Women in the Arts to sponsor this comprehensive collection of the pottery created by master craftswomen of the original Americans. Second, as an oil company, we make our living from the earth's resources. It is only fitting that we join in celebrating these women potters, whose talented hands and creative genius rely on clay drawn from the same Mother Earth. Finally, as a company dedicated to building diversity, we are proud to salute the achievements of a long-neglected sisterhood of artisans.

This book has described stunningly the impact of social and religious values on the form and shape of pottery, the overwhelming challenges faced by traditional artists in a rapidly changing world, and the emergence of today's "modern" Indian pottery as art made primarily by women. While we at Mobil think of ourselves as an old company with a history of one hundred and thirty years behind us, it is somewhat humbling to recognize that the "new tradition" established by our modern American Indian potters is itself over a hundred years old.

The Legacy of Generations provides a fascinating glimpse at the history of this remarkable art form and features twenty-eight artists from the pueblos of Arizona

and New Mexico, the Navajo Nation of the Southwest, and the Winnebago, Sioux, and Osage tribes of the Midwest. You have learned about matriarchs—from Nampeyo of Hano and María Martinez of San Ildefonso to Lucy Martin Lewis of Acoma and Helen Cordero of Cochiti—women whose differing artistry and traditions sowed a diverse field in which modern craftswomen have blossomed. Today, a new generation of artists has flowered, including Lu Ann Tafoya of Santa Clara and Joanne Bigcrane of the Winnebago. They have been building on tradition and adding their own individual styles and techniques to create an even broader landscape of American Indian art. Learning about it will enrich the lives of every one of us.

We are proud to share this great heritage with you, and we salute the National Museum of Women in the Arts for presenting it so elegantly to all of us.

<div align="right">

LUCIO A. NOTO
Chairman and CEO
Mobil Corporation

</div>

Bibliography

Allen, Paula Gunn. *The Sacred Hoop.* Boston: Beacon Press, 1986. An informative and provocative collection of essays on American Indian women's history and the importance of the women-centered culture to the Indian identity.

Bahti, Mark. *Pueblo Stories and Storytellers.* Tuscon, Arizona: Treasure Chest Publications, Inc., 1988. A wonderful collection of folk tales from the New Mexico pueblos, with many fine examples of pottery Storytellers shown in full color.

Blair, Mary Ellen and Laurence R. *Margaret Tafoya: A Tewa Potter's Heritage and Legacy.* West Chester, Pennsylvania: Schiffer Publishing, Ltd., 1986. A comprehensive, well-illustrated biography of Margaret Tafoya and her family. Includes a history of the Pueblo people and a discussion of pottery making techniques. Excellent color photographs of pottery.

Bunzel, Ruth L. *The Pueblo Potter: A Study of Creative Imagination in Primitive Art.* New York: Columbia University Press, 1929. A landmark work presenting the state of the art among the pueblos in the 1920s, with particular emphasis upon design. Illustrated with drawings and photographs.

Campbell, David, ed. *Native American Art and Folklore.* New York and Avenel, New Jersey: Crescent Books, 1993. A book encompassing the Eastern, Southwest, Plains, Basin, California, Northwest Coast, and Arctic tribes from prehistory to the 1990s. Many beautiful color photographs of pottery, baskets, jewelry, and ceremonial objects.

Caraway, Caren. *Southwest Indian Designs.* Owings Mills, Maryland: Stemmer House Publishers, Inc., 1983. Black and white reproductions of authentic designs from the Southwest tribes of Colorado, Utah, Arizona, and New Mexico.

Chauvenet, Beatrice. *Hewett and Friends: A Biography of Santa Fe's Vibrant Era.* Santa Fe, New Mexico: Museum of New Mexico Press, 1983. An in-depth and intriguing biography of the much admired, often controversial Hewett—acclaimed founder of the Museum of New Mexico, the Institute of American Archaeology, and the San Diego Museum of Man, and key player in bringing southwestern Indian art into focus.

Coe, Ralph T. *Sacred Circles: Two Thousand Years of North American Indian Art.* Kansas City, Missouri: Nelson Gallery of Art–Atkins Museum of Fine Arts, 1977. An excellently portrayed exhibition of North American Indian art, with over 700 entries of black and white photographs and 20 color plates.

Collier, John. *On the Gleaming Way.* 1949. Reprint. Denver: Sage Books, 1962. The lives, philosophies, customs, and tribal art of Navajos, Eastern Pueblos, Zunis, Hopis, and Apaches.

Collins, John E. *A Tribute to Lucy M. Lewis: Acoma Potter.* Fullerton, California: Museum of North Orange County, 1975. A catalog published in conjunction with the 1975 Lucy M. Lewis show in New York, illustrated with some of the finest pottery produced in the United States.

Congdon-Martin, Douglas. *Storytellers and Other Figurative Pottery.* West Chester, Pennsylvania: Schiffer Publishing, Ltd., 1990. Four hundred Storyteller figures and other pottery by over one hundred artists, reproduced in magnificent color.

Dillingham, Rick. *Fourteen Families in Pueblo Pottery.* Albuquerque, New Mexico: University of New Mexico Press, 1994. An enlarged and updated version of *Seven Families in Pueblo Pottery,* which documented the history and contributions of generations of potters in the southwestern United States.

Dittert, Alfred E., and Fred Plog. *Generations in Clay: Pueblo Pottery of the American Southwest.* Flagstaff, AZ.: Northland Press, 1980. Describes two thousand years of pottery-making by Pueblo people in the American Southwest. Contains beautiful illustrations.

Dockstader, Frederick J. *Indian Art In America: The Arts and Crafts of the North American Indian.* Greenwich, Connecticut: New York Graphic Society, 1961. Color and black and white examples of work from tribal artists representing all major areas of the United States and Canada.

————. *Indian Art of the Americas.* New York: Museum of the American Indian, Heye Foundation, 1973. A comprehensive pictorial exhibition of the aesthetic achievements of Amerindian societies as they have evolved over the last four thousand years.

Douglas, Frederic H., and Rene D'Harnoncourt. *Indian Art of the United States.* New York: Museum of Modern Art, 1941. An exhibition catalog containing color plates and black and white photographs, divided into three sections: prehistoric art, historic art, and Indian art for modern living. Includes many fine and unusual pottery pieces.

Dutton, Bertha P. *Indians of the American Southwest.* Englewood Cliffs, New Jersey: Prentice-Hall, Inc., 1975. An informative book covering all of the Indian groups of the Southwest, with a section on arts and crafts.

Eaton, Linda B., and J. J. Brody. *Native American Art of the Southwest.*

Lincolnwood, Illinois: Publications International, Ltd., 1993. Art of the Navajo, Hopi, Zuni, and the groups collectively known as the Eastern Pueblos; illustrated in color.

Frank, Larry and Francis H. Harlow. *Historic Pottery of the Pueblo Indians, 1600–1880*. Boston: New York Graphic Society, 1974. A comprehensive account of historic Pueblo pottery.

Gault, Ramona. *Artistry in Clay: A Buyer's Guide to Southwestern Indian Pottery*, 2d ed. Santa Fe, New Mexico: Southwestern Association for Indian Arts, Inc., 1995. A collector's guide to southwestern Indian pottery.

Hanson, James A. *Spirits in the Art: From the Plains and Southwest Indian Cultures*. Kansas City, Missouri: Lowell Press, Inc., 1994. A useful resource for students of Native American history with a profusely illustrated text.

Hartman, Russell P. and Jan Musial. *Navajo Pottery: Traditions And Innovations*. Flagstaff, Arizona: Northland Press, 1987.

Howard, Kathleen and Diana F. Pardue. *Inventing the Southwest*. Flagstaff, Arizona: Northland Publishing, 1996. An account of Fred Harvey's influence in merchandising Native American art.

Iverson, Peter, and Frank W. Porter III, general editor. *The Navajos*. New York: Chelsea House Publishers, 1990. Examines the significance of Navajo Indians in our society.

Jacka, Lois Essary. Photographs by Jerry Jacka. *Beyond Tradition: Contemporary Indian Art and Its Evolution*. Flagstaff, Arizona: Northland Publishing, Inc., 1988. Explores the artistic extensions of Native American cultures.

———. *Enduring Traditions: Art of the Navajo*. Flagstaff, Arizona: Northland Publishing, Inc., 1994. Modern Navajo pottery, jewelry, sculpture, rugs, paintings, sandpaintings, and baskets.

James, Harry C. *Red Man, White Man*. San Antonio: The Naylor Co., 1958. An exploration of Hopi tribal lore and customs.

Kabotie, Fred. *Designs from the Ancient Mimbrenos: With a Hopi Interpretation*. 1942. Reprint. Flagstaff, Arizona: Northland Press, 1982. A Hopi artist's interpretation of Mimbres designs drawn from Fewkes, Bradfield, and Nesbitt.

Katz, Jane B., ed. *I Am the Fire of Time: The Voices of Native American Women*. New York: Dutton, 1977. Native American women and their songs, poetry, prose, prayer, narrative, and oral history.

Kramer, Barbara. *Nampeyo and Her Pottery*. Albuquerque, New Mexico: University of New Mexico Press, 1996. Maps and drawings by James Kramer. A biography based on first person accounts, photographic evidence and interviews with Nampeyo family members. Many fine illustrations of her work in both color and black and white.

LeFree, Betty. *Santa Clara Pottery Today*. Albuquerque, New Mexico: University of New Mexico Press, 1975. Examines the making of contemporary Santa Clara pottery.

Leftwich, Rodney L. *Arts and Crafts of the Cherokee*. Cullowhee, North Carolina: Land-of-the-Sky Press, 1970. A look at traditional Cherokee arts and crafts.

Mera, Harry P. *Pueblo Designs: 176 Illustrations of the "Rain Bird"*. 1938. Reprint. New York: Dover Publications, Inc., 1970. Drawings by Tom Lea. Traces the prehistoric origins of the Pueblo Indians' distinctive Rain Bird motif, with forty-eight plates and 176 drawings copied from all phases of Pueblo art.

Miles, Charles. *Indian and Eskimo Artifacts of North America*. Foreword by Frederick J. Dockstader. New York: Bonanza Books, 1963. Over two thousand pictorial examples of all the major kinds of North American native artifacts, organized according to function.

Milton, John R., ed. *Conversations with Frank Waters*. Chicago: Sage Books, 1971. Informal conversations with Waters covering many topics of Southwest Indian culture, including references to his friendships with Taos artists.

Minge, Ward Alan. *Acoma: Pueblo in the Sky*. Albuquerque, New Mexico: University of New Mexico Press, 1976. A social, economic, and political history of the Acoma people from 1540 to the present.

Naranjo-Morse, Nora. *Mud Woman: Poems from the Clay*. Tucson, Arizona: University of Arizona Press, 1992. A collection of poems and photographs of claywork by this important Indian artist.

Niethammer, Carolyn. *Daughters of the Earth: The Lives And Legends Of American Indian Women*. New York: Collier Books, 1977. An authoritative chronology of the Native American woman's life, including a discussion of crafts as the opportunity for self-expression and pleasure.

One Space/Three Visions. Albequerque, New Mexico: The Albuquerque Museum, 1979. A catalog for an exhibition that ran from August 5 through November 4, 1979, exploring the crafts of three different New Mexico groups: prehistoric American Indians, Spanish Americans of the sixteenth century, and Anglos of the late nineteenth century. Contains outstanding historical photographs.

Page, Susanne and Jake. *Hopi*. New York: Harry N. Abrams, Inc., 1982. Examines modern Hopi life in a highly detailed and well illustrated text, with a description of Hopi women potters. Numerous plates in full color depict life among the artisans.

Peckham, Stewart. *From this Earth: The Ancient Art of Pueblo Pottery*. Santa Fe, New Mexico: Museum of New Mexico Press, 1990. Photographs by Mary Peck. Depicts pottery making traditions from the earliest utilitarian wares to contemporary artistic works. Extremely fine illustrations of historic and current pieces.

Penny, David W., And George C. Longfish. *Native American Art*. Hong Kong: Hugh Lauter Levin Associates, Inc., 1994. A magnificent collection of full color photographs and critical commentary, covering Native American art from the earliest traditions to the twentieth century.

Peterson, Susan. *The Living Tradition of Maria Martinez*. Tokyo: Kodansha International, 1977. *The Living Tradition of Maria Martinez* is a well-illustrated account of Maria and her pottery making tradition.

———. *Lucy M. Lewis: American Indian Potter*. Tokyo: Kodansha International, 1984. An in-depth biography of one of America's greatest craftswomen. Contains over 220 color plates and 120 black and white photos.

———. *Maria Martinez: Five Generations of Potters*. Washington, D.C.: Renwick Gallery of the National Collection of Fine Arts, Smithsonian Institution Press, 1978. An illustrated exhibition catalog examining the pottery made by the Martinez family.

———. "Remembering Two Great American Potters: Lucy—Maria." *The Studio Potter* 23 (Dec 1994): 41–64.

Sedgwick, Mary Katrine Rice. *Acoma, the Sky City*. Chicago: The Rio

Grande Press, Inc., 1963. A vivid account of Acoma, New Mexico, and its inhabitants.

Spinden, Herbert Joseph, trans. *Songs of the Tewa*. Santa Fe, New Mexico: The Sunstone Press, 1976. A rare work on the poetic expression of American Indian ethics and ideals.

Stratton, Joanna L. "The Clashing of Cultures: Indians." In *Pioneer Women: Voices From The Kansas Frontier,* 107–126. New York: Simon & Schuster, 1981.

Thomas, David Hurst, et al. *The Native Americans: An Illustrated History*. Atlanta: Turner Publishing, Inc., 1993. A comprehensive archaeological history of the native peoples of North America from prehistory to the present day.

Thomas, Davis, and Karin Ronnefeldt, eds. *People of the First Man: Life Among the Plains Indians In Their Final Days of Glory*. New York: Dutton Publishing, 1976. A firsthand account of Prince Maximilians' expedition up the Missouri River in 1833 and 1834, supplemented with Karl Bodmer's watercolors of tribal warriors, women, and chiefs in full regalia.

Townsend, Richard F., ed. *The Ancient Americas: Art from Sacred Landscapes*. Chicago: The Art Institute of Chicago, 1992. An exhibition catalog exploring the arts, thought, and history of the first civilization of the Americas and their descendants.

Trimble, Stephen. *Talking with the Clay: The Art of Pueblo Pottery*. Santa Fe, New Mexico: School of American Research Press, 1987. Interviews with sixty artisans in the pottery making villages of New Mexico and Arizona. Includes discussions with Lucy Martin Lewis, Maria Martinez, and Nora Naranjo-Morse, and illustrations of many fine pottery pieces.

Underhill, Ruth. *Life In The Pueblos*. 1946. Reprint. Santa Fe, New Mexico: Ancient City Press, 1991. An updated version of the classic *Work a day Life of the Pueblos,* with displays of ancient Pueblo pots and pottery dishes.

———. *The Papago Indians of Arizona and Their Relatives, the Pima*. Washington, D.C.: U.S. Department of the Interior, Bureau of Indian Affairs, 1941. A pamphlet about Indian life and customs before the coming of the white man, with illustrated examples of ancient pottery and basketry.

Wade, Edwin L., and Carol Haralson, eds. *The Arts of the North American Indian: Native Traditions in Evolution*. New York: Hudson Hill Press, 1986. Essays by distinguished Indian art scholars, each exploring the problems of defining and understanding historical and contemporary American Indian art. An outstanding portrayal.

Waldman, Carl. *Atlas of the North American Indian*. New York: Facts on File, Inc., 1985. Maps and illustrations by Molly Braun. History, culture, and tribal locations of North American Indians, with a chronology of Indian history, and listings of archaeological sites and museums.

Washburn, Dorothy K., ed. *The Elkus Collection: Southwestern Indian Art*. California Academy of Sciences, 1984. An important pictorial record of the extensive Elkus collection of southwestern pottery, paintings, jewelry, textiles, and other Indian artifacts. Includes fine examples by Lucy Lewis, Maria Martinez, and other Pueblo and non-Pueblo artisans.

White, Leslie A. *The Acoma Indians: People of the Sky City*. 1932. Reprint. Glorieta, New Mexico: Rio Grande Press, 1973. A historical record of Acoma life from 1540, first issued as part of the forty-seventh annual report of the Bureau of American Ethnology. Updated with color plates of Acoma pottery from around 1970.

Whiteford, Andrew Hunter, et al. *I Am Here: Two Thousand Years of Southwest Indian Arts and Culture*. Santa Fe, New Mexico: Museum of New Mexico Press, 1989. Lavishly illustrated catalog of the New Mexico Museum of Indian Arts and Culture collection, with illustrations of pottery, jewelry, basketry, and weaving from prehistoric to contemporary times.

Wissler, Clark. *Indians of the United States*. 1940. Reprint. New York: Doubleday, 1966. An anthropological classic on the history and culture of the American Indian.

Wormington, H. M., and Arminta Neal. *The Story of Pueblo Pottery*. Denver: Denver Museum of Natural History, 1974. A pictorial pamphlet of ancient pottery and other handcrafted vessels.

Index

(Page numbers in *italics* refer to illustrations.)